WONDER

WO ND ER

Nicholas R. Bell

with an introduction by
Lawrence Weschler

Renwick Gallery
of the Smithsonian American Art Museum
Washington, DC

in association with D Giles Limited
London

CONTENTS

WONDER is organized by the Renwick Gallery
of the Smithsonian American Art Museum
with generous support from:

Mr. and Mrs. J. Kevin Buchi

Melva Bucksbaum and Raymond Learsy

Barney A. Ebsworth

Shelby and Frederick Gans

Deborah and Larry Gaslow

Nancy and Carl Gewirz

Elizabeth Firestone Graham Foundation

Susan and Ken Hahn

Bannus and Cecily Hudson

Ann Kaplan and Robert Fippinger

Thomas S. Kenan III

Mirella and Dani Levinas

Jacqueline B. Mars

Robin and Jocelyn Martin

Marcia Mayo

Caroline Niemczyk

Debbie Frank Petersen, in memory of James F. Petersen

The James Renwick Alliance

Dorothy Saxe

Lloyd and Betty Schermer

Suzanne and Walter Scott Foundation

Mary Ann Tighe

Foreword

ELIZABETH BROUN
THE MARGARET AND TERRY STENT DIRECTOR
SMITHSONIAN AMERICAN ART MUSEUM AND ITS RENWICK GALLERY

The Renwick Gallery reopens after a comprehensive renovation, renewed for the next half century and showcasing a breathtaking exhibition, *WONDER*, throughout the galleries. The idea of the exhibition returns to the earliest inspiration for museums in history. The *Wunderkammer*, or cabinet of wonders, began with the Holy Roman Emperors and other rulers; these early collectors and those who followed filled their treasure rooms with natural history specimens—shells, coral, bones, tusks, horns, minerals, stuffed animals and fishes—as well as man-made objects that could be exquisite or complex—paintings, sculptures and carvings, automata, and artifacts from exotic places. Centuries later, emperors and aristocrats were replaced with bankers and businessmen in the new American democracy, but the urge to collect and share wonders of the world continued. The Renwick Gallery's building was born to be an art gallery full of objects for admiration by the public, the first in our young country intended for this express purpose. Banker William Wilson Corcoran wanted rooms that evoked European grandeur to house his considerable collection of paintings and sculptures. He planned its decoration and acquired artworks for the new museum to reassure both citizens and foreign visitors that America valued culture and beauty, even carving in stone above the front door the words "Dedicated to Art."

History played out over the next century, with the building serving variously as a Civil War post for the Union army, Corcoran's Gallery of Art, and the Court of Federal Claims; in the 1960s it had grown shabby with use and was condemned for demolition, then rescued from the wrecker's ball. Eventually it was renovated and rededicated to its original purpose as an art museum, this time under Smithsonian auspices. Since 1972, the renamed Renwick Gallery has shown many marvels to the public—exquisitely made objects conceived by the best American artists working in clay, fiber, metal, wood, and glass, as well as historical decorative arts and architectural design. For more than four decades, the Renwick Gallery proudly continued the building's first purpose as a place where all who visit can be inspired by wonder.

Now once again a new generation of thinkers—artists and curators alike—bring fresh vision and youthful vigor to the renovated Renwick Gallery. To celebrate the reopening, Nicholas Bell invited nine artists who accepted the challenge to create new wonders for our time. Jennifer Angus, Chakaia Booker, Tara Donovan, Patrick Dougherty, Janet Echelman, John Grade, Maya Lin, and Leo Villareal have devised ingenious ways to fill these classic rooms with index cards and insects, rubber and thread, glass and light, orchestrating new experiences that reflect our changed world. In this inaugural exhibition, they spin elements from nature and manufacture into modern magic, heralding a wondrous new life for a landmark historic building that remains "Dedicated to Art." □

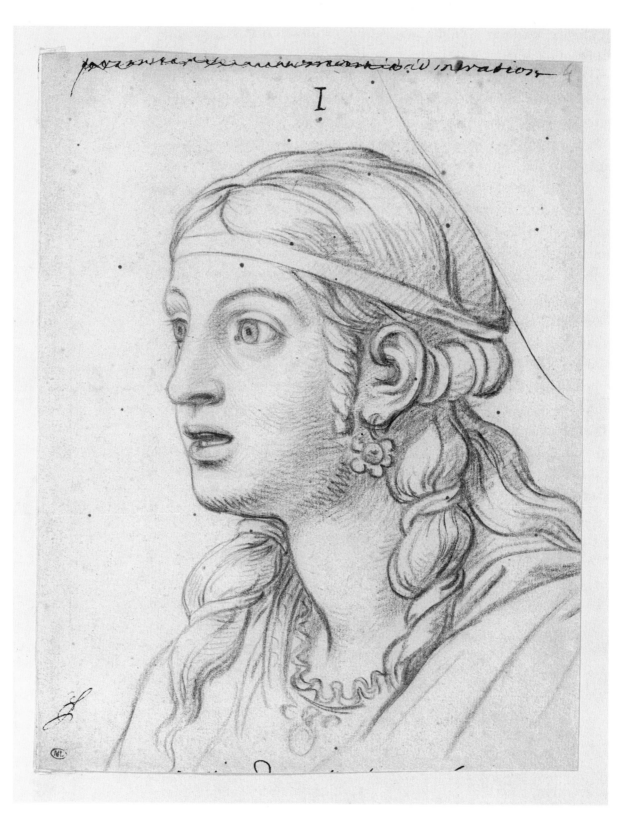

Pillows of Air

L<small>AWRENCE</small> W<small>ESCHLER</small>

"Pillow of air" moments is how I have come to think of them, those
times when one can become so gobsmacked, so taken (in and away,
transported) by the object before one—this Marvel, that Wonder—that
one notices how, in astonishment, a pillow of air has formed and become
lodged in one's very mouth and that one has neither breathed in nor
out for what seems a good ten-second eternity.

That experience, in turn, puts me in mind of that marvelous, mad volume
by the midcentury University of London philologist and divine R. B.
Onians, *The Origins of European Thought about the Body, the Mind,
the Soul, the World, Time and Fate* (1951)—now there's a tome every
self-respecting word/world maven ought sport on his/her shelf! I think
specifically of his reflections: "The Greek word for *I perceive* [which is,
in turn, as Onians points out, at the root for the term 'aesthetics'] is
to be found in the middle of the Homeric term for *I gasp, I breathe in,*
the eyes being understood [as with breath] as not only passive but active
outwardly. Thus for the race at an early stage the primary relation of
breath to consciousness appears to have been worked out to a logical
conclusion as a harmonious system."[1] The lungs and chest were presumed
as the seat of perception, the manifestations of which were, in turn,

Charles Le Brun (French, 1619–1690), *L'admiration avec étonnement* (Admiration with astonishment), before 1690,
black chalk on paper, 10 x 7 ¾ in. Musée du Louvre, Paris

understood in terms of in and out, reception and projection, the world flowing in through one's retina, but attention no less flowing out.

Pillows of air, by a commodious vicus of recirculation, are caesurae between such breaths: those seemingly endless instants when everything pauses in perfect equilibrium. All those awkward moments (and one is back there in this essay's first sentence) can be experienced only by a solitary soul, the world in its singularity addressing an individual in the unique entirety of his/her being. Oh, but the savor of it all, the delicious experience of finding oneself momentarily at a loss and losing oneself in that finding. That swell, vertiginous sense of slippage as the sea comes surging to shore and then goes sluicing back out, the sweet, racing undertow under one's squish-slippy toes as they sink under the receding sand.

Which in turn brings us back to the Age of the Marvelous, that absolute debauch lasting (more or less) a century and a half (from around 1492, to choose a year not quite at random—"Before, behind, between, above, below./O my America! my new-found-land"[2]—through roughly 1650), when Europe seemed veritably to revel in a taste for wonder and astonishment. Right smack in the middle of it all, in 1595, we had Sir Francis Bacon advising any would-be magus, "so that you may have in small compass a model of universal nature made private," to contrive a "goodly huge cabinet, wherein whatsoever the hand of man by exquisite art or engine hath made rare in stuff, form, or motion." Further, "whatsoever singularity chance and the shuffle of things hath produced; whatsoever Nature hath wrought in things that want life and may be kept,"[3] could be gathered under a single roof—in a Wonder Cabinet, as it were.

And talk about the shuffle of things! The sheer volume of stuff! The very organizing principle of the show *WONDER*, it seems to me, is the prodigious profusion of matter—as in Shakespeare's sly coinage, almost

contemporaneous with Bacon's prescription: "What's the matter?"—matter as in *mater*, and from mother *mater* back to matrix, as in womb and loom. (I feel myself channeling my own father master, Norman O. Brown, from my college days as his Latin student at University of California Santa Cruz: "Oh GrandNobodaddy, what big obs you had!")

Our host and Latter Day Cabinetman Nicholas Bell does a fine job in the essay that follows, tracing the rise and fall (and subsequent revival) of that hankering for marvel. (Can there be any doubt that wonder is distinctly back in flair these days? Haven't you, too, dear reader, not chanced to nose this?) At a certain point in the seventeenth century a more rigorous "modern" sensibility became suspicious of the beguiling sinuosities of the wondrous; it insisted on taming marvel's seductive profusions with more methodical stringencies, a prim and proper assertion that indeed may with time have provoked its own polymorphous countertide. For aren't we speaking here, as the late great critic Thomas McEvilley discerned, of the premodern roots of the postmodern?[4] (Think of that sly old saw about why grandparents and grandchildren so cotton to one another: common enemies!)

In the midst of method's grand hegemony, in the nineteenth century, however, John Stuart Mill noted (as Bell reminds us), "It is not understanding [i.e., science] that destroys wonder, it is familiarity."[5] In that sense we might ourselves well concur. Nor is it confusion that engenders marvel: rather, it's defamiliarization, or realienation—in short, the reenchantment of the world. That's art's brief. "Art's job," as Eudora Welty often insisted, is "to render the real real."[6]

So welcome to this show! About its sublime splendors and the sorcerer crew who entrammeled them, perhaps the less said the better. Come see for yourself! Breathe in, breathe out.

I sure hope somebody's told young John Grade about olde Bill Merwin's prose poem *Unchopping a Tree*, because Others are indeed waiting and Everything is going to have to be put back.[7] (Weatherknot anyone did, you, dear reader, well Google versed, will be able to track down that one for yourself.)

Come see for yourself and revel, perhaps, in that sense of inevitable happenstance perfectly captured by that other star-bound necromancer from the Age of Marvel, Johannes Kepler, who once recorded:

> Yesterday, when weary with writing, I was called to supper, and a salad I had asked for was set before me. "It seems then," I said, "if pewter dishes, leaves of lettuce, grains of salt, drops of water, vinegar, oil and slices of eggs had been flying about in the air for all eternity, it might at last happen by chance that there would come a salad."
> "Yes," responded my lovely, "but not so nice as this one of mine."[8]

Breathe in, breathe out, and do come get yourselves good and lost!
For as Northrop Frye used to recount (in Alberto Manguel's retelling):

> A doctor friend . . . travelling on the Arctic tundra with an Inuit guide, was caught in a blizzard. In the icy cold, in the impenetrable night, feeling abandoned by the civilized world, the doctor cried out: "We are lost!" [Whereupon] his Inuit guide looked at him thoughtfully and replied: "We are not lost. We are here."[9] □

Breathe in,

breathe out,

and do come get yourselves

good and lost!

I am the space where I am.

—Noël Arnaud, 1950

ON WONDER

NICHOLAS R. BELL

The Encounter

The most beautiful experience we can have is the mysterious. It is the fundamental emotion which stands at the cradle of true art and true science. Whoever does not know it can no longer wonder, no longer marvel, is as good as dead, and his eyes are dimmed.

—ALBERT EINSTEIN, 1931

Last spring I was invited to speak at a symposium at the Ontario College of Art and Design in Toronto. After my talk I sat quietly fidgeting in the back until I could sneak off with least offense, to pick my way through the March snow to the school's esteemed neighbor, the Art Gallery of Ontario. If asked, I would have claimed I was on a mission to review Frank Gehry's redesign of the museum, the architect's first major project in his hometown. The truth is more prosaic: I like to wander in museums, particularly in the departments furthest from my own expertise. It's here, among Chinese bronzes, Assyrian reliefs, and Saxon hoards, where I find inspiration is most likely to surface. So it was on this day. Three cases into the medieval ivories from the Thomson Collection, I spied an object that clearly wasn't ivory: two concave shells of mottled wood, each no more than two inches in diameter, were hinged together to form an open nut [figs. 1 and 2].

Chakaia Booker, *Its So Hard to Be Green* (detail), 2000, rubber tires and wood. Collection of Chakaia Booker

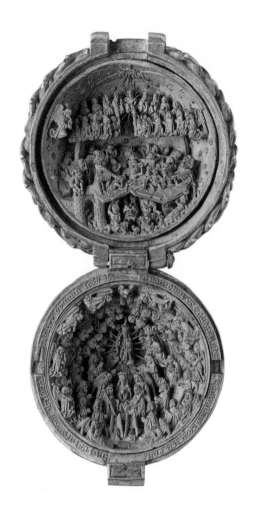

Leaning into the glass and peering through the conservation-dimmed lighting brought just enough definition for visual, if not contextual, clarity. What I initially mistook for a rough, discolored interior surface was in fact the play of shadows across astonishing carvings. Each half of the piece contained a world in itself. In the upper hemisphere, demons rose from the earth to drag anguished souls to a pit of damnation and the jaws of the waiting Hellmouth. The agony of those captured was palpable, their bodies churning in a sea of limbs resisting the inevitable path downward. The lower half revealed Heaven, populated by dozens of serene figures, their heads bowed and hands clasped toward the Virgin at center. Here, within the total volume of a plum, was a masterful rendition of the Final Judgement down to the jewels in crowns and the feathers on angels' wings, a feat of craftsmanship that brings to mind Constantijn Huygens's proclamation of the world beneath a microscope as "everywhere an equally indescribable majesty."[1] But what was this thing exactly? Moving around to the other side of the exhibit case, I could see on the exterior of the nut a complex pattern of gothic tracery, two bands of carved script, and, around the midpoint, a carefully entwined crown of thorns. Closed, the nut could fit snugly in the palm of a hand, its rubbed surface revealing that, before museums or the age of gloves, vitrines, and controlled climate, the piece was quietly and attentively loved. In time I would come to learn about the object's past. It is a prayer bead, a paternoster turned then painstakingly carved from a single piece of boxwood during the first quarter of the sixteenth century, in Flanders or Picardy where the dense wood grows. Scholarly opinions differ as to which studios or towns might have been responsible for the scattering of surviving examples. What we do know is that prayer beads were intended for private devotion; indeed, when open, both the Hellmouth and the Virgin stare directly at the holder, emphasizing the fork in the road of life the worshiper faces daily.[2] All of this was great fun to learn but is largely beside the point of this essay, which is, rather,

Figs. 1 & 2 (actual size) Netherlands, Prayer Bead: The Last Judgement and The Coronation of the Virgin, about 1500–1530, boxwood with metal fittings, open 2 ¼ x 1 ¼ x 4 ¾ in. Art Gallery of Ontario, Toronto; The Thomson Collection. © Art Gallery of Ontario, AGOID.29365

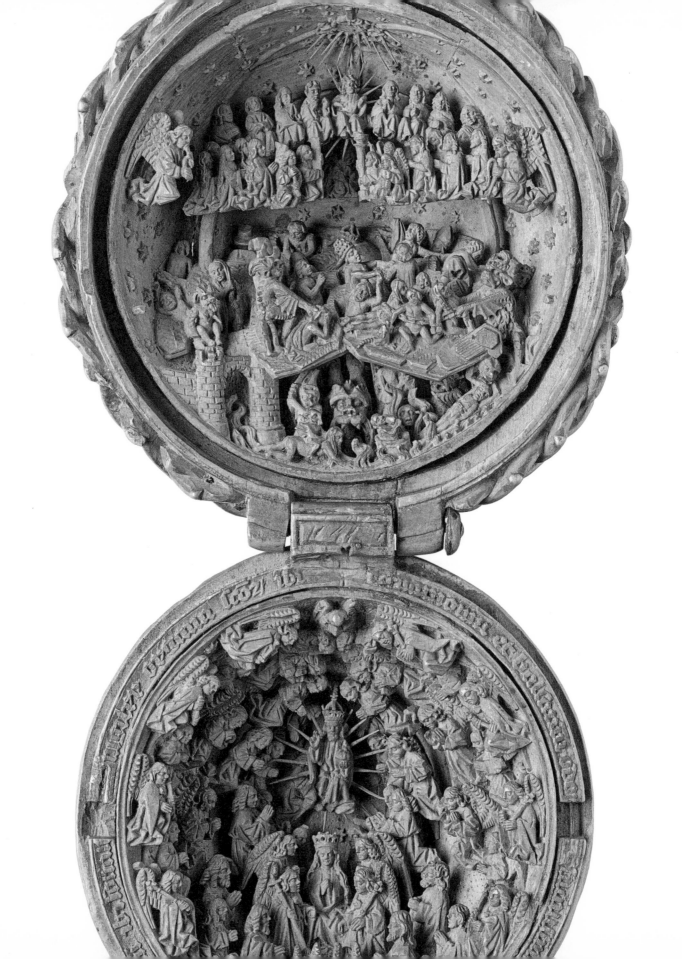

to consider the moment of discovery within a gallery—the minutes
(or more?) spent straining, in the words of historian David Summers,
to "see something we cannot understand how we can see"[3]—in short,
the time lapsed in wonder.

The history of the experience of wonder is peppered with vivid descrip-
tions of what it feels like to stand before an object, blissfully unknowing,
in the moments before context, history, intellect, and taste drown
out the senses. Master printmaker–painter Albrecht Dürer's oft-cited
example on viewing treasures recently brought from the New World is
appropriate to mention here, not only because he wrote these words a
short distance and a few years from the creation of the prayer bead
in the Thomson Collection:

> August 27, 1520—At Brussels is a very splendid Townhall, large and
> covered with beautiful stonework, and it has a noble, open tower. . . .
> I saw the things which have been brought to the King from the new
> land of gold, a sun all of gold a whole fathom broad, and a moon all
> of silver of the same size, also two rooms full of armor of the people
> there, and all manner of wondrous weapons of theirs, harness and
> darts, very strange clothing, beds, and all kinds of wonderful objects
> of human use, much better worth seeing than prodigies. These things
> were all so precious that they are valued at 100,000 florins. All the
> days of my life I have seen nothing that rejoiced my heart so much
> as these things, for I saw amongst them wonderful works of art, and
> I marveled at the subtle *Ingenia* of men in foreign lands. Indeed I
> cannot express all that I thought there.[4]

Dürer was "stunned," to use Stephen Jay Gould's term, by not only
the quality and character of the things he saw but also the challenge the
subtle *Ingenia* brought to his worldview: each Aztec object on display at

Prayer Bead (detail), fig. 1

the Brussels town hall played a role in undermining the valued concepts Dürer might have held certain about the existence of life beyond his firsthand experience.[5]

Leaping ahead from Dürer's time, historian Stephen Greenblatt offers a contemporary experience of wonder that, coincidentally, took place geographically close to the source of Dürer's awe. Upon visiting the Mayan ruins at Coba in Quintana Roo, Greenblatt casually asked a structural engineer his opinion of Nohoch Mul, the major pyramid there. "'From an engineer's point of view,' he replied, 'a pyramid is not very interesting—it's just an enormous gravity structure. But,' he added, 'did you notice that Coca-Cola stand on the way in? That's the most impressive example of contemporary Mayan architecture I've ever seen.'"

Skeptical, Greenblatt returned the next day to the site where, in fact, he saw an extraordinarily complex structure of interwoven sticks and branches, the Coca-Cola stand he had previously missed. "My immediate thought," Greenblatt later wrote,

> was that the whole Coca-Cola stand could be shipped to New York and put on display in the Museum of Modern Art. It is that kind of impulse that moves us away from resonance and toward wonder. For MoMA is one of the great contemporary places not for the hearing of intertwining voices, not for historical memory, not for ethnographic thickness, but for intense, indeed enchanted looking. Looking may be called enchanted when the act of attention draws a circle around itself from which everything but the object is excluded, when intensity of regard blocks out all circumambient images, stills all murmuring voices.[6]

Looking may be called enchanted when the act of attention draws a circle around itself from which everything but the **object** is excluded, when intensity of regard blocks out all circumambient images, stills all murmuring voices.

—Stephen Greenblatt

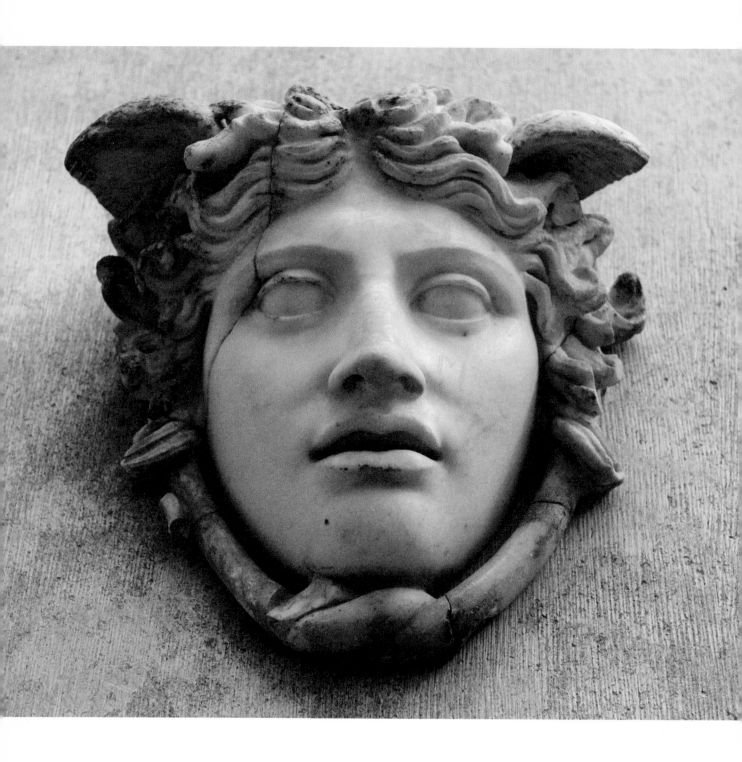

26

Greenblatt here advocates for the object of wonder to enter a modern American cultural vortex, a place where we go specifically to consume and be inspired by Great Things lest we overlook the object in situ, as he first did. The politics of his suggestion are knotty, but they do serve to highlight the museum as an effective frame of experience. We might also consider the classroom, such as the one in which Glenn Adamson, director of the Museum of Arts and Design, New York, was first handed an eighth-century Tang-dynasty dish in an undergraduate seminar on Chinese ceramics. What hit him "like a ton of bricks" and would eventually direct his career toward the study of design and decorative arts was not the history of the piece, but rather the "physical force of the thing," a palpability ensuring that "no amount of talking about it seemed to use it up or approach an adequate explanation of it."[7] That experience was for Adamson what Lawrence Weschler would call a "pillow of air" moment, when the beholder becomes so consumed in a thing that he or she fails to breathe "for what seems a good ten-second eternity," as Weschler describes it in his prelude to this volume.[8] Looking back once more we can turn to Johann Wolfgang von Goethe's astonishment upon unwrapping the Medusa Rondanini [fig. 3], a Roman copy of a fifth-century BCE Greek sculpture of the head of the monster: "The mere knowledge that such a work could be created makes me twice the person I was." What history Goethe might fashion for the work was unequal to the power of his first confrontation with it: "I would say something about it if everything one could say about such a work were not a waste of breath." Late in life, in his conversations with the young Johann Peter Eckermann, Goethe would reflect generally on the nature of astonishment as the "highest that man can attain in these matters." He continued, "If the primary phenomenon causes this, let him be satisfied; more it cannot bring."[9]

It is easy, today, to overlook wonder, whether as the quality of a thing or our experience of it. Were I to draft a list of suspects for the drift in our

Fig. 3 Medusa Rondanini, Roman copy after 5th-century BCE Greek original by Phidias (fl. about 490–430 BCE), 125–150 CE, Parian marble, 15 ¼ x 14 ⅞ in. Glyptothek, Munich ☐ Goethe encountered the Medusa at the Bevilacqua Palace in Verona in 1787. Decades later and in indulgence to his love for the poet, Prince Ludwig of Bavaria (later, King Ludwig I) purchased the sculpture from the heirs of the Marchese Rondanini while he was on tour in Italy. The prince brought the Medusa to Munich to enrich the collections of the then-new Glyptothek, a museum of Greek and Roman antiquities, where it has remained since the early nineteenth century.

focus, somewhere near the top might be the sheer overuse of the word's linguistic variations in contemporary English. We lazily tumble out with "I wonder" to begin a question. We label things and events as "wonderful" and only slightly less often "a wonder," leaving our vocabulary for the marvelous firmly in the grip of the mundane. Such lip service, however casual in intent, belies the seriousness with which wonder was considered, then subverted, in Western thought, a topic addressed below. In brief, we can return to Goethe, who lamented about astonishment: "[It] is not generally enough for people. They think they must go still further; and are like children who, after peeping into a mirror, turn it round directly to see what is on the other side."[10] The same condition partly accounts for the general state of information, post Internet, when the promise that we can know virtually everything drives us blindly to solicit as much, perhaps as a stopgap against falling behind our peers; more likely, we do it simply because, like the proverbial mountain, the information is there. To wonder is now ever so quickly followed by knowing, and too often the stamping out of the opportunity for good that arises in the face of uncertainty or the sublime. Further, to speak of wonder—whether at the unknown or in service to the marvelous— is to speak of how you feel. Yet to speak of feelings, at least in the world of art, sighs the critic Martin Gayford (who is clearly saddened by the state of affairs), "would seem unscholarly."[11]

One only need spend a few moments in the company of a toddler to rediscover what geographer Yi-Fu Tuan has labeled an "intense openness to the world"—a perspective on our surroundings as a miraculous place where an unending stream of phenomena are closely observed yet infrequently explained by parents worn down by the question heard around the clock: why?[12] Yet somewhere along the road from the time we first pick up a stone to the moment we arrive at our first day of gainful employment, each of us passes through a bottleneck that seizes up

wonder, transforms most of the objects around us into the everyday, and colors our experience of the world a little drab.

The challenge in locating wonder, then, is to catch it in the wild, to pull up to the Mayan refreshment stand and have the engineer's wherewithal to see it. Our prevailing indifference to the world around us is why Greenblatt wanted to ship the stand to New York: when we visit an art museum, we do so (ostensibly) with a mind to active looking; in a site freighted with a high level of intentionality, we are more likely to take notice of what we go to see, whether it is the Medusa, the Tang dish, or the Dutch prayer bead; we draw circles around them and still the murmuring voices. "Wonder is often enhanced by the isolation of its object," by "suppressing the background that confers intelligibility or causal continuity," asserts historian of philosophy Ronald Hepburn.[13] Museums serve many public functions, among them research, education, and, increasingly (and controversially), entertainment; yet I would argue that their most critical task is to trigger our "startle reflex," to use Greenblatt's term, by placing before us things that fall outside the range of everyday experience.[14] Historian Ludmilla Jordanova has proposed that it is precisely through such confrontations that objects become "triggers of chains of ideas and images that go far beyond their initial starting point." She continues, "Feelings about antiquity, the authenticity, the beauty, the craftsmanship, the poignancy of objects are stepping-stones towards fantasies, which can have aesthetic, historical, macabre or a thousand other attributes."[15] It is through the force of our encounters with wonder that we construct the knowledge to make our way through the world with hands out and eyes open, wending from point to marvelous point of experience; through the weaving together of the unknown, the uncanny, and the uncertain, wonder's use folds into the practice of life itself. That is why David Wilson, proprietor of the renowned microinstitution (and possible post[post]modern performance artwork) the Museum

Museums serve many public functions, among them research, education, and, increasingly (and controversially), entertainment; yet I would argue that their most critical task is to trigger our

"sta
refl

rtle
ex
,,

...by placing before us things that fall

outside the range of everyday experience.

of Jurassic Technology in Los Angeles, explains, "Part of the assigned task [self-assigned, as it were] is to reintegrate people to wonder."[16]

It was around the time I saw the prayer bead in Toronto that the staff of the Renwick Gallery, the Smithsonian's national craft museum, began to move out of the building in preparation for a much-needed renovation. Fifty years since the structure had been snatched from the jaws of demolition and restored to Victorian(esque) splendor, systems were failing, energy use was soaring, and plaster was crumbling. We packed up the second floor first. As I strolled through the newly empty galleries, the kernel for an exhibition on wonder took form. Have you ever noticed

The most valuable object in our collection

that most things you are meant to look at in a museum hover at about the same height? We have formalized "eye level," which at the Renwick is thirty-six inches for pedestals and sixty inches for wall hangings (i.e., three and five feet) so that your eyes never need stray far in their search for the artworks that justify your visit. The benefit is your comfort as a visitor; the drawback is what you miss when objects are so tidily presented. As the last of the collections were removed—and with them the pedestals, vitrines, platforms, and labels that organize the collections and guide our behavior—a new museum appeared before me, or, more accurately, an old museum. Those who inquire whose mansion the Renwick initially was are frequently surprised to learn that no industrial baron ever lived there; rather, William Wilson Corcoran (1798–1888) constructed

it as the original Corcoran Gallery of Art, the first art museum in Washington, DC, and no less than the first purpose-built art museum in the still-young United States. That is why a grandiose C is carved above each doorway; why the ceilings soar from eighteen feet in the galleries to thirty-eight feet in what we call the Grand Salon (why there is a Grand Salon!); why two statues—of Peter Paul Rubens (identifiable by his hat) and Bartolomé Estebán Murillo—based on Moses Jacob Ezekiel's original eleven sculptures of the great artists are perched in niches over 17th Street; and most important, why the phrase "Dedicated to Art." is chiseled in stone above the entrance (the period after "Art" is significant, a clear statement that the building is dedicated to no other subject).[17]

is the building itself.

Freed from the standard plane, my gaze drifted upward to cove ceilings, across plaster friezes, and around cast-iron banisters and pinpoints of gilding in memory of the luster of its namesake age. Taking in the full volume of these spaces is when the point stuck: the most valuable object in our collection is the building itself.[18]

The exhibition *WONDER* marks the third instance in the Renwick building's 156 years spread over three centuries in which it has been opened as an art museum. Construction for a building to house Corcoran's collection began in 1859, and after intervening events during the Civil War it was eventually inaugurated as the Corcoran Gallery of Art in 1874; from the turn of the century to the mid-1960s, the building

was used for the US Court of Claims; and in 1972 it reopened as the Renwick Gallery of the Smithsonian Institution. Considering that the galleries served more years as a courthouse than as either the Corcoran or a branch of the Smithsonian, and the building was nearly razed before becoming the Renwick, the exhibition celebrates the building's tenacity as a bastion of culture and the museum as a site for the arousal of wonder. It is of no small consequence that we, as a public, commit to perpetuating spaces that harbor the potential for intensive and subjective encounters with art.

It was in a stew of historical research, emotion, and half-formed intentions that I reached out to a small group of contemporary artists working in the United States with an idea to turn the building into an immersive hall of wonders. Each of the nine artists who accepted—Jennifer Angus, Chakaia Booker, Gabriel Dawe, Tara Donovan, Patrick Dougherty, Janet Echelman, John Grade, Maya Lin, and Leo Villareal—did so in part because the many facets of wonder underpin the reasons they have elected to create art. Each of the artists has demonstrated a talent for conjuring the right balance of materials, scale, and sensitivity to a site to prompt reactions among viewers that hinge on surprise, awareness, and, crucially, awe. Such elements matter in the context of the Renwick, which has been devoted for more than four decades to showing the creations of individuals who are exceptionally skilled in working materials. Although wonder can be found in the infinitesimal (the smallest object in the Renwick's collection is a turned-wood goblet from 1979 by Del Stubbs, $\frac{1}{16}$th of an inch tall, that can be lifted, marvelously, by the static charge from a straight pin held above it),[19] it is the gigantic work, not the prayer bead in the dim case, that will best draw your attention to the genuine capacity of the gallery and your situation within it.

Separately, the nine artists came to the Renwick after it was emptied for renovation but before demolition began. They were able to feel their way through the site unencumbered and, critically, reflect on the layout of the museum as it was conceived in the nineteenth century and restored a half century ago. The works they have created in response are discussed toward the end of this essay, after sections on the scope of wonder, its role in the West in the development of spaces in which to encounter wondrous things, and the intentionality of the Renwick's site. It is our hope that the nine artists' installations will affirm once more the essential nature of the unexpected and underscore the value of the museum as a locus of wonder. □

A Sense of Wonder

Wonder—is not precisely Knowing
And not precisely Knowing not—
A beautiful but bleak condition
He has not lived who has not felt—

Suspense—is his mature Sister—
Whether Adult Delight is Pain
Or of itself a new misgiving—
This is the Gnat that mangles men—

—EMILY DICKINSON, 1874

The history of the consideration of wonder in Western thought is far more complex than the modern reader is likely to presume given the subject's scant influence today. The following commentary, then, is not intended as a comprehensive overview so much as an introduction to key perspectives on wonder's role in our perception of the world, from antiquity to the early modern period.

In his so-called *Metaphysics*, Aristotle assigns wonder a prefatory but crucial role in our engagement of the world: "It is through wonder that men now begin and originally began to philosophize; wondering in the first place at obvious perplexities, and then by gradual progression raising questions about the great matters too, for example, about the changes of the moon and of the sun, about the stars and about the origin of the universe."[20] In this most basic definition, wonder is born of not knowing and seeking to know, an internal state necessarily preceding critical thought and the evaluation of external phenomena. Aristotle's

Gabriel Dawe, *Plexus No. 4* (detail), 2010, thread, wood, and nails. Courtesy of the artist

definition has come down to us reasonably intact insofar as it mirrors the contemporary usage described above. To utter "I wonder" is to exclaim a specific ignorance and a desire to quench it. The pleasure of wonder comes not from its attachment to ignorance (although a Renaissance proverb described wonder as the "daughter of ignorance") but from the opportunity to learn the cause of the unknown—something new and of value.[21] The original Greek texts for *Metaphysics* (which had been translated into Arabic) came to Europe in the early thirteenth century following the Fourth Crusade; new Latin translations would guide (and bedevil) medieval and early modern considerations of wonder, including the writings of Saint Albertus Magnus, Saint Thomas Aquinas, Benedict de Spinoza, and René Descartes, among others.

Saint Albertus, the thirteenth-century bishop and great man of medieval German theology (he was actually called Albert the Great), discussed the above explanation of wonder in his *Commentary on the Metaphysics of Aristotle*:

> Wonder is defined as a constriction and suspension of the heart caused by amazement at the sensible appearance of something so portentous, great, and unusual, that the heart suffers a systole. Hence, wonder is something like fear in its effect on the heart. This . . . springs from an unfulfilled but felt desire to know the cause of that which appears portentous and unusual: so it was in the beginning when men, up to that time unskilled, began to philosophize. . . . Now the man who is puzzled and wonders apparently does not know. Hence wonder is the movement of the man who does not know on his way to finding out, to get at the bottom of that at which he wonders and to determine its cause. . . . We define the man who wonders as one who is in suspense as to the cause, the knowledge of which would make him know instead of wonder.[22]

Wonder is defined as a constriction and suspension of the heart caused by amazement at the sensible appearance of something so portentous, great, and unusual, that the heart suffers a systole.

—ALBERTUS MAGNUS

While the underlying premise of this passage hews closely to Aristotle's foundation, it is striking for its emotional description of the unknown as more than something undefined—rather, as an object of interest that has already accumulated forceful qualities, including the potential for the unusual, marvelous, fearful, tragic, even calamitous. Despite the title of Saint Albertus's treatise, I would argue that the passage is inflected less with consideration of Aristotle's *Metaphysics* and more of his *Poetics* (in which the philosopher discusses the centrality of the marvelous to tragedy), and astonishment's ability to make the improbable instantly plausible to the previously unaware audience—a late-breaking narrative trick frequently employed from early modern drama to contemporary cinema. (Poet and critic J. V. Cunningham gives the conclusions to *As You Like It* and *A Midsummer Night's Dream* as examples of the former, while others have suggested memorable sources of the latter to be the climaxes of such films as *The Usual Suspects*, 1995, and *The Sixth Sense*, 1999.)[23]

Later, and somewhat peculiarly, given Spinoza's disagreement with Descartes on such fundamental philosophy as the concept of mind-body dualism, the two seventeenth-century rationalists advanced a similar and essentially Aristotelian definition of wonder at the beginning of the Enlightenment. For Spinoza, wonder "depends upon a suspension or failure of categories," according to Greenblatt's analysis, "and is a kind of paralysis, a stilling of the normal associative restlessness of the mind." In wonder, Spinoza wrote, "the mind comes to a stand, because the particular concept in question has no connection with other concepts," leaving the object in question psychically and momentarily orphaned while the beholder develops an appropriate response.[24] Descartes, meanwhile, in his *Passions of the Soul* (1649), lists wonder as the first of six passions (the others being love, hatred, desire, joy, and sadness) because it necessarily precedes our comprehension of all new phenomena [fig. 4]. "When our first encounter with some object surprises us and we find it

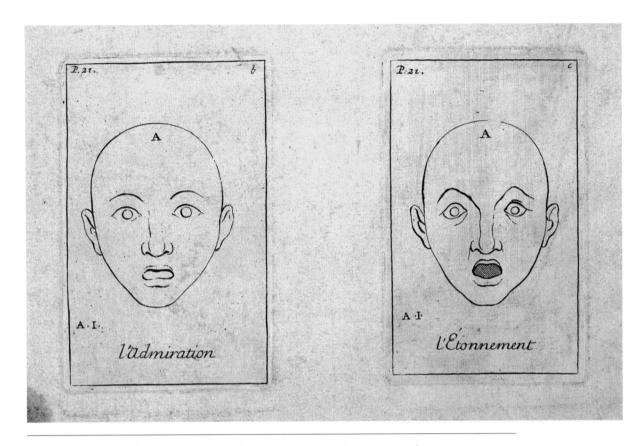

Fig. 4 Etching by Bernard Picart (French, 1673-1733) after Charles Le Brun (French, 1619-1690), *L'admiration avec l'étonnement* (Admiration with astonishment), 1713, etching, 3 ¾ x 2 ⅜ in. Wellcome Library, London

Descartes's *Passions* served as the foundation for Charles Le Brun, court painter to Louis XIV, to develop a robust theory on how aspects of human emotion described by the philosopher were manifested in facial expressions. This card, and the related drawing on page 10, demonstrate the meticulous detail Le Brun provided on how to depict the passage of wonder:

> As admiration [wonder] is the chief and most temperate of all the passions, wherein the heart feels less emotion: so all the parts of the face also receive very little change. If there are any, 'tis only in the elevation of the eyebrow, but both ends will be even, and the eye rather more opened than ordinary; the pupil in the center between the two lids without motion, and fixed upon the object admired. The mouth also will be somewhat open, but without alteration, any more than the other parts of the face. All the effect of this Passion is an entire suspension of motion, to give the Soul time to deliberate upon what she has to do, and attentively consider the object that presents itself to her; which if uncommon and extraordinary, what was but, at first, a simple emotion of Admiration, then becomes Esteem.

Le Brun's theories of representation achieved widespread influence at the French Academy, where he was chancellor and a regular lecturer.

novel—i.e., very different from what we formerly knew or from what we supposed it should be—this brings about that we wonder and are astonished at it."[25] Contrary to Saint Albertus, Descartes argued that wonder alone among the passions "doesn't involve any change in the heart or in the blood," because a wondrous state prefaces our capacity to judge the value of the unknown. Rather,

> Wonder is a sudden surprise of the soul that . . . is caused (1). by an impression in the brain, which represents the object as unusual and therefore worthy of special consideration; and (2). a movement of the spirits, which the impression disposes—to flow strongly to the impression's place in the brain so as to strengthen and preserve it there, and also—to flow into the muscles controlling the sense organs so as to keep them focused on the object of wonder.

Give me an apple tree in a suburban garden.

For Descartes, wonder is useful insofar as it encourages inquiry. "It is good to be born with some inclination to wonder, because that increases scientific curiosity." But we should avoid "excessive wondering," as the first passion is not an end but simply a compulsory step in the quest for knowledge, which we procure "not by wondering at . . . things that seem unusual and strange . . . but by examining them." Descartes's vigilance on this point marks the limit of wonder's value among Enlightenment theorists and the root of its eventual subsumption beneath increasingly rigorous models of inquiry in all fields of study.

To break away from a definition of wonder as a window of uncertainty largely dependent on surprise (whether a philosophical or physiological response), we must look way back to the early Christian theologian Augustine of Hippo. For Saint Augustine, the range of phenomena that could be counted as wondrous in nature was artificially limited to things encountered beyond the familiar. "Men go forth to marvel [*mirari*] at the heights of mountains, at the huge waves of the sea, the broad flow of the rivers, the vastness of the ocean, the orbits of the stars, and they neglect to marvel at themselves."[26] The quotidian was as deserving of wonder as every other component of this world, including its occupants, and all were examples of God's work. Wonder, then, reflected not simply the urge to make sense of the unknown but also the existential appreciation for the well known—independent of causal explanation. French painter Pierre-Auguste Renoir tidily summed up this perspective in a comment

I haven't the slightest need of Niagara Falls.

hinting at Saint Augustine's imprint on the work of the impressionists: "Give me an apple tree in a suburban garden. I haven't the slightest need of Niagara Falls."[27] As further illustration, compare Dürer's wonder at the spoils of the New World ("I cannot express all that I thought there") with the terrifically modest subject of his watercolor *The Great Piece of Turf*, 1503, which draws the viewer down to the level of a hare to consider the near-ground perspective of an exuberant clutch of common grasses and weeds [fig. 5]. The draftsman's genius is not just the revolutionary naturalistic rendering of pimpernels and persevering dandelions but more important, his ability to capture the essence of majesty in a

—PIERRE-AUGUSTE RENOIR

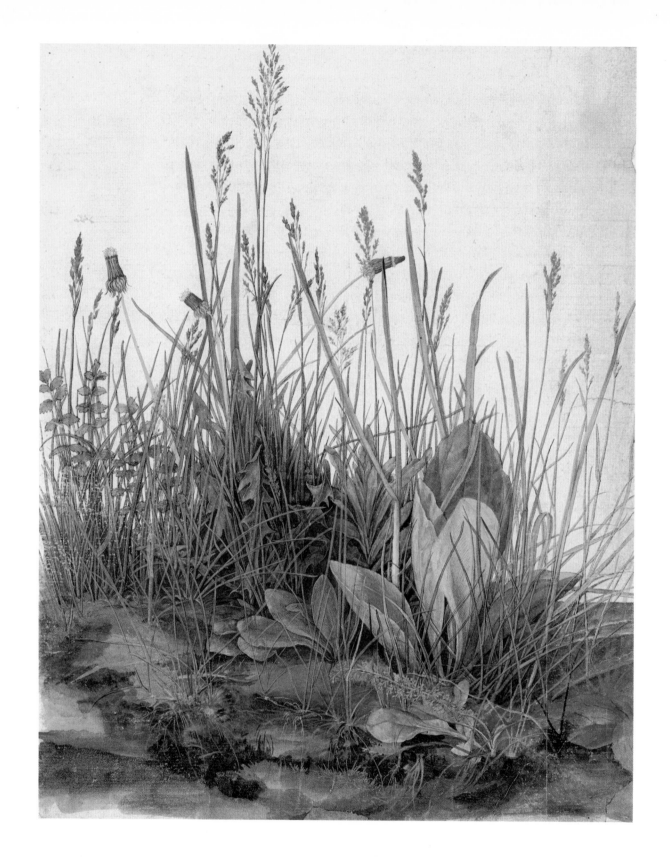

44

subject we are more likely to ignore, curse, or trample underfoot than revere.[28] "The general Augustinian message that everything in creation was wonderful," contend historians Lorraine Daston and Katharine Park, meant that the world itself, in Saint Augustine's words, was "beyond doubt a marvel greater and more wonderful than all the wonders with which it is filled."[29] Historian Valerie Flint goes yet further, underscoring the significance of "wondering amazement [at] God's work of creation" as a value so central to Saint Augustine that "he came close to asserting that it was the distinguishing feature of the true Christian."[30]

The wonders with which Saint Augustine's world was filled, of course, prominently featured miracles, and it is in consideration of events outside the perceived natural order that we find something of a rapprochement between Aristotelian and Augustinian camps. Saint Augustine defines a miracle as "anything great and difficult or unusual that happens beyond the expectation or ability of the man who wonders at it."[31] Saint Thomas Aquinas (Albertus's best-known student) would tease this out in his landmark *Summa contra gentiles*, proposing that what remains hidden to some but not all observers should be defined conservatively as a wonder, not a miracle: "The astronomer does not wonder when he sees an eclipse of the sun, for he knows its cause, but the person who is ignorant of this science must wonder, for he ignores the cause. And so, a certain event is wondrous to one person, but not so to another." If wonder hinges on the subjectivity of knowledge, then only a miracle, whose source (God) remains hidden from all, can be universally declared a wonder.[32]

Finally, for a perspective that departs from both established camps, we can turn to the sixteenth-century Italian theoretician Francesco Patrizi, whose massive *Della poetica* (1586) would earn him a modern reputation as the "most persistently anti-Aristotelian critic of his century."[33] A passage in his *La deca ammirabile* describes wonder (as it is generated

Fig. 5 Albrecht Dürer (German, 1471–1528), *The Great Piece of Turf*, 1503, watercolor and gouache heightened with white, mounted on cardboard, 16 x 12 ⅜ in. Albertina, Vienna, inv. 3075

Wonder's most consistent quality is its heterogeneity,

which in turn lends itself to the rampant subjectivity

of our experience of it . . . and to the competing claims

that what is joyous or tragic, marvelous or forbidding,

astonishing or plain can equally be **wonderful.**

in the mind of the audience of a work) as a "mediatory power" between reason and affect: "The above-mentioned power of wonder is neither reason nor emotion, but separate from them both; and that, placed on the boundary between the two, it is able to spread and flow, through its movement, swiftly up to the regions of reason and down to those of emotion. . . . The power of wonder is almost [a] Euripos [violent current] . . . , the tide running back and forth from reason to emotion." When confronted with the what Patrizi called the "new, sudden and unexpected," our soul is caught between the acts of believing and not believing: "of believing because the thing is seen to exist; and of not believing because it is sudden, new, and not before either known, thought, or believed able to exist."[34] Hints of Saint Albertus's systole and Descartes's surprise of the soul crop up here, as we stand astonished at the arrival of the unknown. But Patrizi also proved to be a new force, which, literary historian Peter Platt argues, took dead aim at the Aristotelian assumption that reason—in the form of established knowledge—diminishes wonder. If wonder courses—even violently—from a midpoint between reason and emotion, it follows that wonder is capable

of diminishing reason as well. Patrizi's work was not apparently known in Elizabethan literary circles, although, in what Platt titles a "rare coinciding" of Renaissance theory and practice, Shakespeare sometimes introduced wonder, in the form of illogical or unexplainable events, expressly to undermine the natural order of things—what Platt refers to as the "potential epistemological tyranny of the rational."[35] The dizzying leaps in space and time in *The Winter's Tale* are the classic example, but consider also the succinct message in Hymen's wedding speech at the conclusion of *As You Like It*:

> Whiles a wedlock hymn we sing,
> Feed yourselves with questioning,
> That reason wonder may diminish,
> How thus we met, and these things finish.[36]

If we should take a single conclusion from the diversity of viewpoints touched upon above, it is that, even as the focus of concerted study across centuries of intellectual and emotional engagement, the fundamental nature of wonder remains in dispute. Wonder can be experienced as each of these philosophers has described it: to stand in awe before the unexpected and unexplained, craving knowledge; to revel in the glory of the heavens or the dandelions beneath our feet; to witness order succumb to chaos; to feel passive, even stupefied; or to be jolted to launch a most fervent investigation. Wonder's most consistent quality is its heterogeneity, which in turn lends itself to the rampant subjectivity of our experience of it, whether in the heart or brain, mind or soul, and to the competing claims that what is joyous or tragic, marvelous or forbidding, astonishing or plain can equally be wonderful. □

The Shuffle of Things

*If there ever was an age when one sees varied
and wondrous things I believe that ours is
one, for it is an age in which, more than
any other, things happen that are worthy of
astonishment, compassion, and reproach.*

—Matteo Bandello, 1554

Although the perspectives detailed above were more often drafted in consideration of poetics, theology, or earnest inquiry, they equally elucidate the evolution of our responses to certain classes of things and how we have chosen to engage them. The history of early collecting in the West—the practice that predates the birth of modern museums—is tangled up with the astonishing and the mysterious, and so with wonder. It is a history of the pursuits of royals, inquisitive noblemen, and pioneering scientists, and of exploration and the wielding of cultural and economic power that is far too vast to be given justice in the scope of this essay.[37] Instead, I want to consider just two specific aspects of that preoccupation—Europe's long-standing interest in the margins of the known world, and the creation of spaces in which to view and experience the marvelous.

The medieval European worldview hinged on a deeply religious reading of topography: Europe, the Holy Land, and the Mediterranean were at

Tara Donovan, *Untitled* (detail), 2014, styrene index cards, metal, wood, paint, and glue. © Tara Donovan, courtesy Pace Gallery.

49

the center of the world, with Jerusalem believed to be the absolute center, as described in Ezekiel: "Thus says the Lord God: This is Jerusalem; I have set her in the center of nations, with countries all around her."[38] The miraculous occurred at a considerable distance from this center; and between it and the periphery of the known world, what Daston and Park call a "privileged place of novelty, variety, and exuberant natural transgression," clustered wondrous things and events [fig. 6].[39] The perimeter included Asia, India, and Africa and, perhaps curiously for the contemporary reader, Ireland, given Europe's continued ignorance of the New World. It is in reference to that western edge that fourteenth-century English monk Ranulf Higden reflected, "At the farthest reaches of the world often occur new marvels and wonders, as though Nature plays with greater freedom secretly at the edges of the world than she does openly and nearer us in the middle of it."[40] A growing number of fantastical descriptions and travel narratives chronicling the far reaches of this topography, including those of Marco Polo, Prester John, and Sir John Mandeville, mushroomed in popularity in those years.[41] *Mandeville's Travels* (the earliest manuscripts began to circulate around 1366) is especially entertaining, with its careful descriptions of cannibals, dragons, and strange beasts, such as the half-man half-goat in the Egyptian desert, the Scythian lamb, which grew from gourds on trees in Cathay (Mandeville says these are "no great marvel," as he is familiar with Ireland's barnacle geese, which also grow on trees), and, in Java, snails whose shells were large enough to hold three or four men, "as it were in a little house or lodge" [figs. 7 and 8].[42] To follow Mandeville on his circumambulation is to stumble over a new marvel in every country; each range of mountains, river, and sea reinforces the view that ever-widening circles from the center remove us from the security of the ordinary.[43] To reassure his audience that his account is accurate, "as many men trow [trust] not but that at they see with their eyes, or that they may conceive with their own kindly wits," Mandeville wound down

Fig. 6 Unidentified artist, Latin Psalter World Map, about 1265. The British Library, London. Image © The British Library Board, Add. 28681, f.9 □ This world map from a medieval book of psalms is a T-O map, for *orbis terrarum*, so named for the proportions of the known world: Asia, or the Orient, constituted the top half of the map (the word "orientation" derives from this convention), while Europe and Africa each occupied a lower fourth. The map centers on Jerusalem, as prescribed in the Bible. With the notable exception of the Red Sea, large bodies of water are rendered in green, while the monstrous races described in *Mandeville's Travels* and other narratives of the period lurk around the edges of the world.

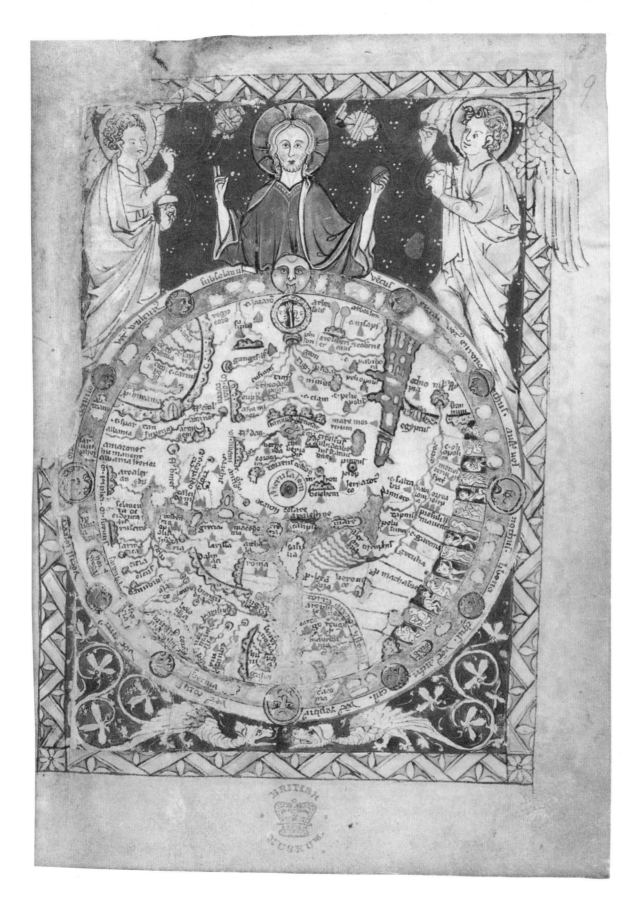

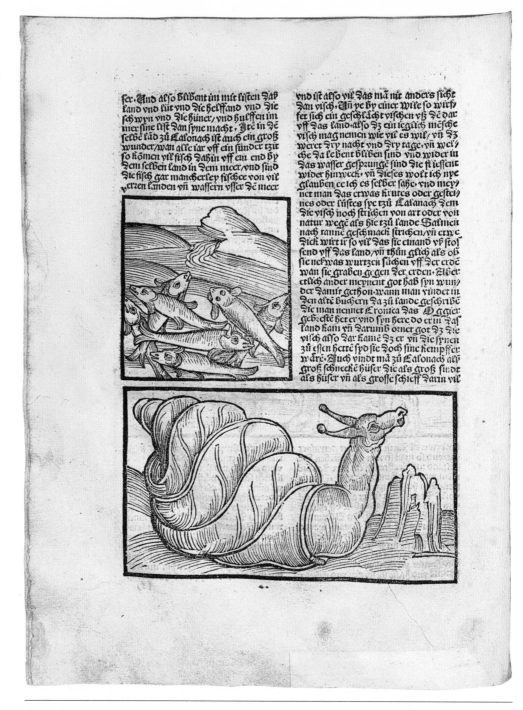

Fig. 7 Folio 82 from John Mandeville, *Von der erfarün[g] des strengen Ritter[s] johannes von montauille* (Strasbourg, 1499), edited by Otto von Diemeringen. Bayerische Staatsbibliothek München/Bavarian State Library, Munich, Rar. 982 □ The woodcut at the bottom of this page from an Alsatian edition of *Mandeville's Travels* shows one of the great Javanese snails. The upper image illustrates a marvel from the same country "that is not in other lands." The text continues, "For all manner of fishes of the sea come at a certain time of the year . . . and lay them near to the land and some upon the land. And there they lie three days; and men of the country come thither and take of them what they will." Mandeville relates that "no man knows the cause" of this, affirming Saint Thomas Aquinas's definition of what can universally be declared a wonder.

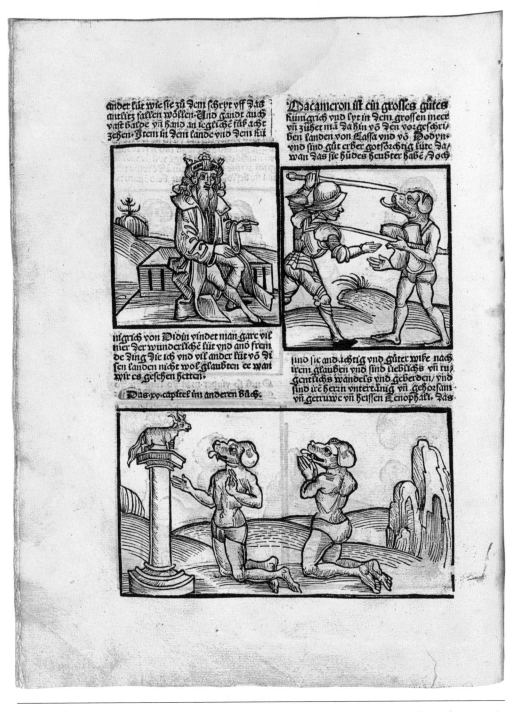

Fig. 8 Folio 88 from John Mandeville, *Von der erfarün[g] des strengen Ritter[s] johannes von montauille* (Strasbourg, 1499), edited by Otto von Diemeringen. Bayerische Staatsbibliothek, München/Bavarian State Library, Munich, Rar. 982 □ Mandeville writes of an island called Natumeran, where men and women called Cynocephales "have heads like hounds . . . yet they are full reasonable and subtle of wit." The woodcut at bottom shows them worshiping an ox for their god. One of the lasting pleasures of reading period editions of Mandeville is discovering the variety of illustrations of this particular race, often featuring familiar dog breeds.

his return journey with a stop in Rome, so that an unimpeachable source might vouch for its fidelity. Meeting the pope, Mandeville wrote, "I told him the marvels which I had seen in divers countries, so that he with his wise counsel would examine it with divers folk that are in Rome, for there are evermore dwelling men of all nations of the world. And a little after, when he and his wise counsel had examined it all through, he said to me for certain that all was sooth that was therein. . . . Therefore our holy father the Pope has ratified and confirmed my book in all points."[44] Perhaps the author needn't have bothered with that dubious claim: according to Daston and Park, the sheer distance separating the margins from Europe made the authentication of purported wonders effectively moot, as did a medieval sensibility that comfortably emphasized the texts' entertainment value over their veracity (our insistence on the latter underscores a fixation on objectivity stemming from the Enlightenment).[45] All fine for the casual reader, but for the serious voyager—the seeker of the margins—such a profession of truth might prove highly influential. Consider that these texts permeated European culture in the years leading up to the great age of exploration, which unfolded well before skepticism diminished the authority of Mandeville's most marvelous declarations. Indeed, Flint argues that Mandeville "clearly ranked among the most respectable geographic sources," while Greenblatt writes that his own interest in Mandeville stemmed from the assumption that Columbus read the *Travels* and might well have carried them on his first voyage. Columbus's heavily annotated copies of such books as Marco Polo's narrative and Pierre d'Ailly's fabulous *Imago mundi* (1410) survive, and Columbus's son, Fernando, cites Mandeville's and Marco Polo's works as inspirations for his father's journeys.[46] We must recall that Columbus believed he was establishing a new route to a land previously visited by Europeans and that his claims of territory for the Spanish crown were against the Mongol empire of the Great Genghis Khan, not an heretofore "undiscovered" country.[47] It is precisely the

makeup of what Flint refers to as Columbus's "mental cargo" that led him to mistake the island of Cuba for Cipangu (Japan) and later for the coast of Cathay.[48]

It is difficult to convey the shock the introduction of the New World had on the psyche of the Old. Imagine if you were to learn today that the moon, which had long ago been established to be a desolate rock, was in fact teeming with flora and fauna and the civilizations of alien species. Your response might begin to illuminate the wonder experienced by awestruck Europeans and the quandary the information posed to their conception of the natural world, still rooted in the observations of Saint Augustine, Ptolemy, and Pliny the Elder. How could the pillars of Western knowledge have missed something as substantial as a hemi-sphere? How could they have so misjudged the location of the edge of the world?[49] The abrupt need to categorize new information in existing frameworks led the European continent to experience a collective systole. As "circumferences or horizons of knowledge and expectation . . . giddily expanded," in English professor James Mirollo's words, knowledge of new plants, animals, objects, and the subtle *Ingenia* of men in foreign lands passed uneasily through what historian Anthony Grafton has defined as "tightly woven filters of expectation and assumption from the past," the old ways of doing, thinking, and feeling about the world.[50]

Dürer would have been aware of the discovery of the New World for more than twenty years before his journey to Brussels in 1520 afforded him the opportunity to corroborate any oral or textual accounts of the New World with his own eyes and "kindly wits." That the encounter led him to proclaim the shortcomings of his reaction and at the same time rejoice leads me to believe several iterations of wonder discussed above were at play in his visit to the town hall. Foremost among them was a deep Aristotelian pause to consider how to digest so many different things

from the "new land of gold," including armor, weapons, clothing, beds, and the like, which, while corresponding to known ontological categories, nevertheless left his mind (or soul) reeling from the disquieting unfamiliarity in their appearance, materiality, and meaning—what Greenblatt would call their "radical otherness."[51] Although Dürer's diary never quite shows him departing the stage of bewilderment, his conclusion that these newly discovered things merit celebration suggests that he had not only moved past Descartes's first passion to joy but also had reached an Augustinian affirmation of the underlying worth and wondrousness of all things. Finally, by leading with the gold sun and silver moon, Dürer foregrounds the two objects that were most distinctly new and unlike the things within Europe's material culture (the sun and moon are not what they seem to be); but by beginning his description with these sonorous objects, he emphasizes the subject to which Europeans could most directly relate: the shared heavens. I would argue that the push and pull between the poles of anomalous and familiar experience fairly replicates Patrizi's Euripos current coursing mightily between reason and wonder.

Unfortunately, it appears that none of the objects on view in Brussels that day have survived to illustrate Dürer's description, although similar works, such as the Aztec feather headdress from around 1520 (which offers an intriguing comparison to the piece of turf), exist in other European collections [fig. 9]. Such spoils from the early years of colonization, coursing east along their own Atlantic current, would form a cornerstone of the collections that flourished beginning in the sixteenth century. But these cabinets of curiosities, *studioli* (private rooms for cultural activities), and *Wunderkammern* (wonder rooms) would also come to include far broader materials, as interest in experiencing the marvelous firsthand outstripped the textual divertissements of an earlier age. *Naturalia*, or articles of nature, including taxidermic animals, fish, and birds as well as plants, shells, and fossils, jostled up against

Fig. 9 Feather headdress, Aztec, about 1520, feathers, gold applications, fiber, pipe shavings, leather, and color, 68 7/8 x 45 5/8 in. Weltmuseum, Vienna, VO_10402

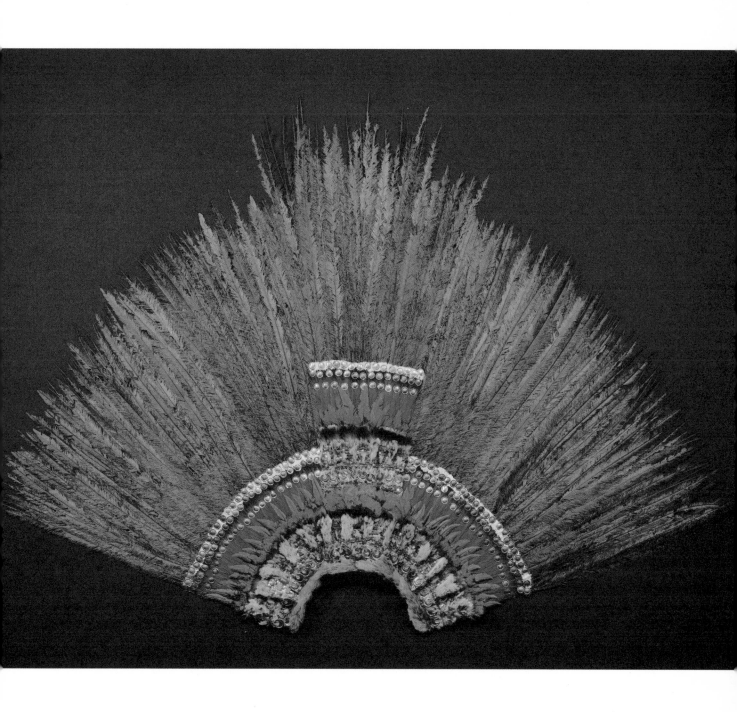

artificilia, or articles of human effort, including all manner of ethnologi-
cal material, paintings, sculpture, feats of craftsmanship (such as the
prayer bead), and marvels of engineering, or automata. The purpose
behind such eclectic groupings was in part to astonish, but it was also
to provide the context for the formulation of universal knowledge. By
gathering a "world in one closet shut," a collector established a space
in which he could comprehend the connections between things, present
them to others, reaffirm the primacy of the center, and solidify a grip
on the margins. Take, for example, Samuel Quiccheberg's *Inscriptiones*
(1565), now recognized as the first published treatise on museums, in
which the Flemish physician in the employ of Bavaria's Duke Albrecht V
details the ideal organizational structure for establishing a *Kunst-und-
Wunderkammer* and why such a collection is vital:

Own all, display all, study all,

Since all those topics are present that universal nature embraces, that
all books teach, that all of human life can offer, it is perfectly clear
that no discipline can be taught, no work of art examined, no state of
life imagined, that does not have its foundations, equipment, means of
support, or examples here in the theater [museum]. And thus for the
aspiring leader in a theater of the kind I have just planned to set up
with an eye for practical matters . . . if he contemplates the names
given to all the present objects . . . and if he does not prove to be
completely ignorant about what classes he should properly choose . . .
and has examined what things should be considered as similar, differ-
ent, opposite, or in a further subordinate class—it cannot be but that

in the shortest time, without great exertion and dangers or troubles (which would in general have to be faced in the investigation of things), he will acquire unbelievable practical knowledge regarding everything and a manifestly divine wisdom. For while books are the other common equipment of all disciplines, here—through the observation of paintings, the examination of objects, and the display of the world of instruments, assisted by the tables of divisions and reliable synopses—everything becomes clearer and more comprehensible.[52]

Own all, display all, study all, and you shall know all, Quiccheberg informs the duke, from not only the conventional medium of books but also the immediacy, tangibility, and primacy of the encounter with objects. The museum, then, provided not just the opportunity to wonder

and you shall know all.

but also, of equal significance, the bridge from initial contact to prolonged study that allowed the most privileged individuals to investigate new materials in the search for knowledge and, potentially, clarity in an increasingly murky age. Amid tectonic shifts in Western understanding (and misunderstanding!) the nascent museum offered the promise that one could grab hold of a turbulent world and be sure to come through it on top. Writing in his *Gesta Grayorum* only a few decades later, Francis Bacon echoed Quiccheberg in stating that the collector (in this case, a mock prince) should amass a "goodly huge Cabinet, wherein whatsoever the hand of man, by exquisite art or engine, hath made rare in stuff, form, or motion, whatsoever singularity, chance and the shuffle of things hath

produced, whatsoever Nature hath wrought in things that want life, and may be kept, shall be sorted and included." The gargantuan task completed, the sovereign master of such a collection would become all-powerful, and "when all other miracles and wonders shall cease, by reason that you shall have discovered their natural causes, your self shall be left the only miracle and wonder of the world"[53]—a fine fantasy, never mind its staggering impracticality. (From the enlightened perspective of the late eighteenth century, Catherine the Great would recall with dismay her father's efforts at creating a universal collection, stating, "I often quarreled with him about his wish to enclose Nature in a cabinet—even a huge palace could not hold Her.")[54] Indeed, many early modern collectors never attempted to meet the universal standard outlined by Quiccheberg or Bacon, opting instead to focus their energies on objects more likely to astound than to evenly educate the visitor. Historian Giuseppe Olmi evaluates, for example, the seventeenth-century *studiolo* of Ferdinando Cospi in Bologna, which was organized "in such a way as to exclude systematically all normality." European flora and fauna were simply not represented, as "evidently the fundamental aim of Cospi's museum was to provoke astonishment and wonder rather than analytically to reconstruct the whole natural world."[55] Predictably, such diminished goals would strike accuracy as the first victim. In her analysis of early collections and practices of display, historian Daniela Bleichmar considers a Miztec codex that Cospi received as a gift in 1665 that would come to be labeled a "libro della China," as well as a finely carved oliphant in the contemporaneous collection of Vincencio Juan de Lastanosa of Huesca, Spain, which was alternatively described as originating from Japan or India.[56] At times the truth of wondrous things mattered less to collectors than the resonance their otherness propagated within the emerging context of the museum, a bastardization of Aristotle's origin of philosophy more akin to the origin of entertainment.[57]

Herein lies a critical point in our grasp of the function of early collections. Bleichmar makes a compelling argument for why we need to look past the mediums through which we typically comprehend such collections today—namely, the catalogs and inventories published by the collectors that tend to isolate objects as inventory in a list—and delve deeper into the experience of the visitor within the space of the museum. We can gain insight into that experience via the engravings that illustrate some of the best-known collections, including Ferrante Imperato's cabinet of *naturalia* in Naples and Cospi's Bolognese *studiolo* [figs. 10 and 11]. In each picture we see a single room lined with cabinets and shelves, every whit of space devoted to the display of curiosities, which seem to come to life in the struggle for territory and our attention. The dynamic of this active and visceral model is pronounced in the frontispiece to Imperato's *Dell'historia naturale* of 1599 (which may well have influenced the composition of Cospi's later engraving).[58] In the image from Imperato's book a guide offers a tour of the collection to three dapper gentlemen who appear to listen attentively as the young man gestures with a long

When all other miracles and wonders shall cease, by reason that you shall have discovered their natural causes, your self shall be left the only miracle and wonder of the world.

—Francis Bacon

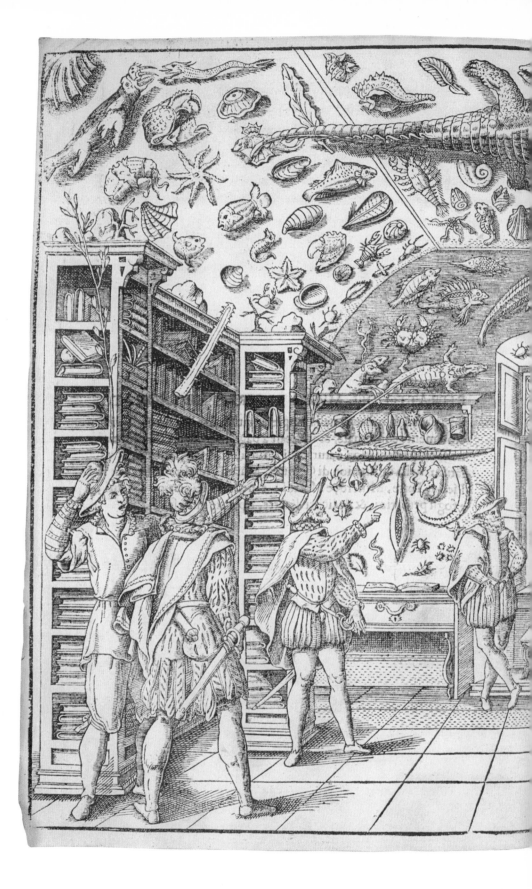

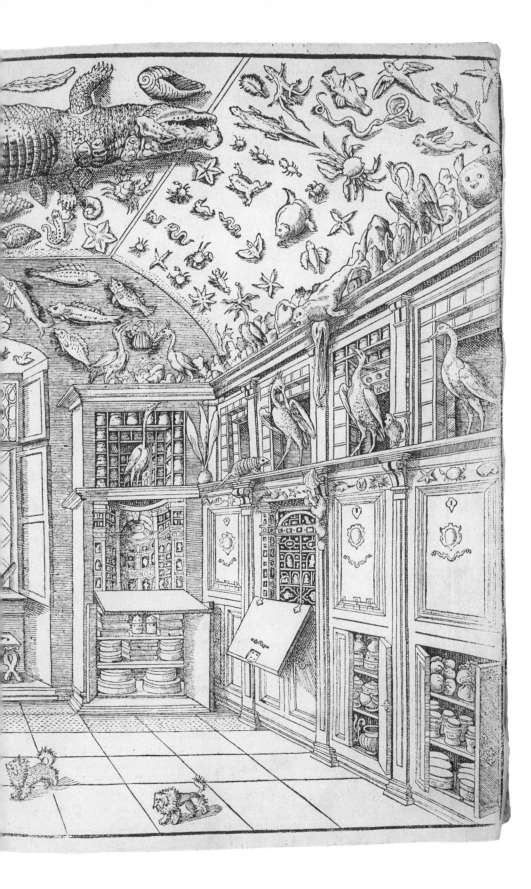

Fig. 10 Book by Ferrante Imperato (Italian, 1550–1625), *Dell'historia naturale di Ferrante Imperato* (Naples, 1599), showing woodcut attributed to Mario Cartaro (Italian, active by 1560–d. 1620). Smithsonian Libraries, Washington, DC

Fig. 11 Book by Lorenzo Legati (Italian, d. 1675), *Museo Cospiano* ... (Bologna, 1677), showing copperplate engraving by Ferdinando Cospi (Italian, 1606–1686) from a drawing by Giuseppe Maria Mitelli (Italian, 1634–1718). Smithsonian Libraries, Washington, DC

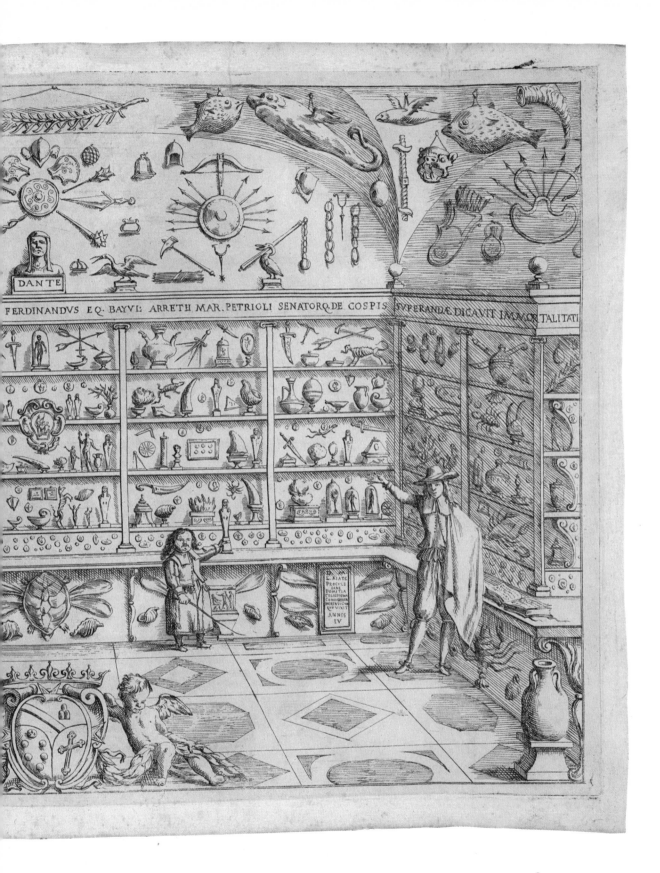

FERDINANDVS EQ. BAYVL. ARRETH MAR. PETRIOLI SENATORQ. DE COSPIS IVPERANDÆ DICAVIT IMMORTALITATI

rod toward objects high up in the cove on the opposite side of the gallery.[59] The installation is semicoherent, with at least some effort apparently under way to separate out general categories of things so that books are shelved on one wall and jars and boxes are bursting out of cupboards on another, with stuffed specimens relegated to the upper reaches of the walls, cove, and ceiling. The pièce de résistance is the immense crocodile suspended upside down from the center of the ceiling (inaugurating a trope that would epitomize *Wunderkammern* for centuries). What better way to announce our domination of the universe than to launch such a terrifying creature from world's edge into the center of learning, belly up. To emphasize the accessibility of the collection, Imperato's cabinet is depicted from eye level so that the reader is able to immediately connect with the contents of the space—to step out onto the marble tile floor, stand beneath suspended wonder, look up, and marvel.

By contrast, Cospi portrays his collection from a high angle, so that the reader looks slightly down upon the space, enlarging it in relation to the collector within. In Cospi's image of his museum, four shelves wrap around the three walls visible to the reader, beginning at about waist height and extending as many as ten feet above the floor. The shelves display a nearly endless variety of objects, including daggers, jugs, shoes, figurines, mounted bits of coral, shells, horns, animal teeth, crustaceans, and stuffed lizards. Below them, near the floor, are mounted larger objects such as tortoise shells, and between them and the shelves are dozens of medals. Above the shelves in the cove are primarily mounted weapons and militaria from distant cultures, plus a few fearsome and frankly unrecognizable marine mammals (one resembling our prayer bead's Hellmouth), and featured prominently in the middle, a bust of Dante. Bleichmar cautions us not to take at face value the illustrations showing how collections were actually installed, but instead to read them as idealized depictions.[60] Even so, the images reveal important aspects of

how visitors might have negotiated such collections. Note the two figures in Cospi's engraving: in the center the dwarf custodian Sebastiano Biavati (himself a collected item), with one hand on the base of a (vaguely Egyptian) statuette and the other holding a long rod for pointing out objects on display; and at right, the collector himself, gesturing with one hand—either generally to his holdings or perhaps to a similar statuette on the shelf—looking like he has just turned away from the open catalog resting on the counter behind him.[61] Each man stares directly at the reader as if to invite him into the collection, to begin the momentous act of examining the stranger contents of the world. How that event would transpire is dramatically at odds with how we visit museums today. Writes Bleichmar:

> This is a way of seeing in which the eye is in constant motion from object to object, zooming in and out. A viewer would first look around the room to get a sense of the cabinet as a whole, as a space or composite artwork that brings together multiple parts (*Gesamtkunstwerk*); then focus on a specific portion, a group of objects—the animals hanging from the ceiling, the group of small items in one box or shelf; then focus on one single object, perhaps a medal, a shell, or a stone that can be held in one's hand, brought toward the body for close inspection; only to spring back to another object, near or far in space, that resonates with the first one; and so on.[62]

Because the collected wonders blanket observable space within the room the whole interior shell of the museum is transformed into a resplendent tapestry for sensual engagement, urging the viewer to ping between unlike objects, the better to reach metaphorically beyond the museum's walls, to extend the mind's eye across space and time to the very brink of the world.

When *Museo Cospiano* was published in 1677, Cospi's methods of collection, display, and interpretation were already waning in influence among Europe's intellectual classes. Descartes's caution against "excessive wondering" had been published nearly thirty years earlier, reflecting a growing distrust of the first passion's emotional sway in the opening decades of the Enlightenment. As Daston and Park explain at length,[63] the subject of wonder's appropriate role in the life of the individual was widely debated beginning in the high medieval period of the eleventh through thirteenth centuries; it would not collapse until the close of the seventeenth century, when the resonance of marvelous reports sent back by Columbus and his followers had diminished, worldviews had forcibly expanded, and the strange and titillating discoveries across the sea had been consumed, digested, and stashed away for more prudent inquiry. Contact, exploration, and the collection and examination of new things not only continued but also increased in the eighteenth century, but through a cultural lens that refocused to emphasize curiosity and its virtues over wonder's implied ignorance. In 1714, Anthony Ashley Cooper, third Earl of Shaftesbury, crystallized the growing sentiment, admonishing against "that false Relish which is govern'd rather by what immediately strikes the Sense, than by what consequently and by reflection pleases the Mind, and satisfies the Thought and Reason."[64] The air of disappointment evident in Catherine the Great's review of her father's catholic collecting habits speaks to Shaftesbury's outlook, which edged toward the belief that museums should specialize so as to portray specific aspects of the world exhaustively rather than all of it poorly. No anecdote summarizes that view more succinctly than anthropologist Margaret Hodgen's observation that by the end of the seventeenth century the comic character in English plays had evolved from the astrologer to the "vague and peevish" antiquarian and collector, who might be found perched over a microscope haplessly searching for "the nature of eels in vinegar, mites in cheese, and the blue of plums."[65]

The collections so feverishly gathered in the name of wonder would mostly disappear (like so many Aztec treasures in Brussels). The exceptions were the lucky few that would form the nuclei of the earliest of the encyclopedic museums we still know today, among them the collections of the two John Tradescants (father and son) at the University of Oxford's Ashmolean Museum, and Sir Hans Sloane's collections at the British Museum, London. The eighteenth century saw the drive toward systemization first outlined by Quiccheberg and Bacon and that would become fully engaged by the nineteenth century, together with the firm establishment of the museum as a site for the increasingly serious study of ordinariness. As the museum blossomed into an apparatus for methodical knowledge building, it often did so at the expense of naked astonishment and once-plentiful opportunities to embrace that fleeting surprise of the soul. □

Mr. Corcoran's Museum

Have We a Louvre among Us?

—*Philadelphia Bulletin*, 1869

Now let us shift our focus to the United States, where practices of collecting, display, and museum organization in general lagged considerably behind European counterparts. The central case study for public culture in antebellum America is Charles Willson Peale's museum in Philadelphia, which he opened in an outbuilding at his home (1786–94) before graduating it in later years to grander and more symbolically freighted spaces, including the American Philosophical Society (1794–1802) and, finally, a wing of the Pennsylvania State House (1802–27), better known today as Independence Hall. Peale explicitly outlined his intent to be the betterment of the fledgling nation's newly minted citizens. He quoted Richard Pulteney's translation of the writings of the contemporaneous taxonomist and biologist Carolus Linnaeus and stated that he (Peale) hoped to prompt the museum visitor "to the consideration of what he ought to be, as an *intelligent and moral being*," citing the endeavor as a bastion in the preservation of the "virtue of the people."[66] But such enlightened proclamations didn't always

Jennifer Angus, *A Terrible Beauty 3: To Have and to Hold* (detail), 2007, at Musée d'Art de Joliette, Quebec

correspond with the museum's practice, particularly in its early years at Peale's home, when the "natural curiosities" were said to be "arranged in a most romantic and amusing manner."[67] The method of organization is exuberantly illustrated on an admission ticket from 1788 that describes the museum as "containing the Wonderful works of NATURE! And Curious works of Art," the words emblazoned on a banner unfurled between two trees, its edges ringed by a monkey, wolf, pelican, and (without fail) a crocodile.[68]

Peale would gradually shift away from such overt references to the *Wunderkammer* model, eventually classifying his thousands of natural specimens along the Linnaean system, but he would never entirely escape the shadow of the early modern period's "world in one closet shut" manner of display.[69] Consider Peale's late masterpiece, *The Artist in His Museum*, 1822 [fig. 12], commissioned by the trustees of the museum in celebration of the eighty-one-year-old patriarch's contributions to American art and science. In the towering canvas, nearly nine feet tall, a confident Peale stands directly before the viewer, lifting a lavish, fringed curtain with one hand and beckoning us to enter the museum with the other. Behind the artist we see the Long Room at the Pennsylvania State House lined with Peale's prized collection of taxidermic birds (created from his labor), each skillfully positioned within a tailored case, awaiting our close inspection. Above them, well beyond the range of careful viewing, hang two long rows of portraits of the founding fathers by Peale's own hand. At right, partially obscured by the curtain, stands ominously the dusky jewel of Peale's scientific career: the mastodon skeleton, unearthed in 1802 to great fanfare on Jacob Masten's farm in Ulster County, New York. The inclusion of stuffed birds, political portraiture, and the greatest paleobiological discovery of the early nineteenth century within a single gallery confirms the polymath's devotion to an already antiquated mode of presentation. Observe the similarities between

Fig. 12 Charles Willson Peale (American, 1741–1827), *The Artist in His Museum*, 1822, oil on canvas, 103 ¾ x 79 ⅞ in. Pennsylvania Academy of the Fine Arts, Philadelphia; Gift of Mrs. Sarah Harrison (The Joseph Harrison Jr. Collection)

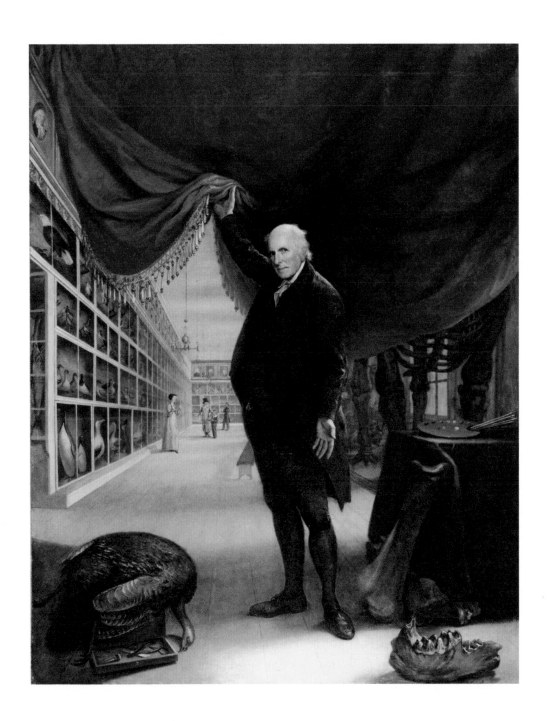

Peale's painting and the engravings of Imperato's cabinet of *naturalia* and Cospi's *studiolo* [figs. 10 and 11]: Peale's beckoning pose bears an exceptional resemblance to Cospi's portrayal within his collection, including the gesture of the subject's right hand, the oblique alignment of his trunk, and the position of his feet, all establishing a like relationship between proprietor, his audience, and his universe; and Peale's painting's meticulously rendered perspective calls to mind that of the illustration of Imperato's cabinet, which likewise tricks the viewer into believing that he may step into the scene before him. As in Imperato's museum, little of interest in Peale's collection is installed low enough to examine closely. Rather, the natural instinct—before the immense canvas, and I presume within the museum itself—is to look up, to strain to view the birds above your head, the features of the men who steered the course of the nation, and mere steps away, the most disquieting section of the mastodon: the head. As if to beckon what Bleichmar identifies as the "agile, darting eye" and "constantly shifted focus from wide to narrow and speed from slow to fast" required to properly absorb a collection installed in the early modern style, Peale has placed a tantalizing clue into the lower right corner of his canvas—a section of the mastodon's jawbone complete with teeth that dwarf the artist's nearby hand.[70] We know what this is, as would have the painting's original audience, so renowned was the fossil; but it lurks before us in a manner both "portentous and unusual," to recall the language of Saint Albertus, and hints at the magnitude of wonder still hidden behind the curtain.[71] How thrilling that experience of wonder could be is affirmed for us by the Quaker woman visiting the museum at left, who throws her hands up in awe, disbelief, fear, or all of the above. Her unabashedly emotional response to the mastodon (in contrast to the reasoned bearing of the two men and the boy nearby) symbolizes the documented responses of many visitors to the museum, including one woman who "went to Bed after she returned home from seeing it with the terror it inspired."[72]

74

The Peale family struggled to continue the museum's operations following Charles's death in 1827, and the collections were eventually sold off to a pitchman with few qualms when it came to exploiting the marvelous side of nature: P. T. Barnum. Reflecting on the character of his particular brand of spectacle, Barnum wrote near the end of his life, "I was not so scrupulous, as possibly I should have been, about the methods used to call public attention to my establishment. The one end aimed at was to make men and women think and talk and wonder, and, as a practical result, go to the museum. This was my constant study and occupation."[73] Thus the great museological experiment of the early republic, fostered by the passions of one of the country's most learned citizens, came to reside in a New York City funhouse for the express purpose of gawking— Descartes's excessive wonder—alongside circus strongmen, General Tom Thumb, and Barnum's most infamous hoax, the Feejee Mermaid. That the first comprehensive attempt at establishing a lasting museum space in the United States failed, notwithstanding the genius of its founder, the obvious significance and draw of its collections (despite archaic pedagogy), and the value of its location—not only in the nation's cultural capital but also under the roof of its most recognized building, arguably the topographic center of a politically minded public—would suggest a grim outlook to any patron looking to follow Peale's lead.[74] In consideration of the arc of Peale's experiment, the success of William Wilson Corcoran's Gallery of Art in Washington rings all the more extraordinary.

Washington was no Philadelphia. When Corcoran was born in Georgetown (then George Town) in the closing week of 1798, the now-posh enclave was little more than a backwoods village, what Abigail Adams described in 1800 as the "very dirtiest hole I ever saw for a place of any trade or respectability of inhabitants."[75] Even so, it would constitute the nearest wisp of civilization within the newly drawn borders of the federal

PLAN
of the City of
WASHINGTON.

George Town

POTOMAK RIVER

EASTERN BRANCH

Lat. Capitol 38: 53. N.
Long. 0: 0.

76

district, which could be labeled a city in name only. The site for the nation's new capital was resolved just nine years before Abigail penned her observation, following George Washington's approval of plans by his aide, the French architect Pierre Charles L'Enfant.[76] The latter had initiated an almost foolishly ambitious design for the city, developed in the firm belief that the new seat of the young democracy should stand shoulder to shoulder with the great capitals of Europe. The plan, first published in 1792 [fig. 13], imagined a stately metropolis of wide avenues, long blocks, and expansive squares, emanating out from the central Mall, flanked by the new Capitol and a presidential palace far grander than what would eventually be built. For now, Washington, DC, would exist on paper only. When John Adams first arrived at the President's House on November 1, 1800, it was still under construction, with unfinished staircases, tools scattered all about, and fires blazing day and night in an attempt to speed up the drying of plaster.[77] The house was grand, to be sure—its scale easily dwarfing any other residence in the country—but its surroundings could not have been more modest. When Abigail joined her husband two weeks later, it was after getting lost at length on the road from Baltimore, her coachmen resorting to breaking the boughs of trees to make paths through the thick woods. The First Lady would comment that her new home's situation was "beautiful," with southern views of the Potomac River and Alexandria, and that "the country around is romantic but a wild, a wilderness at present."[78] In the miniseries *John Adams* (2008, starring Paul Giamatti and Laura Linney), an adaptation of David McCullough's biography of the second president, HBO artfully re-created the District's wilds. Several points are driven home in the scene in which John and Abigail (erroneously) arrive together in a carriage-and-four to solemnly take on the White House's first occupancy, principally the work left unfinished on the house and the related moral incongruity that slaves were building this new symbol of freedom. But the point best to emphasize here is the program's superb portrayal of the surrounding landscape

Fig. 13 Pierre Charles L'Enfant (French, 1754–1825), Plan of the city of Washington, 1794, published by Thackara & Vallance, Philadelphia, 13 ¾ x 16 ¹⁵⁄₁₆ in. Library of Congress, Geography and Map Division, Washington, DC

as one of dense forest and shattered trees rising from dreadful waves of filth and carriage-wheel-sucking muck, without a single other structure in sight. It must be difficult for the contemporary reader to imagine today's bustling city center in its primal state, and yet doing so is vital to comprehending the scope of Corcoran's achievement. For the better part of his adult life, his business and his passion for art would play out within shouting distance of the front door of the White House. And the White House, in the infancy of the Republic, stood alone in a bruised clearing at the edge of the world.

Corcoran and the City of Washington grew up together. As the young man established his credentials in the Georgetown business world, working at his older brothers' dry goods and auction businesses, the capital slowly pieced together L'Enfant's grandiose puzzle. Corcoran's early business efforts were wiped out by the Panic of 1823, which saddled him with significant debts, but he rebounded quickly by managing his father's real estate interests and clerking at the Bank of the United States. In 1837 he opened a small brokerage office near the US Treasury building, which flanks the White House grounds, and quickly found success under the tutelage of the influential bankers Elisha Riggs and George Peabody. In 1840, Corcoran formed a partnership with Elisha's son, George Washington Riggs, and founded the banking firm Corcoran & Riggs, which would thrive as the US government's lead banking partner. Prosperity allowed them to move the bank in 1845 to the former headquarters of the now-defunct Bank of the United States, directly across from the Treasury.[79] Corcoran & Riggs reaped a windfall when, with the government unable to sell bonds domestically to finance the Mexican-American War (1846–48), Corcoran sailed to London to sell them on the European market. By now Corcoran's fortune and his political and social capital were firmly established. In 1849 he purchased the home (no longer extant) of former secretary of state Daniel Webster,

which faced south on H Street, NW (where the US Chamber of Commerce sits today), so that only the diminutive Lafayette Park stood between his front door and the north portico of the White House.[80] Corcoran would reside in the house until the end of his life, maintaining ready access to his friends and neighbors in power.[81]

Little is known about Corcoran's early interest in art, but we do know that he began to fill his home with paintings and sculpture in his first years of residence there.[82] Corcoran initially purchased art on business trips to Europe, but he also began to buy contemporary American paintings beginning with a version of Daniel Huntington's *Mercy's Dream*, 1850, which typified his lasting interest in genre subjects.[83] Although Corcoran was notably cautious in his acquisitions, his tastes rarely edging into the avant-garde, his collection took a progressive leap with his purchase in 1851 of the first authorized copy of Hiram Powers's *Greek Slave*, the most influential American sculpture of the century and the work that would become an icon of Corcoran's future Gallery.[84] The statue, depicting a Greek woman being sold at an Ottoman slave market during the Greek War of Independence (1821–32), had debuted at the Crystal Palace Exhibition in London that year, causing titillation among viewers unprepared for the subject's matter-of-fact, if dignified, nudity. Powers's statue was installed prominently in the gallery in Corcoran's home, which from 1855 was open to the public two days per week. A catalog published in 1857 shows that about one-third of Corcoran's art collection was American, evidence that his growing interest was in the nascent domestic field.[85]

It was to enlarge the house that Corcoran first hired James Renwick Jr., who would go on to build Corcoran's Gallery, which today stands as the Renwick Gallery. Renwick was the young architect of the fledgling Smithsonian Institution's fanciful headquarters on the National Mall

(Corcoran served on the institution's board of regents) and had already been recognized for his imaginative embrace of neohistorical styles. In 1850, Renwick distilled his expertise into an intimate Gothic chapel at the entrance to Corcoran's new Oak Hill Cemetery in Georgetown. It is in consideration of the Smithsonian building (1847–55), the charming (and recently restored) chapel (1850–53), and Renwick's most celebrated project outside the District—Saint Patrick's Cathedral in New York (begun 1858)—that the Corcoran Gallery falls so clearly outside the design sensibility of its times. If Renwick's other projects plumbed the depths of medieval architectural history in the pursuit of good taste, Corcoran's new building would do something positively radical: look to the present. In 1855, Corcoran traveled to Paris, where he attended the Exposition Universelle and saw the new north wing of the Palais du Louvre under construction [fig. 14] to connect it with the Palais des Tuileries. Renwick traveled separately to Paris the same year as Corcoran, and he, too, reviewed the design of the Louvre's Pavillon Colbert, in a style that would come to be called the Second Empire in honor of its popularity during the reign of Napoleon III. Identifiable by its steep mansard roof, a strong central element with equally robust corner pavilions, embrace of symmetry, elaborate ironwork, frequent deployment of decorative (rather than structural) paired columns, and neo-Baroque ornament, the style must have seemed a strange new beast to the American visitors. Although no correspondence between Corcoran and Renwick on the topic of their responses to the Louvre's addition has been found, they each clearly enjoyed it:[86] in 1859, Corcoran commissioned Renwick to build his Gallery in the new style, setting it on the path to be one of the first examples of Second Empire architecture constructed in the United States. A lithograph from that year [fig. 15] imagines the finished museum weighted heavily toward the Louvre's design, with a prominent mansard roof, twelve columns lining the second floor, and a rigid symmetry to the overall plan. Four second-story niches house statues of Old Masters

(they would eventually hold Ezekiel's statues of Phidias, Michelangelo, Raphael, and Dürer) that recall the eighty-six statues of notable men ringing the Louvre's Pavillon Colbert, offering artistic inspiration to the three elegantly dressed patrons promenading toward the Gallery's entrance, above which are inscribed Corcoran's initials, *WWC*, to mirror the *N* (for Napoleon III) on its French counterpart.[87] What Corcoran and Renwick could not easily replicate was the Louvre's vast scale. Instead, the Gallery is designed as a Louvre in miniature, absent the French model's epic corridors, with the result that the east and west promontories accordion down to within thirteen feet of the central element. As if to underscore the relationship to its French inspiration, the Gallery would be built to half the Louvre's height.

Where Corcoran could compete with the Louvre was on location. The Gallery's site, on the northeast corner of Pennsylvania Avenue and 17th Street, NW, placed it directly across from the building housing the departments of State, War, and Navy and on a diagonal from the entrance to the White House. Corcoran's bank, home, and Gallery now formed a chain that snaked around the executive branch of the United States. (When the Gallery moved in 1897 to a new location on 17th Street, the chain was extended even further.) Although documentary evidence describing Corcoran's early thoughts of moving his collection from his home to a dedicated building is lacking, we can infer a great deal from the overt intentionality of the site he chose, on the doorstep of the president. Corcoran's message was clear: culture must be given a voice at the seat of political power; it must be seen, felt, heard, and institutionally established at the locus of national authority (a notion with which Peale, who had tried in vain to garner governmental recognition of his museum, was intimately familiar). Corcoran was looking not only to the Louvre's royal history as precedent or to its role as the cultural and topographic heart of the capital but also to the whole history of modern European

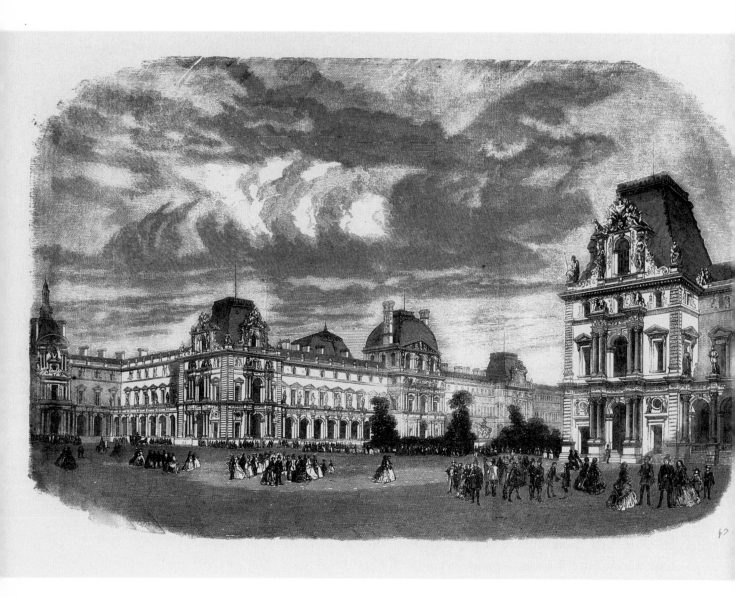

Fig. 14 Unidentified artist, *New Court of the Louvre, Paris, France*, 1856, engraving, 7 ⁷⁄₈ x 11 ¹³⁄₁₆ in. Universal History Archive/Contributor

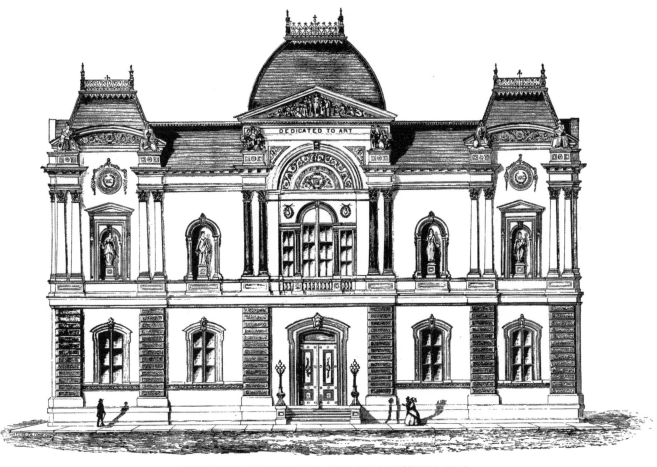

THE NEW GALLERY OF ART, WASHINGTON, D. C.
RENWICK & AUCHMUTY, ARCHITECTS.

Fig. 15 Renwick's design for the gallery, published in 1859 in *Architects and Mechanics Journal*. Photocopy of print, Library of Congress, Washington, DC

museums' relationship to power, dating to the opening in 1733 of the Capitoline Museum on the Campidoglio, thought since the Middle Ages to have been the political center of ancient Rome.[88]

Construction on the Gallery was halted in April 1861 by the looming threat of war. By then, the exterior, including the auspicious carving above the door dedicating the building to art, was essentially complete, but the interior remained largely unfinished. The delay would turn out to benefit the Gallery's first occupant—not Corcoran, but the quartermaster general of the Union army, Montgomery C. Meigs, who commandeered the fireproof structure to serve first as a supply depot and then his headquarters for the duration of the war. Corcoran, a Southern sympathizer whose daughter had married a Louisiana congressman in 1859, wisely departed for France, where he would remain in comfortable exile until war's end. The collector did not return to his Washington residence until 1867 and did not win back possession of his new building from a begrudging army until 1869. Upon its return, Corcoran immediately established a board of trustees for the Corcoran Gallery of Art and deeded the building to it, outlining his wish that they succeed in offering "not only a pure and refined pleasure for residents and visitors to the national metropolis, but [that they could look back on this endeavor knowing they] have accomplished something useful in the development of American genius."[89] Work to transform the interior from a warren of hastily built military offices into the palace of art befitting its founder's vision began in earnest.

By citing his support of American genius, Corcoran was recalling a statement the Washington Art Association, of which Corcoran was the preeminent member, circulated in 1859. It called for the establishment of a "'National Gallery of Fine Arts' in the metropolis of the nation, to call the attention of the government to the neglects, the narrowness, and the

caprices of national patronage; to ask protection for genius; to excite our public men to constitute themselves the true patrons of the living genius of the land."[90] The emphasis on genius and the desire to protect and promote homegrown sources of creativity speak to the defensive zeitgeist of the era—one in which American culture was measured against the deeply rooted accomplishments of Europe, still regarded as the center of the Western world. In his address "The American Scholar" of 1837, Ralph Waldo Emerson eloquently voiced the position that the United States should look within for intellectual inspiration. "Perhaps the time is already come," Emerson said to the Phi Beta Kappa Society in Cambridge, Massachusetts, "when the sluggard intellect of this continent will look from under its iron lids, and fill the postponed expectation of the world with something better than the exertions of mechanical skill. Our day of dependence, our long apprenticeship to the learning of other lands, draws to a close. The millions, that are rushing into life, cannot always be fed on the sere remains of foreign harvests." Emerson's combative vein grew yet more pointed at the close of the speech: "We have listened too long to the courtly muses of Europe. The spirit of the American freeman is already suspected to be timid, imitative, tame." The corrective course was clear if only the nation would rise to take it: "We will walk on our own feet; we will work with our own hands; we will speak our own minds."[91] Corcoran, who held the distinctly noncreative position of broker when the transcendentalist's speech tore through the country, would eventually respond to the spirit of the poet's words by supporting a wide array of American artists. Indeed, when the collection was no longer under Corcoran's personal control, he admonished the trustees to purchase no more than one artwork by any American artist already represented in the Gallery, so that funds might be put toward the support of the broadest possible pool of domestic talent.[92]

The makeup of the artworks on view when the Corcoran Gallery of Art finally opened its doors in 1874 was carefully designed to position contemporary American art as not only the equal of its European counterpart but also, in Alan Wallach's analysis, a "continuation of a Western fine arts tradition stretching back to the ancient Greeks."[93] Visitors to the museum, after passing mammoth busts of Napoleon and geographer-naturalist-explorer Alexander von Humboldt (the latter a correspondent with Corcoran) in the vestibule, entered first-floor galleries installed with a mind-boggling accumulation of copies of sculpture, decorative arts, and assorted *objets* from across the spectrum of the Western canon.[94] The side galleries [fig. 16] contained smaller works, including electrotype reproductions of ninety Renaissance-era household items from the collections of the South Kensington Museum (today the Victoria & Albert), medieval armors, copies in silver of Roman treasures excavated in Hildesheim, Germany, a five-foot-tall electrotype reproduction of Napoleon's Column in the Place Vendôme, Paris, as well as more than one hundred modern bronze sculptures of animals and reptiles (including a "crocodile devouring an antelope") by nineteenth-century French artist Antoine-Louis Bayre.[95] In the long hall along the back of the first floor were full-scale casts of dozens of classical works from the collections of European museums, including the Parthenon frieze and the Elgin Marbles (The British Museum), Venus de Milo and Michelangelo's *Rebellious Slave* and *Dying Slave* (Musée du Louvre), Venus de' Medici (Uffizi Gallery, Florence), Capitoline Venus (Capitoline Museum, Rome), *Laocoön and His Sons* and *Apollo Belvedere* (Vatican Museums, Vatican City), the frieze of Trajan's Forum (Rome), and, against the east wall, Lorenzo Ghiberti's eighteen-foot-tall *Gates of Paradise* (Florence Baptistery) [fig. 17].[96] Ascending the central staircase, visitors were then funneled directly into the magnificent heart of the Gallery—Corcoran's so-called Grand Salon, hung with eighty-eight paintings, American and European and nearly all contemporary, presenting a comingling

Fig. 16 Hall of Bronzes, view looking north, about 1875, stereographic view. Smithsonian Institution Archives, Washington, DC, 2011-1139 □ **Fig. 17** Hall of Statues of the Model Room, about 1882. Museum History Photography, Photograph Archives, Smithsonian American Art Museum

HALL OF BRONZES, (looking North,) Corcoran Gallery of Art, Washington, D. C.

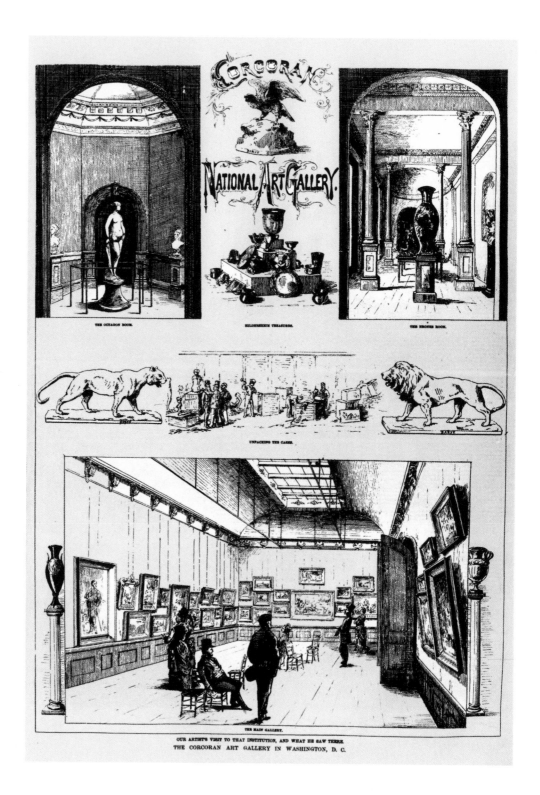

THE OCTAGON ROOM.

MILLENNIUM TREASURES.

THE BRONZE ROOM.

UNPACKING THE CASES.

THE MAIN GALLERY.

OUR ARTIST'S VISIT TO THAT INSTITUTION, AND WHAT HE SAW THERE.
THE CORCORAN ART GALLERY IN WASHINGTON, D. C.

of foreign and domestic genius soaring from the chair rail to the plaster frieze twenty-four-feet above [fig. 18]. On a direct axis from the Grand Salon, in an intimate octagonal gallery over the foyer, stood the capstone to Corcoran's collection: *Greek Slave*, which Hiram Powers modeled after Venus de Milo, a copy of which could be examined downstairs.

Corcoran urged his trustees to acquire works of "transcendent merit," the descriptor revealing his taste for art he perceived as having not only the finest quality but also the power to provoke awe.

The not-so-subtle intent of this distribution was to position the arts of the Old World as the foundation for the arts of the New, with the former positioned directly beneath the latter. But it was also to provide what one publication in 1870 described as the "illumination of the unlettered masses."[97] Americans of all walks of life were being offered the opportunity to enter a space for the express purpose of artistic veneration. Wonder in the Aristotelian sense was not necessarily on the menu (although its potential was felt by the utter lack of labels or posted text of any kind), but Goethe's coveted astonishment was: many examples akin to his beloved Medusa Rondanini (itself a Roman copy) were within reach of those hungry to become twice the person they already were. Corcoran urged his trustees to acquire works of "transcendent merit," the descriptor revealing his taste for art he perceived as having not only the finest quality but also the power to provoke awe.[98] Arousing that

Fig. 18 Unidentified artist, Corcoran National Art Gallery, illustration in *The Daily Graphic*, New York, Saturday, March 21, 1874

response was integral from the institution's inception, as evident in Renwick's design. Consider the insights of architect Hugh Newell Jacobsen, who renovated the interior of the building before its reopening in 1972 as the Renwick Gallery:

> It's designed very deliberately, no accident, to make you feel smaller and the building grander. In photographs, the rooms look vast. You walk in and look around, and you feel like Alice after she drank [the "Drink Me" potion that made her shrink]. For instance, you're accustomed to an 8-inch baseboard. But some of these are 14 inches. The chair rails are not all at 36 inches: some are at 30, 48, even 52 inches high. Doorknobs, you reach for at 36 inches, but some of those 12-foot doors have the knob at 30. The sill lines of the windows downstairs are above your head. You have to look up—and feel smaller.[99]

Less subtle than the heights of baseboards and doorknobs were the sheer volume of the galleries briefly discussed above. If Renwick couldn't compete with the Louvre's staggering footprint, he could replicate an approximate sense of its grandiosity by emphasizing vertical space. The mounting of the Parthenon frieze along the cornice in the rear gallery, the eighteen-foot height of the *Gates of Paradise*, the stacking of paintings in the Grand Salon, the prominent use of skylights, and the placement of ornamental flourishes and gilding near eighteen- and thirty-eight-foot ceilings all encouraged visitors, such as the gentleman in a top hat pictured in the *Daily Graphic* [fig. 18], to look up in surrender to the talents of artists spanning centuries and continents, to admire the elegance of the vehicle carrying us there, and to consider our common quest for the sublime—wonder's palatable modern heir.[100]

Reactions to Corcoran's endeavor were swift and enthusiastic. Allusions to the Louvre came freely after Corcoran in 1869 announced his intentions; they continued with such notable appraisals as Massachusetts Senator Charles Sumner's remark that the Gallery would function as an "American Louvre."[101] The *New York Times* proclaimed it "among the richest foundations ever given to a public institution by a private man," one sure to "rival the most famous collections in the world."[102] The *Washington Daily Chronicle* labeled the institution's establishment a "national event," and the museum came to be commonly referred to as Corcoran's "National Gallery of Art," lacking government sanction but by the nature of its location enjoying widespread association with the symbolism of the White House and burgeoning power of L'Enfant's capital.[103] It would remain the only art museum in Washington for nearly fifty years, until the Phillips Collection opened near Dupont Circle in 1921. Perhaps, then, the greatest of Corcoran's accomplishments was not the gathering of his collection, nor the opening of his building on Pennsylvania Avenue, nor even the survival of his museum into the twenty-first century. Perhaps it was the perceptual shifting of the center of the world from Athens, Rome, London, and Paris to the shores of the New World, to a site that within his lifetime had been no more than a wilderness. ☐

The Exhibition

People feel connected to these pieces,
but they don't exactly know what they are.

—Leo Villareal, 2014

The notion that the world could have a definable center must seem supremely old-fashioned to a contemporary audience. It calls forth the superstitions of the premodern West, the tyrannical overtones of the modern era's infatuation with objectivity, and a mantle of stringent ideologies pitting us against the rim—the irrational other to be wondered at, colonized, and finally "educated" in a bid to pull the edge of the world in line with its core. It is a position that made sense to fourteenth-century readers of *Mandeville's Travels* yearning to see distant lands, Columbus and those who followed his routes west, Cospi and those who sought to collect the marvelous things coming back, and Corcoran and Renwick, who fed into the myth of the center even as they worked to destabilize its location. The construct finally began to crumble late in the last century, first under the persistent questioning of postmodernism in general and postcolonialism in particular, and then with quickening speed through the irrepressible expansion of the Internet. More than twenty years have passed since cultural historian

Leo Villareal, *Volume (Durst)* (detail), 2013, white LEDs, custom software, and electrical hardware. © Leo Villareal, courtesy CONNERSMITH

Barbara Maria Stafford wrote breathlessly of a "New Immaterialism" descending upon us, as "administrative, productive, and personnel activities have become etherealized into chromatic apparitions weightlessly flitting across a computer screen."[104] Yet even Stafford could not have grasped in 1993 the extent to which the digital revolution would render objects increasingly tenuous to our everyday experience of the world. If this one-two punch of postmodernism and hypertext succeeded in dismantling one outmoded conception of "here and there," it was also to foster another, what artist and writer Douglas Coupland describes as the current binary categories attributable to objects and aesthetic experiences: "downloadable and nondownloadable," or here and somewhere in the ether.[105] This dichotomy is worth reviewing in light of the contemporary museum's mission. Should we define a growing feature of our culture as our fixation on what isn't truly there, the museum can refocus our attention on what is. Recall that the crux of Quiccheberg's report to his royal benefactor stated the necessity of unmediated contact with the duke's collection, which would surpass the capacity of books and descriptions to educate him. Quiccheberg knew that the memorable encounter— whether powered by wonder, awe, trepidation, or terror (all related responses to the new)—depends on the combined presence of objects and the self. Through mediation we lose a sense of things—of their scale, heft, surface, texture, scent, and touch—and through contact we come to know them, not simply as objects but as the primary fabric of life. By foregrounding this experience, the contemporary museum can offer what Isamu Noguchi called a "reinstatement of reality"—a sort of metaphoric rather than topographic or ideological new center of the world.[106]

The nine artists featured in the Renwick Gallery's reopening exhibition are intimately familiar with this line of approach. Their work demands our confrontation with stuff by presenting us with dizzying amounts of it, so much so as to astonish through volume alone. The artists—

Jennifer Angus, Chakaia Booker, Gabriel Dawe, Tara Donovan, Patrick Dougherty, Janet Echelman, John Grade, Maya Lin, and Leo Villareal—belong to no single artistic school or movement, though they take cues from postminimalism, land art, and the recent rise of "installation art." But their common interest in the basic elements of our surroundings suggests an informal grouping separate from those predecessors, so that we might call them, in honor of Stafford, the "New Materialists." The point of this moniker is not to launch a true "ism" in the vein of the last century (and "materialism" comes with enough baggage already), but rather to draw attention to a renewed focus by a growing number of practitioners on the very *thingness* of their materials.

Should we define a growing feature of our culture as our fixation on what **isn't** *truly there, the museum can refocus our attention on what* **is.**

They have moved past what Coupland decried as the lazy conceptualism of much contemporary art—the "walled-off room containing flickering and squawking images projected by a highly lumened digital projector, or empty floor space with perhaps some chalk outlines or a piece of string"—to embark instead on intensive journeys of production that overwhelm us through the industry implied by their scale.[107] Consider, for example, Tara Donovan's *Untitled*, 2014, made up of ten towers ranging in height from about eight to thirteen feet built from tens (if not hundreds) of thousands of styrene index cards that have been individually glued together to form irregular, looming spires. They may first appear as a solid, if hazy, mass, and only upon close inspection reveal the paper-thin strata that speak to an eon of repeated motions: glue, card, glue, card, glue, card, glue, card, glue, card, glue, card, etc., what Donovan has labeled a "mechanized process without the luxury of a machine."[108]

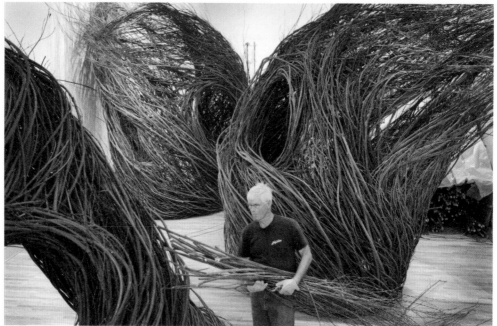

If every word in this book were to represent that pattern of action, it would still fail to raise more than half of one tower from the floor. In Gabriel Dawe's *Plexus A1*, 2015, two great arcs of color sweep from each end of the gallery toward the center and twist together from the floor to the plaster medallion above, catching the space in a tensile grip. Like Donovan's work, Dawe's waves of color may first appear as a constant mass, or alternately as light too ethereal to grasp. They are, in fact, made from thousands of strands of cotton embroidery thread that have been strung between hooks on the floor and ceiling, the artist having cautiously guided each thread from point to point in a ritualistic sweep of the arm over several days [fig. 19]. Patrick Dougherty has woven willow osiers into a cluster of pods; like great overturned eel traps, they crouch against the floor and then launch toward the ceiling. Each of the tall shoots harvested in rural New York is guided by hand into the embrace of the stick next to it, signifying a full month's toil for the artist and his crew [fig. 20]. Wandering among the pods is to become entangled in a curious city, lined with fragrant and sinewy green walls, rough and sometimes damp to the touch. Upstairs Maya Lin has flooded a sun-soaked gallery with a sea of pitted and green-hued marbles. Their current surges across the gallery and up walls, defying basic physics as well as scale—each marble approximating an oversize droplet, as if we could suddenly discern the atomic structure of water. The course the droplets take is far from random. Spend enough time walking along its edge and you may recognize the path: Lin has mapped out the Chesapeake Bay and its tributaries in glass [figs. 21 and 22]. To walk alongside her work is to step around the fingers of our country's largest estuary, a natural wonder only twenty-five miles east of the museum.

A card, a thread, a stick, a marble. Alone these are plain things so familiar as to pass unnoticed. In that, they conform to anthropologist Daniel Miller's theory of the "humility of things," whereby the objects

Fig. 19 Gabriel Dawe installs *Plexus No. 10*, at Gutstein Gallery, Savannah, Georgia, 2011 □ **Fig. 20** Patrick Dougherty working on *Shindig*, 2015, at the Renwick Gallery, Washington, DC

that successfully guide our behavior in everyday life also tend to escape our attention.[109] They work and are reassuringly familiar, so we are blind to them. "It is not understanding that destroys wonder, it is familiarity," wrote English philosopher John Stuart Mill; and he was right—so far as objects remain familiar, they shall not be wondrous.[110] But what if we remove them from their humble functions? What if we disrupt them, alter them, break them, or mass them, so that they appear to us wholly alien? When do you think of a car tire? Probably only when you buy one or it goes flat. Chakaia Booker counts on that when she musters hundreds of tires to be cut, slashed, splayed, and then pieced together into a strange and threatening labyrinth. You can walk around and into it, but how will

It is not understanding that destroys wonder, it is familiarity.

—John Stuart Mill

it make you feel? Do you know what it is? Do you smell the rubber? Have you ever considered the hard fact of a tire—the rubber from trees in places like Sierra Leone (home to Firestone's plantation), its manufacture, the ships it sails on to reach us, the life it leads among us? If you saw four tires, or eight, or sixteen, probably not. But if you saw one hundred or one thousand tires, torn from their perfect circles of familiarity, you might tune into Emerson's declaration: "Man is surprised to find that things near are not less beautiful and wondrous than things remote."[111]

In particular, the massing of objects helps us gain an Augustinian appreciation for the muted creations around us. The same act also renders the routine quite unrecognizable, cracking the door for Aristotelian wonder

Fig. 21 Maya Lin in her studio with the prototype of *Folding the Chesapeake* □ **Fig. 22** Maya Lin considers the configuration of *Folding the Chesapeake*, 2015, for the Renwick Gallery

98

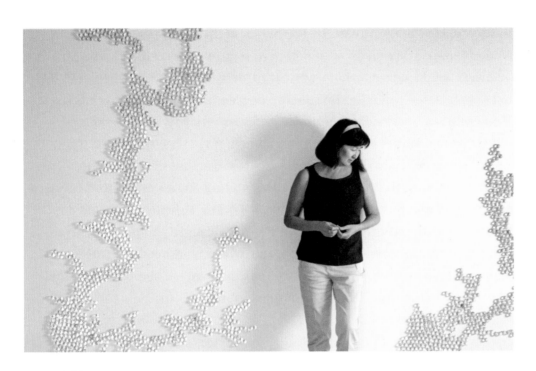

to reconquer the quotidian. In the hands of an artist like Donovan, an element as pedestrian as an index card is utterly transformed so that "viewers might never fathom what it is, even if told."[112] Puzzlement only capitulates to understanding by degrees as you circle around the Humboldtian towers, leaning in to study not crisp, white rectangles, but rather an endless series of corners generating a faint bluish glow. Looking up and then down a tower creates dizzying tricks of perspective, as corners dance in diminishing and expanding circles above and beneath eye level. When do you discover what it is? Per Descartes, we must comprehend the nature of it before we can measure the proper response. Only then can we settle it, fit it into our world, and master it, like so many specimens on the wall. Before that moment, in the throes of that first passion, the object's power surges unbridled, thrilling and potentially threatening.

Threat runs close to the surface in the gallery installed by Jennifer Angus. The artist has painted the walls from the floor to the edge of the cove in a blazing magenta, overtop of which she has created geometric patterns in a range of other colors. The immediate effect is Victorian but peculiar. Why so pink? And why do the outlines of the patterns appear irregular? As you draw closer, the questions come quicker: the patterns are . . . bugs? She has put up bug wallpaper? No, an obvious relief is on the wall. These are objects. She made these bugs? From what? By this time you will have walked into the heart of the gallery and begun to focus on a specific section of wall, a specific pattern, and as you step closer, a specific bug. When will it strike you? From five feet away? From one? The insects are real. I first saw Angus's work installed at the Newark Museum's Ballantine House. If you are like me, you will step back quickly once the realization soaks in.[113] I was perhaps eighteen inches away from the largest six-legged specimen I had ever seen when the truth of it hit me: then I moved three feet farther off as fast as my heels could rock—

but only for a matter of seconds before I again inched forward in rapt
wonder. We think we know something of bugs because we pitch ourselves
against flies, mosquitoes, and spiders or because we might take the time
to explain the work of bees to an inquisitive child. But our collective
ignorance of the earth's diversity of insect life would astonish us if we
had the wherewithal to fathom it. This is Angus's genius. By selecting
a handful of the more glorious examples of species we don't know, and
pinning them into familiar geometries, she presents the unbelievable in
a framework we can digest and that promises to expand our appreciation
of uppercase "Nature," even as we skip the more conventional displays
in a natural history museum. Entomologists who work with Angus refer
to her taste in species as the "showy stuff," which precisely describes its
appeal to a general audience.[114] The species that set me back was a female
Heteropteryx dilatata from Malaysia, commonly known as a jungle
nymph [fig. 23]. Her prickly exoskeleton is an unnervingly bright green
and nearly ten inches in length. Reading that in print is quite a different
experience than having it stare you in the face as you imagine a distant
peninsula where such creatures roam about and are kept as pets.

The typical response to Angus's work is complex. Outwardly, it manifests
in a narrow band of floor around the circumference of a gallery—roughly
three feet wide—where the dance described above takes place, repeating
ad infinitum as viewers recoil and then muster the courage to match
their curiosity. No more fitting illustration of Patrizi's theory of wonder
endures than to compare these tentative footsteps with his violent
current rushing back and forth between reason and emotion as we
struggle to incorporate radical difference into our preexisting knowledge
of the world. Inwardly, the experience of her work unfolds as a sort
of negotiation with oneself as a new reality tamps down the one just
splintered. This, too, involves many questions: did she paint them? (No.)
Where are they from? (Primarily Malaysia, Thailand, Papua New Guinea.)

Fig. 23 (actual size) Female Malaysian stick insect, *Heteropteryx dilatata* (jungle nymph)

Does she catch them or kill them? (No, they are mostly farmed.) Are they endangered? (No, they reproduce at astonishing rates and are quite abundant.) From here the road often splits, with awe branching off one side and unease the other. Which fork you happen down will depend on how you respond viscerally to the realization that you are standing within a matrix composed entirely from this natural "medium." Even the pink wash is insect based, a product of the Mexican cochineal that lives on cacti and was historically prized for its reproducibility into brilliant dye, which quickly found in sixteenth-century Europe a market hungry for New World color.[115] By focusing our attention on the wonders of faraway places, Angus draws us back to the romanticized topography of the early modern period, without yielding to its darker inclinations.

A similar effect is on display in the installation *Middle Fork*, 2015, by John Grade who instead of looking to the Global South has gone trekking into our own wilderness in search of inspiration. The work is quite clearly a tree but is also not at all a tree. Upon entering the gallery you stand before a felled giant, twenty-six feet long from trunk to tip and door to door, running parallel to the floor but suspended above it by wires so that the whole mass levitates at eye level. If you have come in from the north entrance you will stare down the great maw of the trunk, which fans out to embrace you. If you arrive from the south or east entrances, you will instead confront the strange bark of the "tree" and its mess of remaining branches reaching out to explore the gallery's volume. Even with the expected components accounted for, the thing remains uncanny: it is clearly handmade, it is hollow, and light peeks through its patchwork skin. How did it come into being? Grade ventured into the Cascade Range east of Seattle to select a tree approximately the same age as the Renwick's building. On the land of a family that knew its history, he located a tree that fit the bill—a hemlock about 150 years old that would be large enough to dominate the museum's second-floor

gallery. With a crew propelling through its canopy on ropes, Grade then achieved if not the impossible then the extremely unlikely: he created a complete plaster cast of the tree in situ [fig. 24]. Before it fully set, the cast was removed in sections then transported to his studio, where it became the mold for an army of volunteers to construct Grade's hand-made tree around it [fig. 25]. Using old-growth cedar reclaimed from a dismantled bridge, the community individually measured, shaved, and glued a half-million segments of wood along the mold's undulations to re-create the living model as a sculpture in its own material. When the land around the hemlock was logged eighty years ago, this particular tree was left standing, not out of respect but because it was a "junk tree," not worth the mill's return to cut down. In this, Grade's attention to the unsung recalls Dürer's *Great Piece of Turf* [fig. 5], as if the tree were an immense dandelion due our recognition only when seen through the eyes (and hands) of others. (The same allusion applies to the work of Dougherty, who prefers to gather his materials in the neglected corners of our world, where plants are left to grow unhindered—along riverbanks and inside abandoned buildings, old walled gardens, and, memorably, a sewage-treatment plant in Cincinnati. Since a stick's flexibility for weaving matters more than its popularity, some lesser-known species, such as winged elm, java plum, and strawberry guava, are at the forefront of Dougherty's work.)

Contrast the history of Grade's specimen to another in the Renwick's Palm Court: a miniature version of its sibling, about seven feet tall, and from a profoundly different place. Not long after initiating the casting project in Washington, Grade journeyed to Alaska, specifically the deso-late expanse north of the Brooks Range, the southern exposure of which formerly made up the tree line [fig. 26]. As warming occurs the tree line is creeping north, closer to the Beaufort Sea, so that you must venture one hundred miles past the mountains of Brooks Range to find the frontier

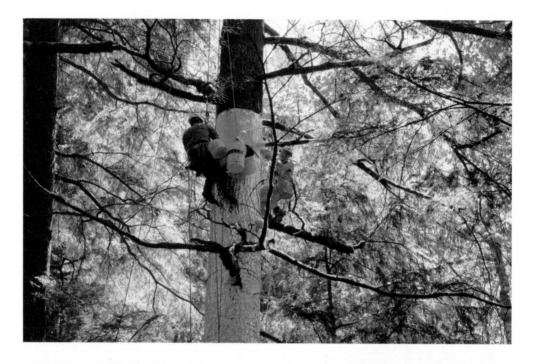

Fig. 24 John Grade is suspended eighty feet in the air casting the hemlock for *Middle Fork (Cascades)* in 2014
Fig. 25 Setting a section of wood in place using a laser level

Fig. 26 John Grade hiking the headwaters of the Noatak River, Gates of the Arctic National Park, Alaska, 2014

where the trees meet the Arctic landscape. It is here the artist and his remarkably understanding wife, Maria Grade, were dropped by bush plane, with a raft stocked with ten days' supplies, to seek out the elusive balsam poplar (or cottonwood tree). After several days moving downriver and numerous close encounters with bears, Grade located the exact tree he would cast. It, too, began life about the time that foundations were laid for the Renwick, but in this case an elfin stature was the result of an unforgiving home. In his efforts to rebuild the trees by hand, Grade has created approximations of the originals—not only in look, feel, and orientation but also in minutely detailed scale. Each study records a specific year in the life of its source. The respective plaster molds could be refitted to the hemlock and balsam poplar soon after they were created. By the time you read this essay, however, the trees will have grown just enough to exceed the measurements of Grade's reproductions. After the exhibition closes, he will return the works to the sites where the trees were cast and still stand, to let these avatars of nature break down and return to the earth.[116]

Above the grand stairs, at the heart of the museum, is suspended something of a box of light, nine feet tall, six feet wide, and twenty-one feet long, running over the stairs so that you first see it from below as you ascend. What hovers over you and then before you as you walk the hall is a constantly shuffling order of flashes, or deep rolling waves of light, followed by short bursts, rings, and whole continents of brilliance drifting across its three axes. This is Leo Villareal's *Volume (Renwick)*, 2015, an installation of 320 steel rods embedded with 23,000 LEDs programmed to display a code the artist wrote and manipulated into endless variations [fig. 27]. Stand here for a while and you will be rewarded with a display that never repeats itself exactly as before. Villareal's works mesmerize in part by their reluctance to rest within our preconceptions of what light is, how it should appear, and what it is for, as evidenced in his remark in

Fig. 27 Leo Villareal programs sequences for *The Bay Lights*, 2013. © Leo Villareal and Lucas Saugen

the epigraph for this section (p. 93). He continues, "People don't have a slot in their brain for this kind of work yet," an observation that recalls Spinoza's proposition that wonder emerges from the failure of existing categories to make sense of the unfamiliar. Villareal's adaptation of light as a medium is not unprecedented in modern or contemporary art. Where it differs is in the treatment of the hardware, not as the primary artwork, although its function is what initially captivates us, but rather as a vehicle for the visual manifestation of code—the binary system of ones and zeros determining whether to turn each LED on or off. Through the marriage of sleek materials and digital tinkering, Villareal succeeds in rendering Aristotle's favorite object of wonder: a cosmos—minor in scale but close and gratifyingly tangible in ways the heavens above can rarely offer.

Janet Echelman presents a dramatic display of nature's potency in the Renwick's Grand Salon. Her installation comprises a fine mesh net woven largely by hand from high-molecular-weight polyethylene and high-tenacity polyester (the former fifteen times stronger than steel); it billows beneath a taut network of ropes that fasten to each wall, pulling the architecture of the site into her sphere of influence. This soft giant casts out from the northwest corner, surging upward across the full one-hundred-foot length of the salon, slicing through the center of its volume so that the very air we peer through is entwined with the whole. The shock of the piece comes from our joint realization of the immensity of its scale and its apparent defiance of physics. To stand beneath it, looking up, is to yield to a gossamer threat, a massive yet fragile life form capable of both dominance and grace. Echelman is toying with our quest for beauty here, tapping into the exaltation that stems from our surrender to something so much greater than ourselves. Only when you are within its delicate embrace does she reveal the terrible root: the net's design and matrix correspond to a map of the energy released across the Pacific Ocean in 2011 by the Tōhoku earthquake and tsunami, which laid

waste to eastern Honshu and stands as the most costly and one of the most devastating natural disasters in recorded history [fig. 28]. The force unleashed was so intense it shifted the earth on its axis. The work's seemingly innocuous title, *1.8*, reflects the number of microseconds by which that fateful day, Friday, March 11, was shortened in its wake. With this information, the work takes on a different feel: now to roam back and forth beneath its span is to toss about as if lost in a roiling sea. In drawing from a traumatic source, Echelman reminds us that not all wonder leads to good and that a "great, portentous, and unusual" path may carry us to the cusp of horror—in this instance, a string of waves taller than the length of the Grand Salon.[117]

Echelman's craft traces its origins to the sea, although in comparatively tame fashion. Trained as a painter, Echelman traveled to India in 1997 on a Fulbright scholarship to teach and mount exhibitions of locally produced work. When her shipment of materials failed to arrive, the artist was forced to improvise, first by working with bronze casters in the coastal city of Mahabalipuram in Tamil Nadu. With only a few weeks left before she was scheduled to fill a large exhibition space, Echelman knew the bronzes were too small to show alone and too expensive to scale up. A way forward sprouted from her nightly walk on the city's beaches along the Bay of Bengal [fig. 29]. There, fishermen sorted the day's catch and folded up their handwoven nets—a simple tool she realized could provide volumetric form without solid mass. Within days, Echelman was working with the fishermen to weave her first fiber sculptures. When they were strung up outside, the corresponding play of wind and light with the knotted forms provided the kernel of wonder that has led her to take on increasingly ambitious projects across the globe.[118] Nearly all of Echelman's works are installed out of doors, where they can interact with the elements, offering what she calls the "simultaneous experience of being sheltered and connected to limitless sky."[119]

Behind the work of several artists in this exhibition is a similar story of discovery, often hinging on a wondrous and unexpected encounter with the new that was sudden or gradual. In the 1990s, Villareal worked on the development of Virtual Reality in California, a project that excited him in concept but left him feeling cold in practice. A space where you could conceive anything in simulation was not necessarily a social space. Soon, Villareal found himself trekking out to Nevada's Black Rock Desert with a group of engineers to attend Burning Man, where he thrived in its renowned DIY/maker culture. In that spirit, Villareal cobbled together sixteen strobe lights and a macrocomputer into a crude wayfinding device to locate his mobile home in the desert night. Here was a digital medium, without a screen or projection, that merged code—the downloadable— with a highly personal experience of place—the nondownloadable. The realization that such a simple concoction could provide a meaningful aesthetic experience planted the conceptual seed that would eventually lead Villareal to projects as formidable as the lighting of San Francisco's Bay Bridge in 2014.

Angus was living in Thailand when she first saw a garment known as the singing shawl, worn by young women who would sing songs with their family while grieving at funerals. Green metallic beetle wings sewn into the shawl in place of beads or sequins caught the light when they moved. For Angus, the experience of the shawl was the first time she considered insects to be beautiful, and it led directly to her first insect-themed installation—a wall of Papuan weevils in a storefront on Toronto's popular Queen Street. Donovan's epiphany came late one night in the midst of a minor art project—skewering potatoes with toothpicks (in a fashion closely resembling her recent large sculptures made from acrylic rods). After she knocked a box of toothpicks onto the floor, she carefully lifted up the box to find the toothpicks inside had maintained a perfect corner. She immediately went to the nearest grocer to clear out its stock

Fig. 28 Janet Echelman used the colors and forms of a computer model that documented the maximum wave amplitude of the tsunami following the Tōhuko earthquake, 2011, in Japan, as the basis of her work for the Renwick Gallery, *1.8*, 2015
Fig. 29 Fishermen on the shore in India near Mahabalipuram, 2009

and within the week was ordering whole crates of toothpicks from the supplier, eventually leading to *Untitled (Toothpicks)*, 1996, her first major work massing everyday materials. For Booker, the decision to work with tire rubber came through observation of her immediate environment [fig. 30]. Walking the streets of New York in the 1980s, she was enthralled by the countless failed retreads littering the roads, and their more violent cousin, pools of rubber melted by weekend car fires. She soon began scraping the elements off burnt chasses to incorporate into her work as a surface treatment. Alternately, inspiration can come from the warmth of memory and the desire to mesh the phenomenological experience of youth with a material that will trigger an early wonder. Such is the case for Gabriel Dawe, who in discussing his series *Plexus* (the term denotes a network of nerves or vessels) recalls his "admiration" (a Latin root for our contemporary use of "wonder") for the sky above his childhood home outside Mexico City and the "dramatic overturns" of the sky in Texas, where he now lives. When asked to contribute to a project that combined fashion with architecture, he found himself experimenting with how to interweave the qualities of light of the skies with the traditional embroideries he was captivated by as a boy.[120] Maya Lin remembers her father, Henry Huan Lin, a ceramist and dean of the Faculty of Fine Arts at Ohio University, Athens, experimenting with blown glass in the 1960s as the studio movement was just getting on its feet in Toledo. The soft green marbles in her Renwick installation are the same ones her father and pioneers of American studio glass sought for their low melting point and ease of use. Long ago supplanted by superior technologies for glass blowing, the marbles show irregular and indented surfaces that disclose their heritage, not as a finished product but instead as raw industrial material; they are a solidified form of molten fiberglass, cooled into marbles for transportation, then remelted into various goods. Lin rediscovered them only recently, in time for this exhibition.[121] □

Fig. 30 Chakaia Booker, *The Foundling Warrior Quest (II21C) (6)* (detail), 2010, photogravure print after original in the collection of the artist

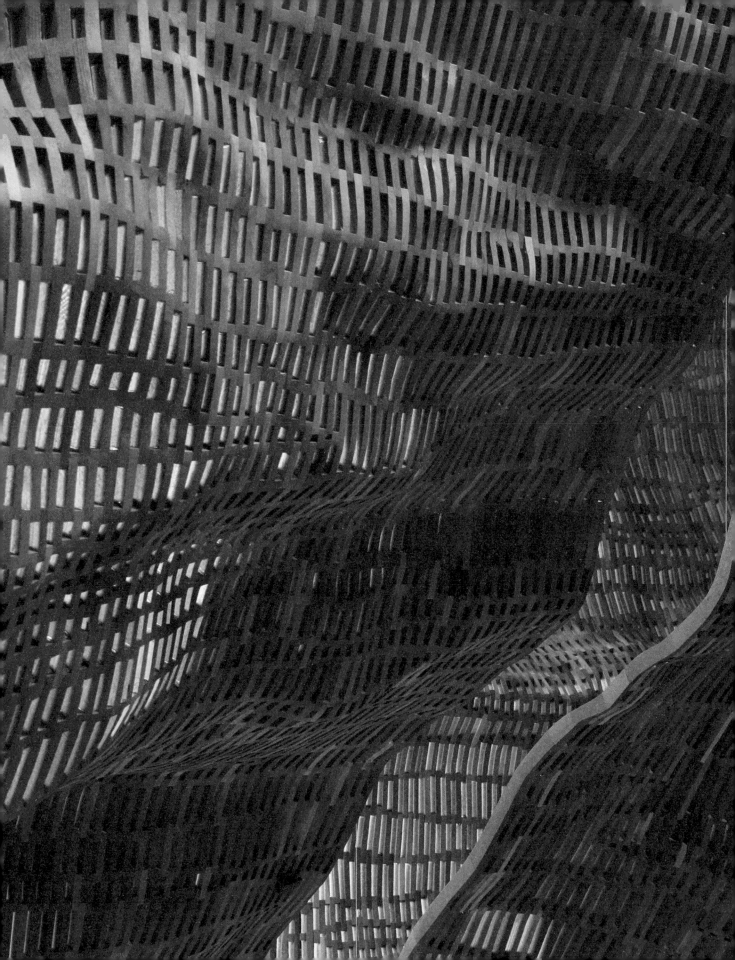

You Are Here

*We live in a world of
unreality and dreams.*

—SIMONE WEIL, 1942

In the origins of an artist's life's work we uncover the central threads that connect the self to the world and the elements within that shower us with wonder, myth, and mystery, driving us in pursuit of further contact and the promise of beauty. "Art is an attempt to transport into a limited quantity of matter, modeled by man, an image of the infinite beauty of the entire universe," wrote French philosopher and Christian mystic Simone Weil. "If the attempt succeeds, this portion of matter should not hide the universe, but on the contrary it should reveal its reality to all around."[122] The installations on view at the Renwick Gallery and their core matters of plastic, glass, wood, rubber, fiber, light, and life itself are here precisely to reveal the reality all around and reinforce the import of witnessing it firsthand. Coming to terms with that purpose is not a simple question of cataloging the artists' materials or quantifying their labors, although that is often our first response when confronting works by the New Materialists. Focusing on monumental scale and the steps taken to achieve its jarring presence provides us with an accessible

John Grade, *Middle Fork* (detail), 2015, reclaimed old-growth western red cedar. Courtesy of John Grade

117

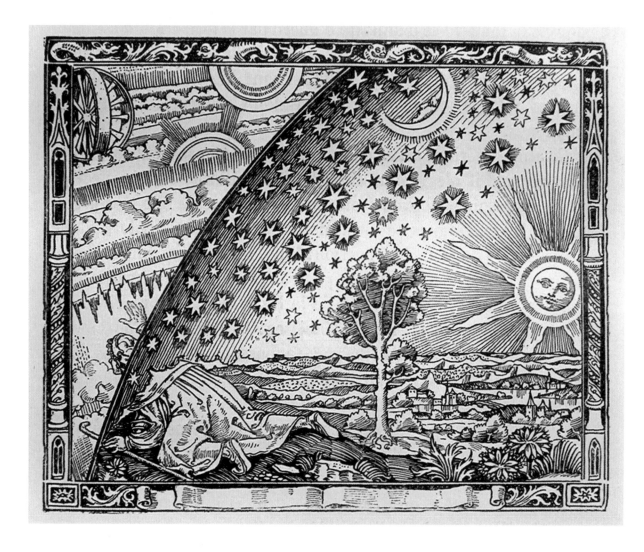

framework for digesting the unfamiliar, but it is an easy out. We ask questions about the making of the piece, and probe the artist's decision to embrace nearly inconceivable acts of repetition for the intimate grasp of just that thing. Delineating the "how" and "what" can provide reassurance, which allows us to resist the pull of wonder's unpredictable current and often skirt the "why" that leads to deeper fulfillment. Understanding the artists' motivations—the stories above that divulge their experience of wonder—opens the doors to answers but not always to one as urgent as why we should spend time with these works, deliberate, challenge, or even cherish them.

To achieve that, we must reach past the surface of what we know to consider instead what we feel in their presence. One way to gauge our impressions is to weigh our bodies' responses to the physical facts of such works within the museum—the nondownloadable moments when we hunch over to focus on just one insect, marble, or clutch of willow, when we run our hands along the jagged edges of Booker's labyrinth, or when we rock back on our heels at the overwhelming sensation of being that much smaller than Donovan's towers or Echelman's turbulent sea. It is in these moments that we become acutely aware of our proprioception— how our bodies register movement and location from within, what poet Charles Olson memorably defined as the "sensibility of the organism by movement of its own tissues."[123] These artworks harbor the innate ability to tell us where we are, not just at the museum, but how our limbs, hands, head, eyes, and our center of gravity hinge upon a constant reading of our fit within the environment [fig. 31]. This zooming in and out from micro to macro scale lets our attention arc across whole galleries and resembles a means of engaging space with stronger parallels to the experience of early modern collections (as Bleichmar describes) than with the narrow plane of installation otherwise dominant in museums since the nineteenth century.[124] Engaging us in the space heightens our sensual

Fig. 31 Camille Flammarion (French, 1842–1925), *L'Atmosphere: Météorologie Populaire* (Paris, 1888), p. 163. History of Science Collections, University of Oklahoma Libraries, Norman

awareness; we become attuned to how we move about in the world, which encourages us to tap into proprioception's ally: memory. Just as we navigate place through the recollection of having been there before (think of how your body 'knows' which way to turn at a familiar crossroads), so, too, can we locate meaning in new works through the connections they provide to our own histories. Grade's trees, Lin's marble drops of water, Dawe's expanse of color, and Villareal's box of stars function as portals with the potential to deliver us to other places and times—previous realities—where and when like things mattered in fundamentally subjective ways. Art's capacity to provide the path to an emotional truth helps account for the museum's unyielding force, drawing us into its center before pushing us back out along horizons of our own making. Kenneth Clark recognized the underlying value of such centers: "The only reason for bringing together works of art in a public place is that . . . they produce in us a kind of exalted happiness. For a moment there is a clearing in the jungle: we pass on refreshed, with our capacity for life increased and with some memory of the sky."[125] Despite the tenor of past ideologies, or the eventful rise and fall of modernism, the ideas touched on above strike at the heart of why we have always freighted museums with symbolic weight. Whether in Brussels, Bologna, Naples, Paris, Philadelphia, or Washington, the drive to gather the world in one closet shut or simply to elevate one aspect of it is born of a searing desire, not just to know but also to be caught up in wonder, to be forced beyond our perspective, to be moved. "The illusion of perspective places [mankind] at the center of space," continues Weil. "An illusion of the same kind falsifies his idea of time; and yet another kindred illusion arranges a whole hierarchy of values around him. This illusion is extended even to our sense of existence, on account of the intimate connection between our sense of value and our sense of being; being seems to us less and less concentrated the farther it is removed from us."[126]

And so we gather up the fragments around the edges of our world in the expectation that bringing them closer will reveal a greater sense of their nature, perchance to enlighten our own. The town hall filled with Aztec treasures, Goethe's Medusa Rondanini, Adamson's Tang dish, Greenblatt's Mayan stand, Imperato's crocodile, Cospi's codex, Peale's mastodon, Corcoran's *Greek Slave*, even Dürer's unassuming piece of turf have come to us in this way. But we should return to the Netherlandish prayer bead to grasp the gravity of these objects' power. In those crowded scenes alternating between euphoria and despair is the message that we are not the center. Per Weil: "To give up being the center of the world in imagination, to discern that all points in the world are equally centers and that the true center is outside the world, this is to consent to the rule of mechanical necessity in matter and of free choice at the center of each soul."[127] Her line of reason is clearly theological, but its point should not be lost on a general audience: we are utterly surrounded by elements, things, and beings that are their own centers. We are the edge. Never is that clearer than in the museum, where we hope to be spirited away by the "transcendent merit" of our peers and predecessors. Because it is in those minutes of enchanted looking that we undergo what Elaine Scarry and James Cuno have labeled a radical moment of "unselfing," a conscious decentering of perspective from ourselves to the object of astonishment.[128] Which things carry this power is often told to us, hence the reigning cult of masterpieces. But in the right hands, anything can be made the center of the world. A card, a thread, a stick, a marble. Is that not wondrous? □

"Pillows of Air"
by Lawrence Weschler

1 Richard Broxton Onians, *The Origins of European Thought about the Body, the Mind, the Soul, the World, Time and Fate* (Cambridge: Cambridge University Press, 1951), 75.

2 From John Donne (1571–1631), Elegy 19, "To His Mistress Going to Bed," *John Donne: Selected Poems* (London: Phoenix, 2003), 57.

3 Francis Bacon, *Gesta Grayorum*, 1688. See below, note 53 in Nicholas Bell's essay.

4 Thomas McEvilley, *Art & Discontent: Art at the Millennium* (Kingston, NY: McPherson, 1991), 98ff.

5 John Stuart Mill, *Examination of Sir William Hamilton's Philosophy.* See below, notes 26 and 110 in Nicholas Bell's essay.

6 The quote, which has been variously worded, is phrased as "Making reality real is art's responsibility" in Eudora Welty, *One Writer's Beginnings* (Cambridge, MA: Harvard University Press, 1984).

7 See W. S. Merwin, *Unchopping a Tree* (San Antonio, TX: Trinity University Press, 2014), or earlier, in Merwin's collection of prose poems, *The Miner's Pale Children* (New York: Atheneum, 1970), 85–88.

8 In an unpublished manuscript, Walter Murch says the passage comes from Kepler's *De Stella Nova* (1606).

9 Northrop Frye quoted in Alberto Manguel, *The Other Side of the Ice*, review of the documentary film *Atanarjuat: The Fast Runner* (2001), in Alberto Manguel, *The City of Words* (Toronto: House of Anansi Press, 2007), 77.

"On Wonder"
by Nicholas R. Bell

Epigraph pp. 16–17: Noël Arnaud, *L'état d'ébauche.* Illustrated by Max Bucaille (Paris: Messager Boiteux de Paris, Gizard, 1950), unpaginated, line 127.

The Encounter

Epigraph p. 19: Albert Einstein, "The World as I See It," originally published in *Forum and Century* 84 (1931): 193–94; reprinted in Albert Einstein, *Ideas and Opinions* (New York: Crown, 1954), 11.

Fig. 3 annotation (Medusa Rondanini), p. 27: Johann Wolfgang von Goethe, *Italian Journey, 1786–1788,* trans. W. H. Auden and Elizabeth Mayer (London: Penguin, 1970), 364–65; Francis Haskell and Nicholas Penny, *Taste and the Antique: The Lure of Classical Sculpture, 1500–1900* (New Haven, CT: Yale University Press, 1981), 116.

1 From Constantijn Huygens's autobiography of 1629–31, cited in Joy Kenseth, "Introduction," in Joy Kenseth, ed., *The Age of the Marvelous,* exh. cat. (Hanover, NH: Hood Museum of Art, Dartmouth College, 1991), 38.

2 The prayer bead in question is catalogue number 50 in John Lowden and John Cherry, *Medieval Ivories and Works of Art: The Thomson Collection at the Art Gallery of Ontario* (Toronto: Skylet and Art Gallery of Ontario, 2008), 139–41. For further reading, see Frits Scholten and Reindert Falkenburg, *A Sense of Heaven: 16th-Century Boxwood Carvings for Private Devotion* (Leeds, UK: Henry Moore Institute, 1999); Richard Marks, "Two Early 16th-Century Boxwood Carvings Associated with the Glymes Family of Bergen op Zoom," *Oud Holland* 91, no. 3 (1977): 132–43; Frits Scholten, "A Prayer Nut in a Silver Housing by 'Adam Dirckz,'" *Rijksmuseum Bulletin* 59, no. 4 (2011): 322–47; Frits Scholten, "Joost van Cranevelt's Prayer Nut," *Simiolus: Netherlands Quarterly for the History of Art* 36, no. 3/4 (2012): 123–41; Frits Scholten, "A Prayer-Nut for François Du Puy," *Burlington Magazine* 153, no. 1300 (July 2011): 447–51. The Ontario College of Art and Design is now called OCAD University.

3 David Summers, *The Judgment of Sense: Renaissance Naturalism and the Rise of Aesthetics* (Cambridge: Cambridge University Press, 1987), 127.

4 Albrecht Dürer, Marnix Gijsen, and Georges Marlier, *Diary of His Journey to the Netherlands, 1520–1521,* trans. Philip Troutman (Greenwich, CT: New York Graphic Society, 1971), 53–54. For a slightly different translation, see Erwin Panofsky, *The Life and Art of Albrecht Dürer* (Princeton, NJ: Princeton University Press, 1971), 209.

5 Rosamond Wolff Purcell and Stephen Jay Gould, *Finders, Keepers: Eight Collectors* (London: Pimlico, 1993), 17.

6 Stephen Greenblatt, "Resonance and Wonder," in Ivan Karp and Steven D. Lavine, eds., *Exhibiting Cultures: The Poetics and Politics of Museum Display* (Washington, DC: Smithsonian Institution Press, 1991), 48–49.

7 Glenn Adamson, "Goodbye Craft," in Nicholas R. Bell, ed., *Nation Building: Craft and Contemporary American Culture* (Washington, DC: Smithsonian American Art Museum and Bloomsbury, 2015), 23.

8 See also "Animal, Mineral, Vegetable: The Material Coming to Life, Tara Donovan in Conversation with Lawrence Weschler," in Nicholas Baume, Jen Mergel, and Lawrence Weschler, *Tara Donovan* (Boston: Institute of Contemporary Art and Monacelli Press, 2008), 153.

9 R. W. Hepburn, *"Wonder" and Other Essays: Eight Studies in Aesthetics and Other Fields* (Edinburgh: Edinburgh University Press, 1984), 139. Goethe's discussion of the Medusa is from Goethe, *Italian Journey,* 364–65; his comments on astonishment are from Johann Peter Eckermann, *Conversations of Goethe with Johann Peter Eckermann,* ed. J. K. Moorhead, trans. John Oxenford (1930; reprint, New York: Da Capo Press, 1998), 296.

10 Eckermann, *Conversations of Goethe,* 280.

11 Philippe de Montebello and Martin Gayford, *Rendez-vous with Art* (London: Thames and Hudson, 2014), 124.

12 Yi-Fu Tuan, *Passing Strange and Wonderful: Aesthetics, Nature, and Culture* (Washington, DC: Island Press, 1993), 23. See also 20–31. Or just have kids.

13 Hepburn, *"Wonder" and Other Essays,* 137.

14 Greenblatt describes the European experience of the New World as being "like the 'startle reflex' one can observe in infants: eyes widened, arms outstretched, breathing stilled, the whole body momentarily convulsed." Stephen Greenblatt, *Marvelous Possessions: The Wonder of the New World* (Chicago: University of Chicago Press, 1991), 14. See also Thomas Lentz's description of the ideal mission of the Smithsonian Institution's adjoining museums of Asian art, the Freer Gallery of Art and Arthur M. Sackler Gallery: "A Sackler goal should be to assist in the repositioning of this sense of wonder, this 'startle reflex' characteristic of the Freer approach to Asian art and so deeply entrenched in the consciousness of the West." Thomas W. Lentz, "In Flux: Asian Art at the Arthur M. Sackler Gallery," in Thomas Lawton and Thomas W. Lentz, *Beyond the Legacy: Anniversary Acquisitions for the Freer Gallery of Art and the Arthur M. Sackler Gallery* (Washington, DC: Freer Gallery of Art/Arthur M. Sackler Gallery, Smithsonian Institution, 1998), 112.

15 Ludmilla Jordanova, "Objects of Knowledge: A Historical Perspective on Museums," in Peter Vergo, ed., *The New Museology* (London: Reaktion Books, 1989), 23. I would strongly disagree with Jordanova's point just a few pages later that "we must lose our childish awe of

'treasures and wonderful things' in order to replace it with a measured appreciation of the awkwardness, the limitations, the downright intractability of objects, that, for whatever reason, we endow with value" (p. 40). Can we not remain in awe of the subjects of our earnest study?

16 Quoted in Lawrence Weschler, *Mr. Wilson's Cabinet of Wonder: Pronged Ants, Horned Humans, Mice on Toast, and Other Marvels of Jurassic Technology* (New York: Vintage Books, 1996), 60.

17 The original eleven statues Corcoran commissioned from Moses Jacob Ezekiel, carved from Carrara marble, were of Phidias, Michelangelo, Raphael, Dürer, Titian, Da Vinci, Rubens, Rembrandt, Murillo, Antonio Canova, and Thomas Crawford. They were sold when the US government purchased the building in 1901 to serve as the US Court of Claims. Today they are on view at the Norfolk Botanical Garden in Virginia.

18 In 1972, when the building was set to open in its new iteration as the Renwick Gallery, founding director Lloyd Herman commented, "The building is our biggest exhibit." Nan Robertson, "A New Era for the Renwick Gallery," *New York Times,* January 25, 1972.

19 The goblet is nested within five turned-wood eggs, the largest measuring one inch by a half-inch tall: Del Stubbs (b. 1952), *Nesting Eggs and Goblet,* 1979, tulipwood, rosewood, desert ironwood, lignum vitae, boxwood, and bone. Smithsonian American Art Museum, Gift of Kay Sekimachi in memory of Bob Stocksdale, 2008.27A-F.

A Sense of Wonder

Epigraph p. 37: Poem 1331 in Emily Dickinson, *The Complete Poems of Emily Dickinson,* ed. Thomas H. Johnson (New York: Back Bay Books, 1960), 577.

Fig. 4 annotation (Etching by Bernard Picart), p. 41: Stephanie Ross, "Painting the Passions: Charles Le Brun's *Conférence sur l'Expression,*" *Journal of the History of Ideas* 45, no. 1 (January–March 1984): 25–47. Quote is from Charles Le Brun, *Conférence de M. Le Brun sur l'expression générale et particulière* (1698), trans. John Williams as *Method to Learn to Design the Passions* (1734; Los Angeles: Augustan Reprint Society, 1980), 24.

20 Aristotle, *Metaphysics* 1.982b. Aristotle's ideal subject of philosophical wonder was celestial bodies as a model of "natural orderliness," not the range of oddities that would dominate medieval considerations of wonder. Lorraine Daston and Katharine Park, *Wonders and the Order of Nature, 1150–1750* (New York: Zone Books, 1998), 116.

21 Peter G. Platt, *Reason Diminished: Shakespeare and the Marvelous* (Lincoln: University of Nebraska Press, 1997), 1; J. V. Cunningham, *Woe or Wonder: The Emotional Effect of Shakespearean Tragedy* (1951; reprint, Chicago: Swallow Press, 1964), 80. For a more in-depth review of theories of wonder from antiquity to the Renaissance, see Platt, *Reason Diminished,* 1–18.

22 Cited in Cunningham, *Woe or Wonder,* 77–78, and Greenblatt, *Marvelous Possessions,* 81. Greenblatt credits Cunningham with shaping his view on the nature of wonder.

23 Cunningham, *Woe or Wonder,* 61, 96; Baxter Hathaway, *Marvels and Commonplaces: Renaissance Literary Criticism* (New York: Random House, 1968), 58. Bobby Rock, senior vice-president and head of acquisitions at Random Media, Los Angles, shared many titles that fit this description.

24 Greenblatt, *Marvelous Possessions,* 20; Spinoza quote, 156. Greenblatt notes that, unlike Descartes, Spinoza believed that wonder did have an opposite: contempt. Samuel Johnson would later echo Spinoza's definition, referring to wonder as a "pause of reason, a sudden cessation of the mental progress, which lasts only while the understanding is fixed upon some single idea, and is at an end when it recovers force enough to divide the subject into its parts." Samuel Johnson, "The Necessity of Literary Courage," *Rambler,* no. 137 (July 9, 1751), in Samuel Johnson, *The Yale Edition of the Works of Samuel Johnson,* vols. 3–5, *The Rambler,* ed. W. J. Bate and Albrecht B. Strauss (New Haven, CT: Yale University Press, 1969), 360. See also Glenn Adamson, "The Labor of Division: Cabinetmaking and the Production of Knowledge," in Pamela H. Smith, Amy R. W. Meyers, and Harold J. Cook, eds., *Ways of Making and Knowing: The Material Culture of Empirical Knowledge* (Ann Arbor: University of Michigan Press, 2014), 247.

25 René Descartes, *Les passions de l'âme* (The passions of the soul), 1649. This and the quotes that follow are from the full English translation at http://www.earlymoderntexts.com/pdfs/descartes1649.pdf.

26 Augustine, *Confessions* 10.8.15, trans. Albert C. Outler, ed. Tom Gill (Gainesville, FL: Bridge-Logos, 2003). *Mirari* could be translated as "to wonder," "to marvel," "to be astonished," "to be amazed," or "to admire." John Stuart Mill would make a similar point in 1865 by quoting Dr. Michael Faraday: "Here it is we are born, bred, and live, and yet we view these things with an almost entire absence of wonder to ourselves respecting the way in which all this happens. So small, indeed, is our wonder that we are never taken by surprise; and I do think that, to a young person of ten, fifteen, or twenty years of age, perhaps the first sight of a cataract or a mountain would occasion him more surprise than he had ever felt concerning the means of his own existence." John Stuart Mill, *Examination of Sir William Hamilton's Philosophy and of the Principal Philosophical Questions Discussed in His Writings* (London, 1865), 546.

27 Daston and Park, *Wonders and the Order of Nature,* 39, and Hepburn, "Wonder" and Other *Essays,* 139. Jean Renoir, *Renoir, My Father,* trans. Randolph and Dorothy Weaver (Boston: Little, Brown, 1962), 129.

28 See catalogue number 37 in Andrew Robison and Klaus Albrecht Schröder, *Albrecht Dürer: Master Drawings, Watercolors and Prints from the Albertina,* exh. cat. (Washington, DC: National Gallery of Art and Delmonico Books/Prestel, 2013), 134–35. Albertina curator Christof Metzger refers to *The Great Piece of Turf* as "among the greatest masterpieces of draftsmanship in existence." See also Pamela H. Smith, *The Body of the Artisan: Art and Experience in the Scientific Revolution* (Chicago: University of Chicago Press, 2004), 60–61. For further context on the fervent window of activity that produced many of Dürer's nature studies, see Panofsky, *Life and Art of Albrecht Dürer,* 80–81.

29 Augustine, *De civitate Dei* (The City of God) 21.6, p. 976, cited in Daston and Park, *Wonders and the Order of Nature,* 41. Leaping centuries ahead, Hepburn cites Ludwig Wittgenstein along a similar vein: "Aesthetically, the miracle [das Wunder] is that the world exists. That what exists does exist." Hepburn, "Wonder" and Other *Essays,* 140.

30 Valerie I. J. Flint, *The Imaginative Landscape of Christopher Columbus* (Princeton, NJ: Princeton University Press, 1992), 15 and n25. She continues, "One must marvel at the right things and in the right way, certainly; but there was no doubt that the capacity to marvel was essential to a Christian."

31 Augustine, *De utilitate credendi,* 16.34, cited in Cunningham, *Woe or Wonder,* 76.

32 Thomas Aquinas, *Summa contra gentiles,* 3.101.2, vol. 3, pt. 2, p. 82, cited in Daston and Park, *Wonders and the Order of Nature,* 122.

See also Cunningham, *Woe or Wonder,* 76, where he notes similar remarks in Aquinas's *Summa theologica.*

33 Baxter Hathaway quoted in Platt, *Reason Diminished,* 12.

34 Cited in Platt, *Reason Diminished,* 15, which claims this to be the passage's first translation into English. Platt traces this unusual position to Longinus through Patrizi's mentor.

35 Platt, *Reason Diminished,* 12. Only two of the seven books of *Della poetica* were published in Patrizi's time; Paul Oscar Kristeller found the other five in Parma in 1949. Platt, *Reason Diminished,* 153. See Platt's entire chapter on *The Winter's Tale.*

36 William Shakespeare, *As You Like It,* act 5, scene 4, lines 125–29, in *The Norton Shakespeare: Based on the Oxford Edition,* ed. Stephen Greenblatt (New York: W. W. Norton, 1997), 1654.

The Shuffle of Things

Epigraph p. 49: Stated in the preface to story 72 in the third part of his *Novelle.* Quoted in Peter G. Platt, ed., *Wonders, Marvels, and Monsters in Early Modern Culture* (Newark: University of Delaware Press, 1999), 26. For context and a slightly different translation, see Matteo Bandello, "Dedicatory Letter," *Novellas,* pt. 3, story 62, in Janet Levarie Smarr, ed. and trans., *Italian Renaissance Tales* (Rochester, MI: Solaris Press, 1983), 229–30.

Fig. 7 annotation (Folio 82 from John Mandeville), p. 52: Malcolm Letts, trans. and ed., *Mandeville's Travels,* Hakluyt Society Publications, 2nd ser., no. 101–2 (London: Hakluyt, 1953), 1:135–36.

Fig. 8 annotation (Folio 88 from John Mandeville), p. 53: Letts, *Mandeville's Travels,* 138.

37 For more information on the economics and trade of wonders during the early modern period, see Pamela H. Smith and Paula Findlen, eds., *Merchants and Marvels: Commerce, Science, and Art in Early Modern Europe* (New York: Routledge, 2002); especially Mark A. Meadow, "Merchants and Marvels: Hans Jacob Fugger and the Origins of the *Wunderkammer,*" 182–200; and Paula Findlen, "Inventing Nature: Commerce, Art, and Science in the Early Modern Cabinet of Curiosities," 297–323.

38 Ezekiel 5:5 as cited in Flint, *Imaginative Landscape of Christopher Columbus,* 8.

39 Daston and Park, *Wonders and the Order of Nature,* 14, 25.

40 Quoted in ibid., 25.

41 Scholars now doubt that Mandeville, who recounts leaving England in 1332 to begin the epic journey, ever existed. The more accurate sections of the narrative were clearly lifted from other sources, and it is even unclear in which language the text was initially drafted, let alone which version is the original. Upward of three hundred manuscripts of the narrative survive. On the fabrication of the text and of Mandeville's personae, see Greenblatt, *Marvelous Possessions,* 30–34.

42 For the half-man, half-goat, see Letts, *Mandeville's Travels,* 33; for the lamb and geese, see ibid.,183; for an illustration of an exchange of barnacle geese for a Scythian Lamb inspired by *Mandeville's Travels,* see Daston and Park, *Wonders and the Order of Nature,* 37; for the snail shell, see Letts, *Mandeville's Travels,* 136.

43 It is interesting to note that Mandeville's descriptions of distant peoples are sometimes more empathetic than those of Christians.

44 Letts, *Mandeville's Travels,* 222.

45 Daston and Park, *Wonders and the Order of Nature,* 60.

46 Flint, *Imaginative Landscape of Christopher Columbus,* 172; Greenblatt, *Marvelous Possessions,* 26, 157 n2. See also Flint, *Imaginative Landscape of Christopher Columbus,* 100: "It is virtually certain that the *Book* [*Mandeville's Travels*] had a place in the great admiral's thoughts and plans." Flint's research on Columbus's "known reading" (pp. 42–77) is incomparable.

47 Greenblatt, *Marvelous Possessions,* 26.

48 Flint, *Imaginative Landscape of Christopher Columbus,* 47.

49 Historian Anthony Grafton identifies an undeniable shift in the weight accorded to ancient sources following the increase in European exploration. His most memorable example comes from Jesuit José de Acosta who, having entered the so-called Torrid Zone (near the Equator), was astonished at how different the climate was from its description: "What could I do but laugh at Aristotle's *Meteorology* and his philosophy? For in that place and season, where everything, by his rules, should have been scorched from the heat, I and my companions were cold." Quoted in Anthony Grafton, *New Worlds, Ancient Texts: The Power of Tradition and the Shock of Discovery* (Cambridge, MA: Belknap Press of Harvard University Press, 1992), 1.

50 James V. Mirollo, "The Aesthetics of the Marvelous: The Wondrous Work of Art in a Wondrous World," in Kenseth, *Age of the Marvelous,* 63; Grafton, *New Worlds, Ancient Texts,* 75.

51 Greenblatt, *Marvelous Possessions,* 22. See also Lentz's reference to the West's interest in Asian art as a "radical reaction to difference," "In Flux," 102.

52 Mark A. Meadow and Bruce Robertson, trans. and eds., *The First Treatise on Museums: Samuel Quiccheberg's Inscriptiones, 1565* (Los Angeles: Getty Research Institute, 2013), 91. Regarding the collection of objects from the margins, Quiccheberg states (p. 75), "Patricians will need to have clever men to send to various regions in order to seek out marvelous things. And, in contrast, those of moderate prosperity who are deeply interested in repositories of this kind will come to know which objects they can exchange with friends; once these objects have been sent to other places, they might be able to entice others to send back diverse objects in return."

53 Francis Bacon, *Gesta Grayorum,* 1688–this is the first date of publication, although the text refers to a discussion occurring in 1594 and apparently circulated in manuscript form starting around that time. See full text at http://fly.hiwaay.net/~paul/bacon/devices/gesta.html. "Contact with the marvelous," as described by Bacon, was only one of many goals driving the formation of early collections and museums. Control of valued objects could serve any number of purposes, including the bolstering of religious, civil, or political authority. For a thorough example, see Thomas DaCosta Kaufmann, *The School of Prague: Painting at the Court of Rudolf II* (Chicago: University of Chicago Press, 1988).

54 Quoted in Purcell and Gould, *Finders, Keepers,* 31. See also Kenseth, *Age of the Marvelous,* 97.

55 Giuseppe Olmi, "Science-Honour-Metaphor: Italian Cabinets of the Sixteenth and Seventeenth Centuries," in Oliver Impey and Arthur MacGregor, eds., *The Origins of Museums: The Cabinets of Curiosities in Sixteenth- and Seventeenth-Century Europe* (Oxford: Clarendon Press, 1985), 14.

56 Daniela Bleichmar, "Seeing the World in a Room: Looking at Exotica in Early Modern Collections," in Daniela Bleichmar and Peter C. Mancall, eds., *Collecting Across Cultures: Material Exchanges in the Early Modern Atlantic World* (Philadelphia: University of Pennsylvania Press, 2011), 17–19.

57 See above, note 20.

58 Bleichmar, "Seeing the World in a Room," 30.

59 Giuseppe Olmi interprets the guide as pointing to a pelican in the act of opening its breast with its beak to resuscitate its young with its blood, an allusion to Christ's blood from the *Physiologus,* which suggests a specific moral theme of redemption within Imperato's installation. See Impey and MacGregor, *Origins of Museums,* 10. Imperato, however, does not describe the scene with this meaning. I would argue that the guide's gesture is generally in the direction of the collection, not specifically to the pelican or such a parable.

60 Bleichmar, "Seeing the World in a Room," 26. Bleichmar's point is made abundantly clear in examining the frontispiece to *Musaeum celeberrimum . . .* of 1678 [see illus. to right], which depicts Jesuit scholar and polymath Athanasius Kircher in his museum at the Collegio Romano. In it Kircher greets two gentlemen visitors to his famed collection, which appears to tower over them. As Joscelyn Godwin observes, however, the men are rendered so diminutive by comparison to the space, they could hardly reach the second shelf on the wall and could easily shelter under a table near the window. A photograph taken of the galleries before the museum's dissolution shows them to be considerably more modest than this oft-cited portrayal. See Joscelyn Godwin, *Athanasius Kircher's Theatre of the World: The Life and Work of the Last Man to Search for Universal Knowledge* (Rochester, VT: Inner Traditions, 2009), 45-46.

61 See Paula Findlen, *Possessing Nature: Museums, Collecting, and Scientific Culture in Early Modern Italy* (Berkeley: University of California Press, 1994), 119. Findlen points out that, while Biavati can hold a single object, Cospi gestures toward the entire collection, as if to underscore his mastery and possession of the world.

62 Bleichmar, "Seeing the World in a Room," 27.

63 Daston and Park, *Wonders and the Order of Nature*.

64 Quoted in Mirollo, "Aesthetics of the Marvelous," 74. Originally from Anthony Ashley Cooper's "Notion of the Historical Draught or Tablature of the Judgment of Hercules, According to Prodicus," in Elizabeth Gilmore Holt, ed., *A Documentary History of Art,* vol. 2, *Michelangelo and the Mannerists, The Baroque and the Eighteenth Century* (Princeton, NJ: Princeton University Press, 1982), 259.

65 Margaret T. Hodgen, *Early Anthropology in the Sixteenth and Seventeenth Centuries* (Philadelphia: University of Pennsylvania Press, 1964), 115. The quote is from Thomas Shadwell's *Virtuoso* and is the description of Sir Nicholas Gimcrack, F.R.S., by his unimpressed niece. The play was first performed in 1676, a year before Ferdinando Cospi published his collection.

Mr. Corcoran's Museum

Epigraph p. 71: "Have We a Louvre among Us?" *Philadelphia Bulletin*, May 17, 1869, cited in Sarah Cash, ed., *Corcoran Gallery of Art: American Paintings to 1945* (Washington, DC: Corcoran Gallery of Art, 2011), esp. 41 n84.

66 The book in question is Richard Pulteney, *A General View of the Writings of Linnæus* (London, 1781). Both quotes by Charles Willson Peale are from David R. Brigham, *Public Culture*

First frontispiece of *Musaeum celeberrimum . . .* (Amsterdam, 1678), a compilation of writings by Athanasius Kircher (1602–1680). Folger Shakespeare Library, Washington, DC. Shelfmark: AM101.K584 1674 Cage (see note 60)

in the Early Republic: Peale's Museum and Its Audience (Washington, DC: Smithsonian Institution Press, 1995), 36.

67 Clergyman Manasseh Cutler's description from 1787 quoted in Brigham, *Public Culture in the Early Republic,* 58.

68 Illustrated in ibid., 37.

69 In 1853, W. S. W. Ruschenberger, who would later rise to be president of Philadelphia's Academy of Sciences, would describe the contents of Peale's museum as "vulgar and ephemeral curiosity which manifests itself in a desire to see what is not commonly held in nature, or art," echoing eighteenth-century criticisms of early modern collections in Europe. Quoted in Carla Yanni, *Nature's Museums: Victorian Science and the Architecture of Display* (Baltimore: Johns Hopkins University Press, 1999), 29.

Charles Willson Peale (American, 1741–1827) and Titian Ramsay Peale (American, 1799–1885), *The Long Room, Interior of Front Room in Peale's Museum*, 1822, watercolor over graphite pencil on paper, 14 x 20 ¾ in. Detroit Institute of Arts, Michigan; USA Founders Society Purchase, Director's Discretionary Fund (see note 71)

70 Bleichmar, "Seeing the World in a Room," 27.

71 For Albertus, see above, note 22. Wonder's role as subject in Peale's painting is made clearer when the work is compared to another rendering of the space: a watercolor by Peale and his son Titian Ramsay also from 1822 [see illus. above]. The view in the self-portrait looks down the Long Room from a point near the entrance that includes the mastodon. In the jointly painted watercolor, the point of view excludes that touchstone of wonder or human subjects and a cloud of titillation is lifted from the musuem, which in the watercolor appears more conducive to quiet study than excitement.

72 Deborah Logan to Albanus Logan, January 10, 1802, Robert R. Logan Collection, Historical Society of Pennsylvania, Philadelphia, quoted in Brigham, *Public Culture in the Early Republic*, 65. Art historian Claire Perry calls out the condescension in Peale's depiction of the Quaker woman but also notes his relatively progressive attitude toward women, labeling it a "polite version of rougher treatment elsewhere." Claire Perry, *The Great American Hall of Wonders* (Washington, DC: Smithsonian American Art Museum and D Giles, 2012), 14. See also Perry's analysis of *The Artist in His Museum*, 1–9.

73 P. T. Barnum, *Struggles and Triumphs; or, Forty Years' Recollections* (Buffalo, NY: Warren, Johnson, 1873), 125.

74 The development of public art museums lagged behind their historical and anthropological counterparts in the United States. It was not until the 1870s that specialty art museums began to be established. Newspaper editor and early art critic J. Jackson Jarves declared in 1870, "Providence, however, matures its best gifts slowest, keeping the richest treasure in hidden store until man is ready to give it welcome. So it is happening with art in America" (J. Jackson Jarves, "Museums of Art: Artists and Amateurs in America," *Galaxy* [July 1870]: 56). When the Corcoran Gallery was incorporated on May 19, 1869, ten years had passed since construction of the new gallery's building had begun. If not for the interruption of the Civil War, during which the building served as the quartermaster general's office, the Corcoran Gallery would have opened to the public well before January 19, 1874. The year 1874 qualifies the Corcoran as the second of what are often called the "triplets" of the early art museums, the other two being the Metropolitan Museum of Art (1872) and the Boston Museum of Fine Arts (1876). While the Corcoran Gallery may have been the second of the three to open, it was the first one to do so in a building constructed as a museum (from 1859 to 1861). The Met opened to the public in the Dodworth Building on 5th Avenue, which had previously been a private residence and dance academy. Likewise, decades earlier, upon opening in 1844, the Wadsworth Athenaeum Museum of Art, the oldest continually operating art museum in the United States, had shared its building with the Connecticut Historical Society, the Young Men's Institute (a precursor to the Hartford Public Library), and the Natural History Society. Indeed, contemporaries, like Jarves, praised "Mr. Corcoran of Washington" as the "first amateur to erect a beautiful building, endow it with a fund and make it over to the national Capital for purposes of art" (Jarves, "Museums of Art," 56–57). For an in-depth investigation of early museums in the United States, see Joel J. Orosz, *Curators and Culture:*

The Museum Movement in America, 1740-1870 (Tuscaloosa: University of Alabama Press, 1990), Laurence Vail Coleman, *The Museum in America: A Critical Study* (Washington, DC: American Association of Museums, 1939), and Steven Conn, *Museums and American Intellectual Life, 1876-1926* (Chicago: University of Chicago Press, 1998).

75 Abigail Adams to her sister, Mary Cranch, dated November 21, 1800, in Stewart Mitchell, ed., *New Letters of Abigail Adams, 1788-1801* (Boston: Houghton Mifflin, 1947), 257.

76 Late in life, William Corcoran published a volume of personal papers in which he noted that his father, Thomas Corcoran, met with Washington at Bladensburg in 1791 when the latter was piecing together land for the new federal city. Washington apparently "had great difficulty in reconciling the different interests and jealousies of the proprietors." W[illiam] W. Corcoran, *A Grandfather's Legacy: Containing a Sketch of His Life and Obituary Notices of Some Members of His Family, Together with Letters from His Friends* (Washington, DC, 1879), 4.

77 William Seale, *The President's House: A History,* 2nd ed. (Baltimore: Johns Hopkins University Press, 2008), 79-81. For extensive background on L'Enfant's plans for Washington and on situating and constructing the White House, see Seale, *President's House,* 1-81.

78 A. Adams to Cranch (see above, n. 75), 256-57.

79 Today, fittingly, a Bank of America branch is on the site, the northwest corner of 15th Street and Pennsylvania Avenue, NW. For a more complete history of Corcoran's career and the founding of his museum, see Charles J. Robertson, *American Louvre: A History of the Renwick Gallery Building* (Washington, DC: Smithsonian American Art Museum in association with D Giles, 2015); Sarah Cash, "'Encouraging American Genius': Collecting American Art at the Corcoran Gallery of Art," in Cash, ed., *Corcoran Gallery of Art,* 15-43; Holly Tank, "Dedicated to Art: William Corcoran and the Founding of His Gallery," *Washington History* 17, no. 1 (Fall/Winter 2005): 26-51; Holly Tank, "William Wilson Corcoran: Washington Philanthropist," *Washington History* 17, no. 1 (Fall/Winter 2005): 52-65; and Alan Wallach, "On the Problem of Forming a National Art Collection in the United States: William Wilson Corcoran's Failed National Gallery," *Studies in the History of Art* 47, Symposium Papers 27: The Formation of National Collections of Art and Archaeology (1996): 112-25.

80 The house was demolished in 1922.

81 *A Grandfather's Legacy,* for example, reveals Corcoran's decades-long friendship with President Millard Fillmore. They planned trips to Europe together and dutifully checked on each other's families at frequent intervals. Among the most uncomfortable and yet endearing passages I have read in any context is Fillmore's letter acknowledging Corcoran's vote against him in the 1856 election: "Certainly no apology was necessary for supporting Mr. Buchanan in preference to myself. Private friendship or personal hate should never control a man's conduct in a matter of so much importance as the election of President of the United States. He should look solely to the welfare of his country, and, regardless of all personal considerations or private friendships, act accordingly. I doubt not *you* did, and I have no cause for complaint." Corcoran, *Grandfather's Legacy,* 152.

82 See Robertson, *American Louvre,* 21; Cash, "'Encouraging American Genius,'" 17-19.

83 Cash, "'Encouraging American Genius,'" 19.

84 Powers's original *Greek Slave* is in the collections of Raby Castle, Staindrop Darlington, England. The other authorized copies are in the collections of the Newark Museum, the Brooklyn Museum, the Yale University Art Gallery, and the National Gallery of Art (Washington, DC). One copy remains unaccounted for. For more information on the *Greek Slave,* see Linda Hyman, "*The Greek Slave* by Hiram Powers: High Art as Popular Culture," *Art Journal* 35, no. 3 (1976): 216-23; Lauren Lessing, "Ties That Bind: Hiram Powers's *Greek Slave* and Nineteenth-Century Marriage," *American Art* 24, no. 1 (March 1, 2010): 40-65; Donald M Reynolds, "The 'Unveiled Soul': Hiram Powers's Embodiment of the Ideal," *Art Bulletin* 59, no. 3 (September 1977): 394; Richard P. Wunder, *Hiram Powers: Vermont Sculptor* (Traftsville, VT: Countryman Press, 1991); and Martina Droth, Jason Edwards, and Michael Hatt, eds., *Sculpture Victorious: Art in an Age of Invention, 1837-1901* (New Haven, CT: Yale Center for British Art, 2014), 306-27.

85 Charles Lanman, *Catalogue of W. W. Corcoran's Gallery* (Washington, 1857), cited in Cash, "Encouraging American Genius," 19.

86 Sarah Booth Conroy refers to Corcoran and Renwick as "spiritual captives of the Second Empire." "The Restoration of James Renwick," *Washington Post,* January 30, 1972.

87 Tank, "Dedicated to Art," 34.

88 Carole Paul, "Capitoline Museum, Rome: Civic Identity and Personal Cultivation," in Carole Paul, ed., *The First Modern Museums of Art: The Birth of an Institution in 18th- and Early-19th-Century Europe* (Los Angeles: J. Paul Getty Museum, 2012), 21.

89 William Wilson Corcoran to the Board of Trustees of the Corcoran Gallery of Art, May 10, 1869, in William J. Rhees, ed., *The Smithsonian Institution: Journals of the Board of Regents, Reports of Committees, Statistics, Etc.* [1846-76], Smithsonian Miscellaneous Collections 18, no. 329 (Washington, DC, 1879), 402, cited in Corcoran, *Grandfather's Legacy,* 32-33.

90 Alan Wallach convincingly argues that the statement by the Washington Art Association is a worthy stand in for the voice of Corcoran, who rarely put his thoughts on paper. Wallach, "Problem of Forming a National Art Collection," 117. The quote is from Mary J. Windle, *Life in Washington, and Life Here and There* (Philadelphia, 1859), 147.

91 Ralph Waldo Emerson, "The American Scholar," in *Essays by Ralph Waldo Emerson,* Merrill's English Texts (New York: C. E. Merrill, 1907).

92 Tank, "Dedicated to Art," 37.

93 Wallach, "Problem of Forming a National Art Collection," 120. See also Cash, "'Encouraging American Genius," 25.

94 The collection also included a handful of original Japanese and Chinese works, among them lacquerware, musical instruments, a cloisonné table, and later, vases produced for the Centennial International Exhibition of 1876 in Philadelphia.

95 The act of casting famous works of art for dissemination to other institutions was hugely popular in the nineteenth century but fell precipitously in the first years of the twentieth. Ironically, the only major museum that still displays its collection of casts is the Victoria & Albert in London. Copies of European paintings were sought after, too. Consider this argument from a review of the opening of Corcoran's Gallery: "We would suggest that instead of following the pernicious example of some of our older galleries, in attempting to secure originals of the great masters of Italian, Spanish, and Dutch schools, even in a state of mutilation, they seek to obtain good copies executed by skillful modern hands, as being far more serviceable than such irremediably faded originals as would be likely to reach our shores. A Correggio, a Titian, a Rubens, or a Murillo of any intrinsic value can be rarely obtained, while copies of surpassing excellence are within the reach of almost every public institution for the cultivations of Art." "Art at the National Capital," *International Review* (May-June 1874), published in book form (New York, 1874), 330.

96 For a full list of works on view in the Gallery, see William MacLeod, *Catalogue of the Corcoran Gallery of Art* (Washington, DC, multiple editions from 1874). See also Wallach, "Problem of Forming a National Art Collection," 120; Tank, "Dedicated to Art," 40; and contemporary descriptions in *International Review,* ibid.; "Art in

Washington: The Corcoran Gallery. The Collection of Paintings and Art Works–History and Purposes of the Institution–Description of the Building," *New York Times,* January 20, 1874; and A. E. Wiswall, "The Corcoran Gallery of Art," *Aldine* 7, no. 6 (June 1874): 120.

97 Tank, citing a magazine titled *Old Dominion,* "Dedicated to Art," 41.

98 Ibid., 43. The description is from the minutes of a board meeting in 1884.

99 Quoted in Sarah Booth Conroy, "Restoration of James Renwick: Let Us Now, after a Decent Period of Time, Praise 19th-Century Architecture," *Washington Post,* January 30, 1972.

100 Like Daston and Park, James Mirollo points out that we should never oversimplify the waning of wonder's influence from the eighteenth century onward: "The Sublime is in its way a resurfacing of the notion of a wondrous world." Mirollo, "Aesthetics of the Marvelous," 75.

101 Quoted in *Washington Daily Chronicle,* May 19, 1869, as cited in Corcoran, *Grandfather's Legacy,* 536.

102 "Art in Washington" (see above, n. 96).

103 *Washington Daily Chronicle,* May 19, 1869, as cited in Corcoran, *Grandfather's Legacy,* 535.

The Exhibition

Epigraph p. 93: Unless otherwise noted, this and all other quotes by Leo Villareal are from conversation with the author, October 4, 2014.

104 Barbara Maria Stafford, "Presuming Images and Consuming Words: The Visualization of Knowledge from the Enlightenment to Postmodernism," in John Brewer and Roy Porter, eds., *Consumption and the World of Goods* (London: Routledge, 1993), 466.

105 Douglas Coupland, "On Craft," in Nicholas R. Bell et al., *40 under 40: Craft Futures,* exh. cat. (Washington, DC: Smithsonian American Art Museum, 2012), 9.

106 Noguchi was referring to the rise of Dada and pop art following the reign of abstract expressionism. Masayo Duus, *The Life of Isamu Noguchi: Journey without Borders,* trans. Peter Duus (Princeton, NJ: Princeton University Press, 2004), 285.

107 Coupland, "On Craft," 8.

108 Quoted in Jutta Mattern, Mette Marcus, and Jeanne Rank Schelde, eds., *Tara Donovan,* exh. cat. (Humlebaek, Denmark: Louisiana Museum of Modern Art, 2013), 15.

109 See Daniel Miller, *Material Culture and Mass Consumption* (Oxford: Basil Blackwell, 1987), 101-2; Daniel Miller, ed., *Materiality* (Durham, NC: Duke University Press, 2005), 5; Daniel Miller, *Stuff* (Cambridge: Polity, 2010), 53.

110 Mill, *Sir William Hamilton's Philosophy* (see above, n. 26), 545.

111 Emerson, "American Scholar."

112 Baume, Mergel, and Weschler, *Tara Donovan* (see above, n. 8), 8.

113 The installation was titled *Insecta Fantasia: A Centennial Commission by Jennifer Angus* and on view in the Ballantine House at the Newark Museum, New Jersey, November 5, 2008– June 14, 2009.

114 Unless otherwise noted, this and all other quotes by Jennifer Angus are from conversation with the author, October 15, 2014.

115 For more on the history of cochineal's use as a pigment and commodity, see Amy Butler Greenfield, *A Perfect Red: Empire, Espionage, and the Quest for the Color of Desire* (New York: Harper Perennial, 2005).

116 In this sense, do Grade's trees support or reject Susan Stewart's proposition that the display of objects "marks the defeat of time, the triumph over the particularity of contexts in which the collected objects first appeared"? See Susan Stewart, *The Open Studio: Essays on Art and Aesthetics* (Chicago: University of Chicago Press, 2005), 185, which is, coincidentally, an essay on the works of Charles Willson Peale.

117 Waves were recorded as reaching a height up to 133 feet in Miyako. Koichiro Ishida, "Tsunami Reached 10 Stories High in Iwate Prefecture," *Asahi Shimbun,* June 3, 2011, http://ajw.asahi.com/article/0311disaster/quake_tsunami/AJ201106030393.

118 At time of publication, Echelman's largest sculpture was *Skies Painted with Unnumbered Sparks,* 2014, which spanned 745 feet along Vancouver's waterfront.

119 Unless otherwise noted, this and all other quotes by Janet Echelman are from conversation with the author, April 8, 2015.

120 Gabriel Dawe, *The Density of Light* (Brussels: Galerie Lot 10, 2012); Dawe, in conversation with the author, October 15, 2014.

121 The marbles are manufactured by Johns Manville for various end-use applications, including HVAC filtration, healthcare products, battery separators, and aircraft insulation. The company generously donated the marbles for Maya Lin's installation at the Renwick Gallery.

You Are Here

Epigraph p. 117: The original phrase, "Nous sommes dans l'irréalité, dans le rêve," originates from a series of letters Weil penned from January 19 to May 26, 1942. The first English publication is Simone Weil, *Waiting for God,* trans. Emma Craufurd (New York: Putnam, 1951), 159.

122 Ibid., 168.

123 Charles Olson, *Proprioception* (San Francisco: City Lights Books, 1965), 1.

124 Bleichmar, "Seeing the World in a Room," 27. See also Stafford, "Presuming Images," 34: "Unlike the false coherence implied by the linear sequences found in annals or narratives, the assemblage and montage of curiosities resembled a mosaic whose *tesserae* were simultaneously accessible to sight. Artificial and natural, pagan and Christian, ordinary and exotic artifacts provoked an immediate awareness of the miscellaneous and chance act of finding itself. These elaborate three-dimensional collages demonstrated how we learn painstakingly by gathering and arranging bits and pieces in the dark. There is always more evidence. . . . Instead of concealing the absence of connections, the dynamic layout summoned the observer to fill in the gaps."

125 Kenneth Clark, "The Ideal Museum," *ARTnews* 52, no. 9 (January 1954): 29. See also Carol Duncan, "The Art Museum as Ritual," *Civilizing Rituals: Inside Public Art Museums* (London: Routledge, 1995), 13.

126 Weil, *Waiting for God,* 158-59.

127 Ibid., 159-60.

128 Elaine Scarry, *On Beauty and Being Just* (Princeton, NJ: Princeton University Press, 1999), 111; James Cuno, "The Object of Art Museums," in James Cuno, ed., *Whose Muse? Art Museums and the Public Trust* (Princeton, NJ: Princeton University Press, 2004), 51.

Plates

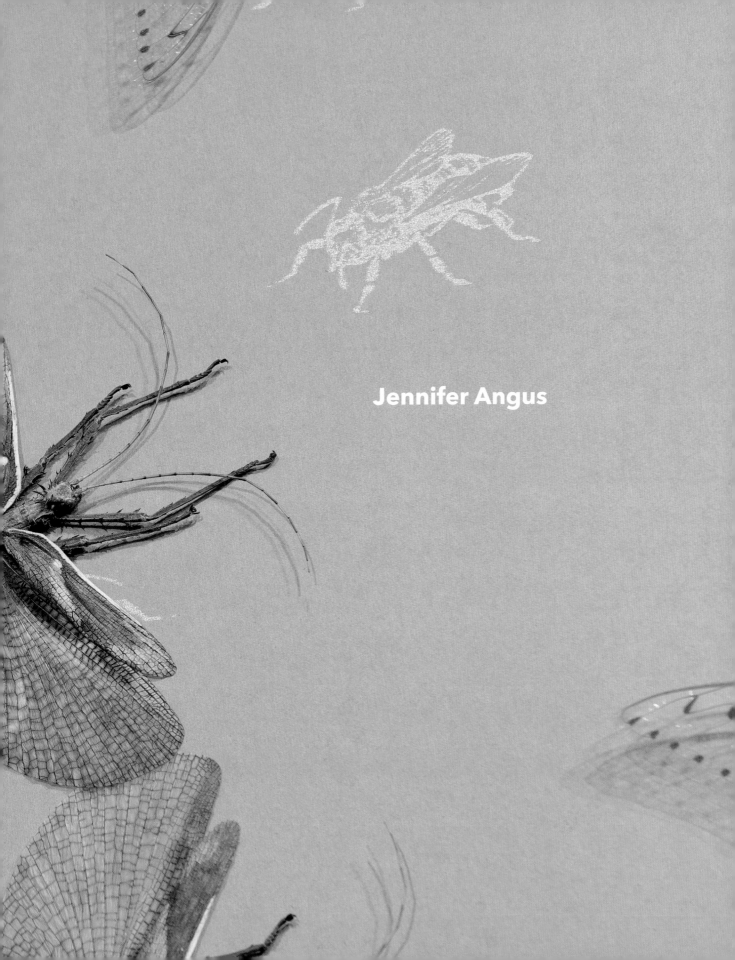

Jennifer Angus

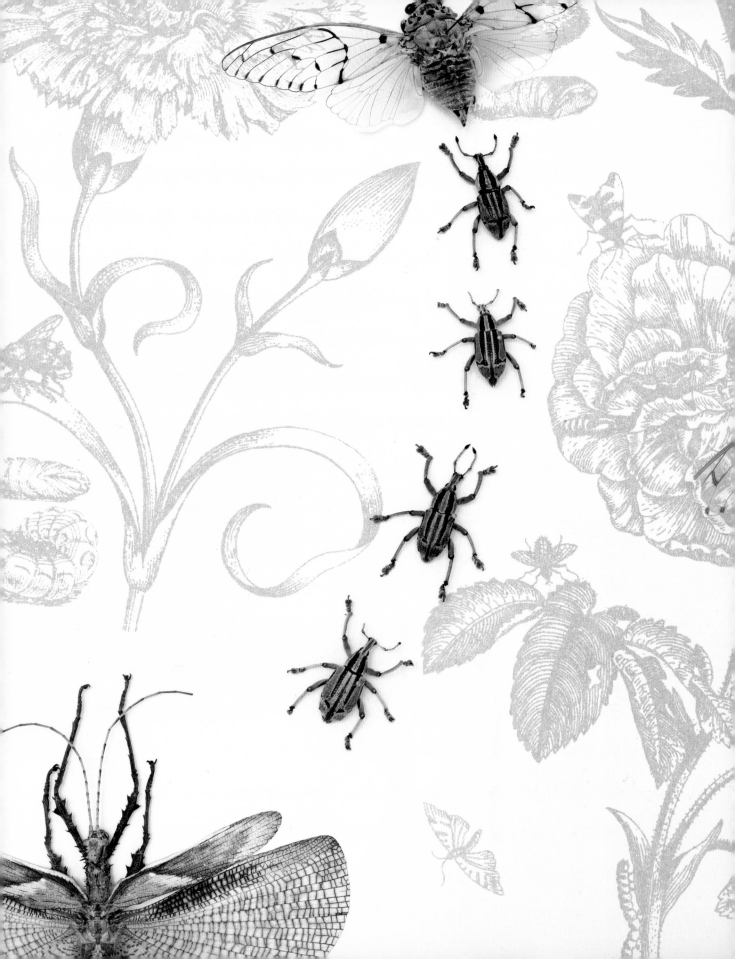

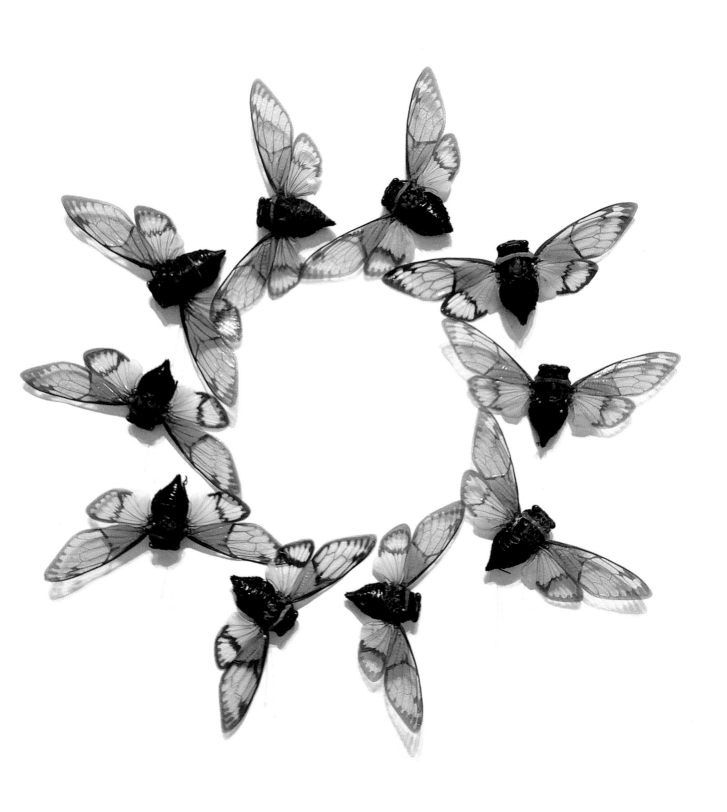

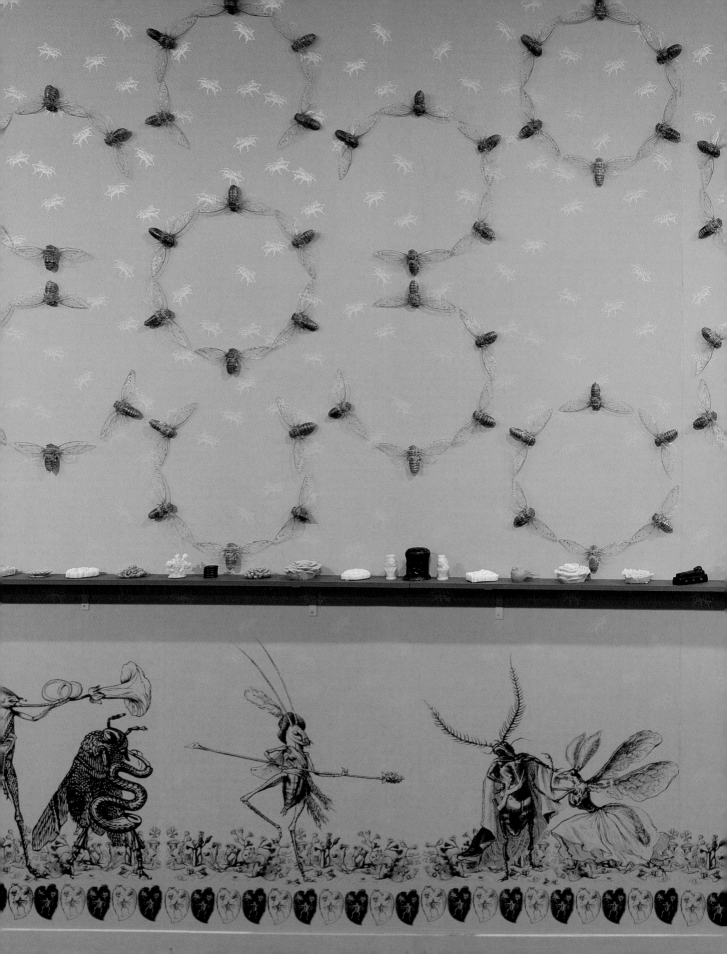

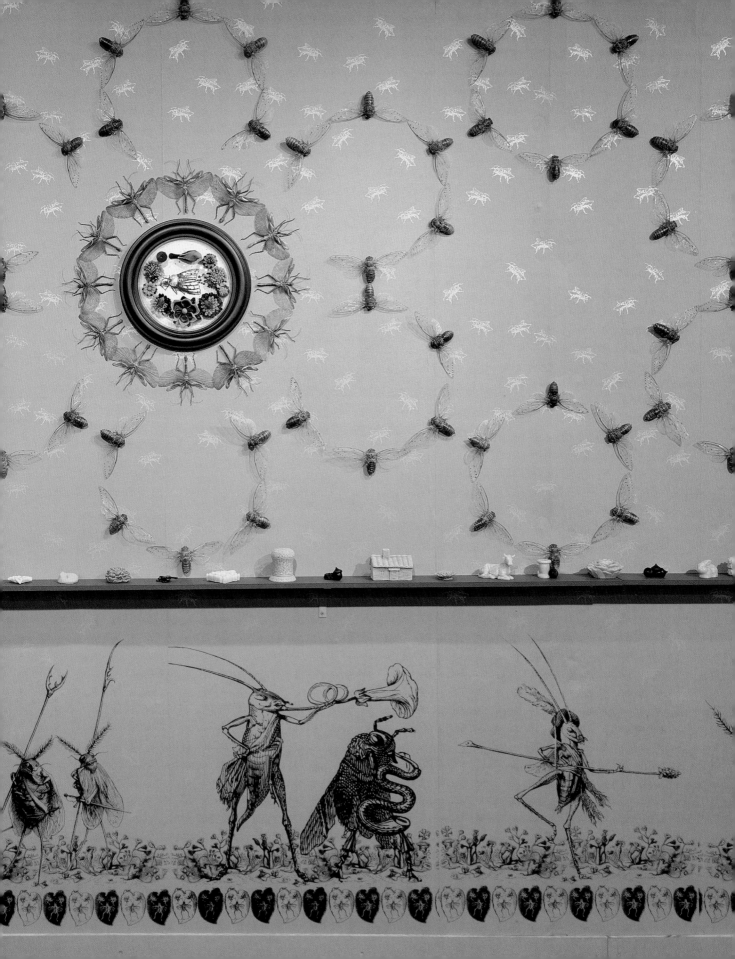

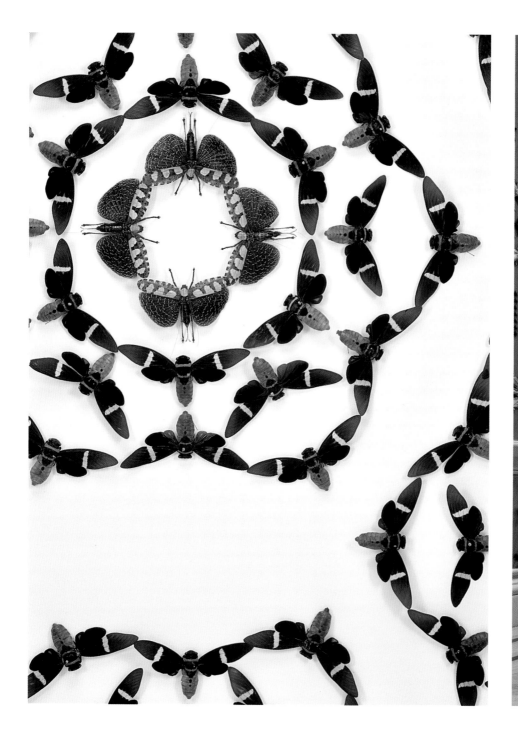

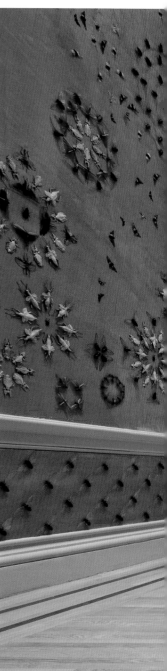

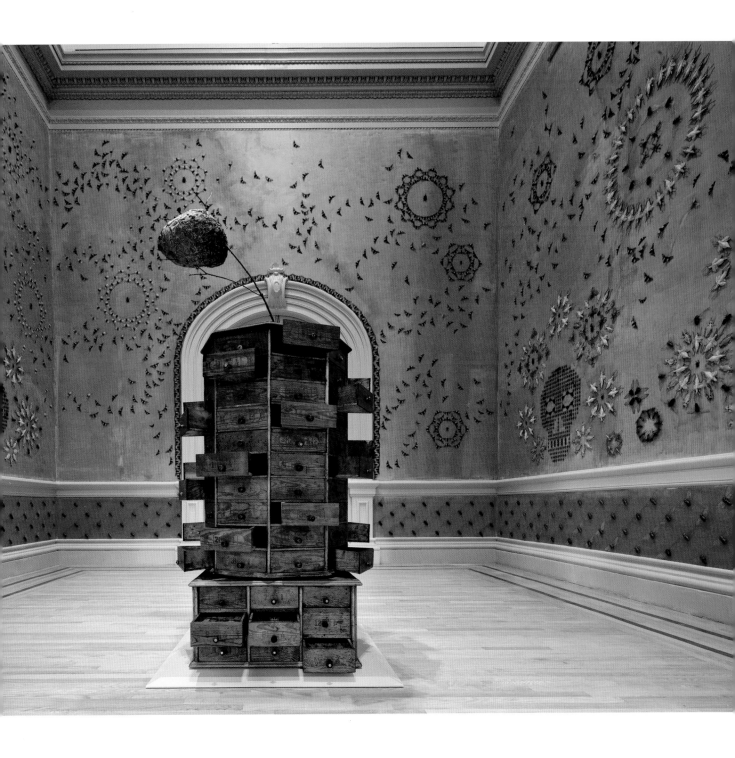

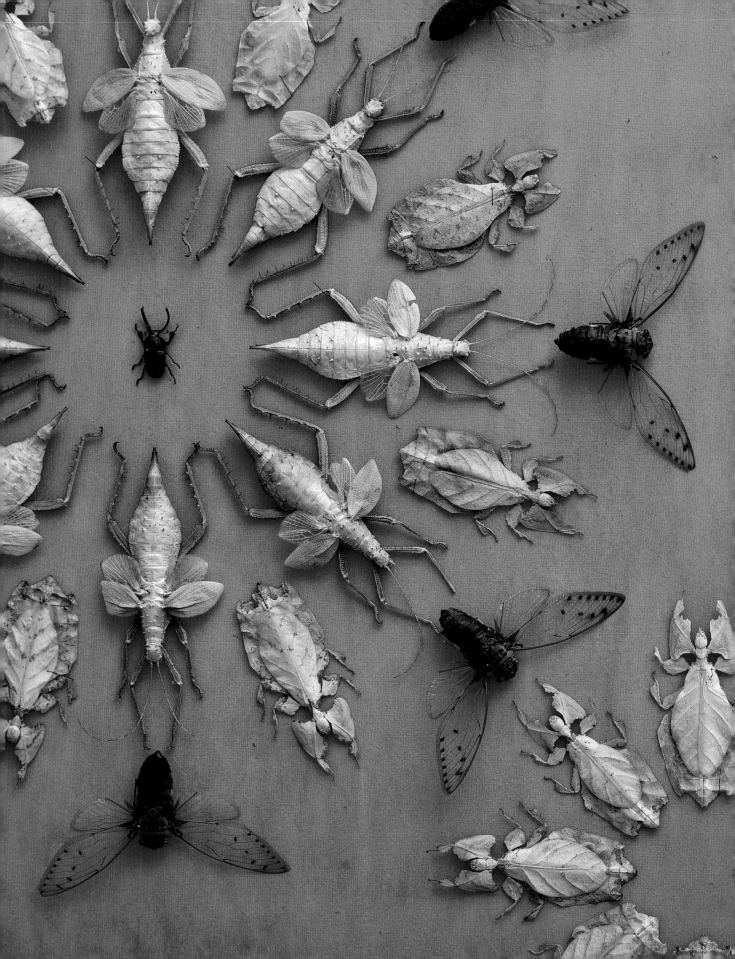

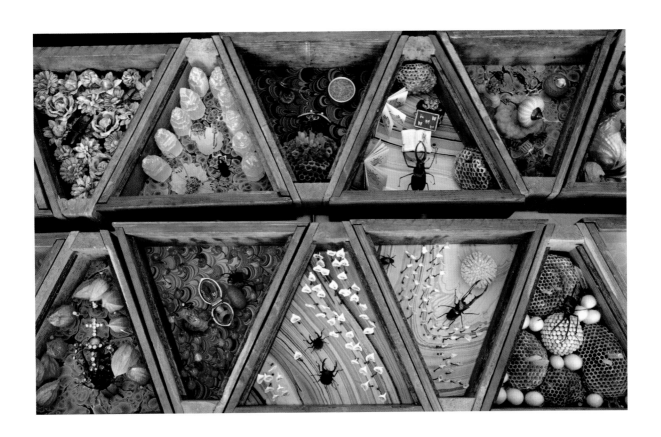

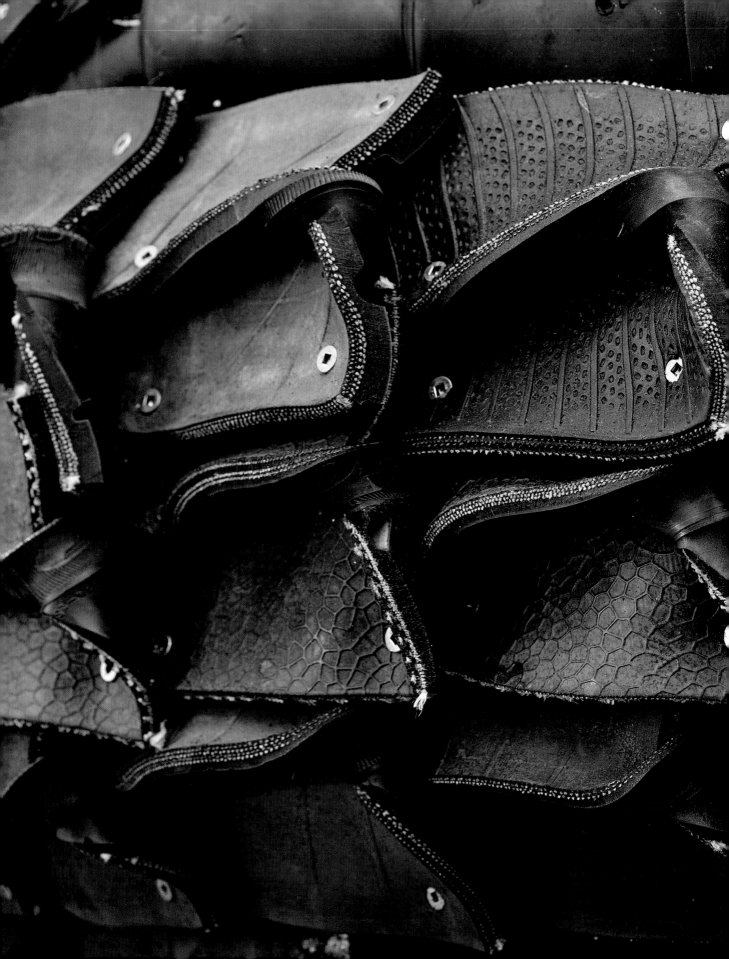

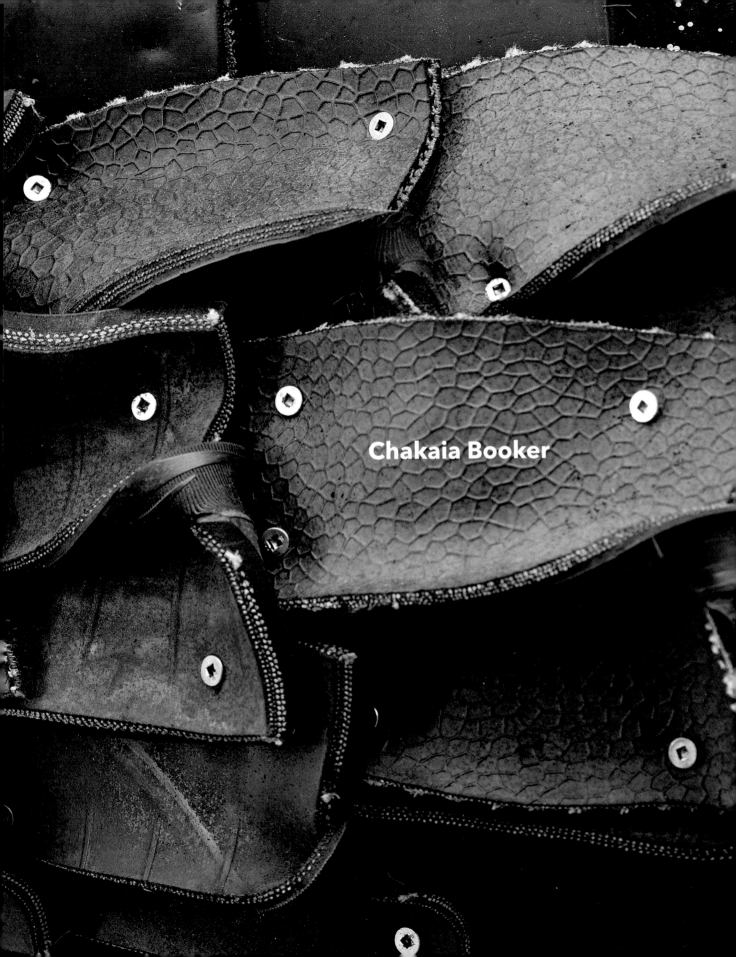

Chakaia Booker

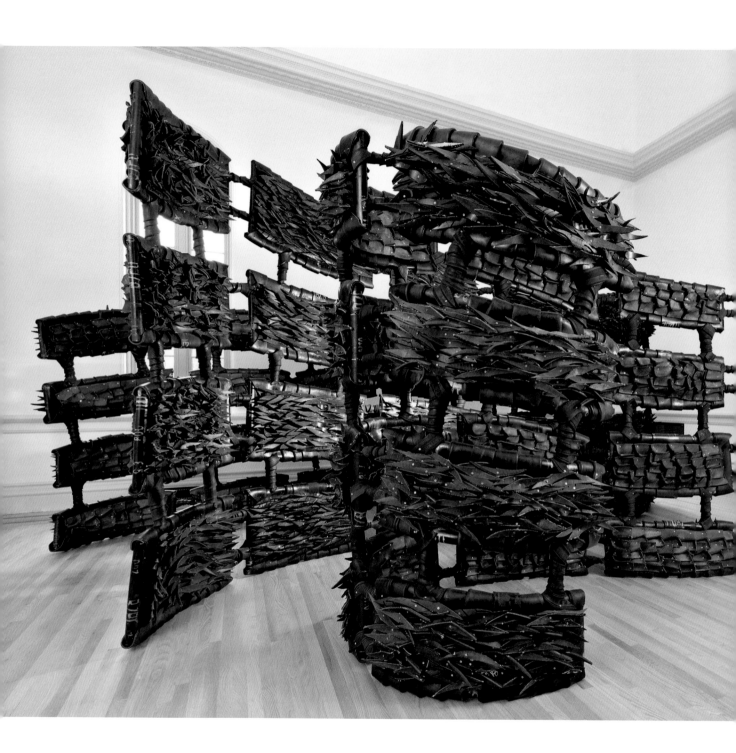

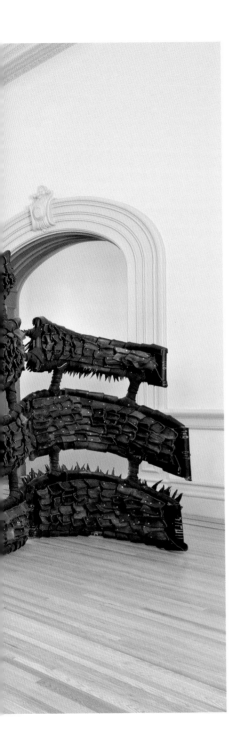

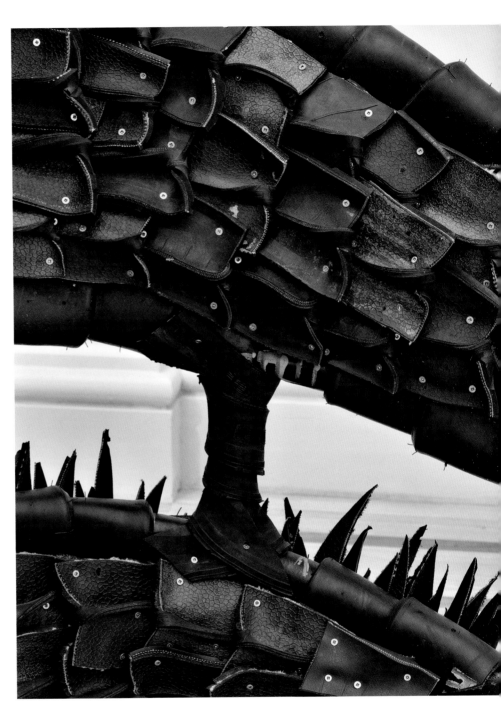

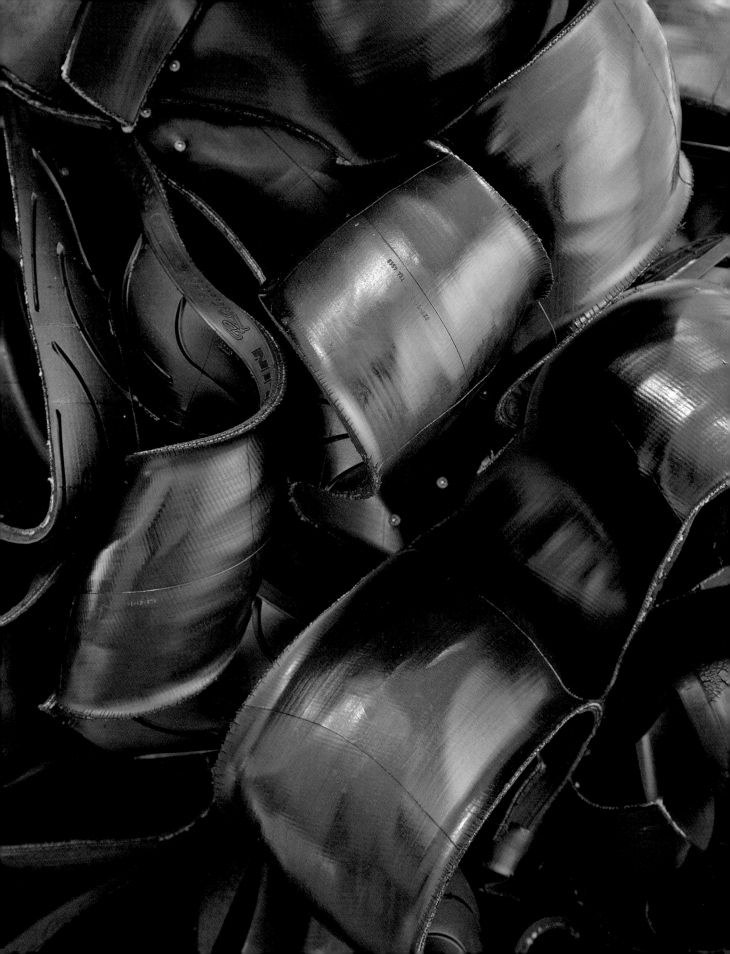

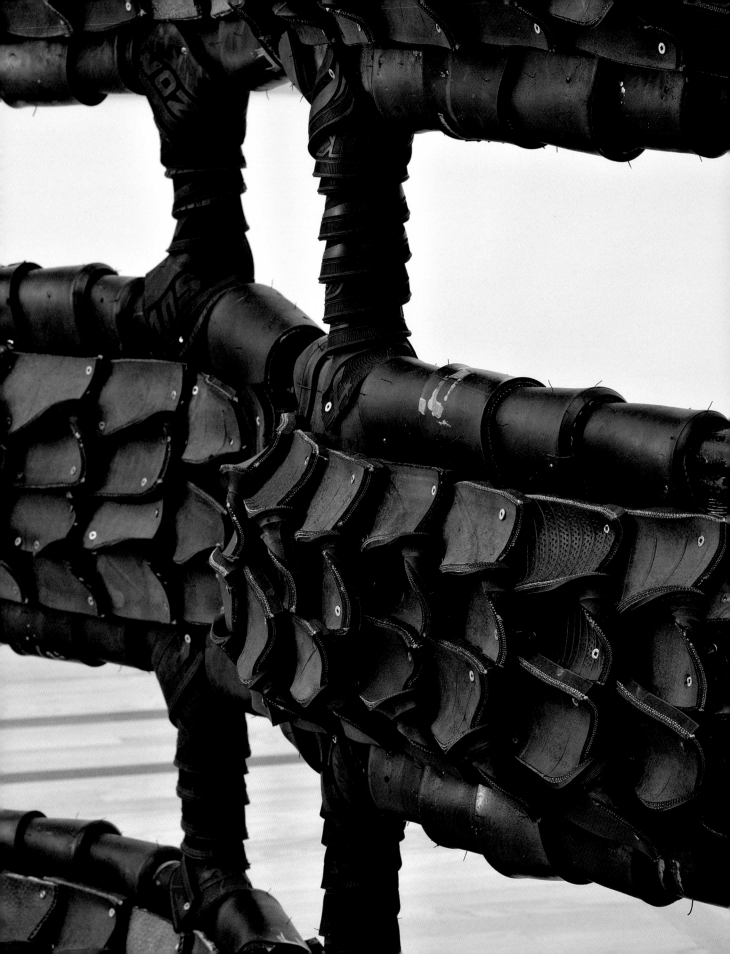

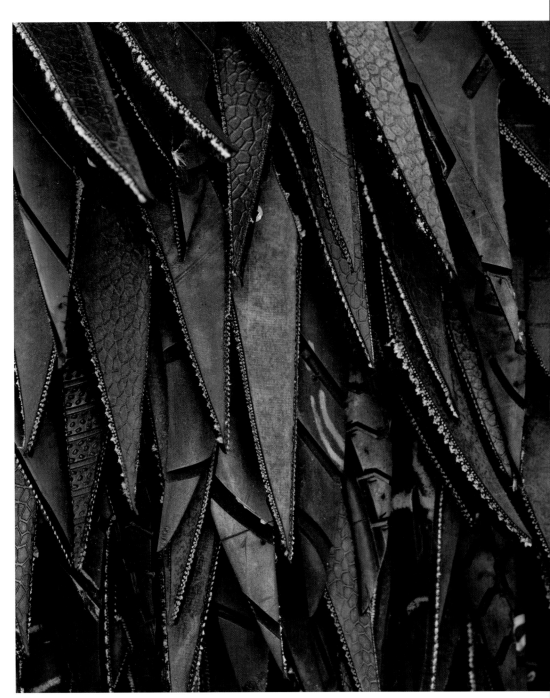

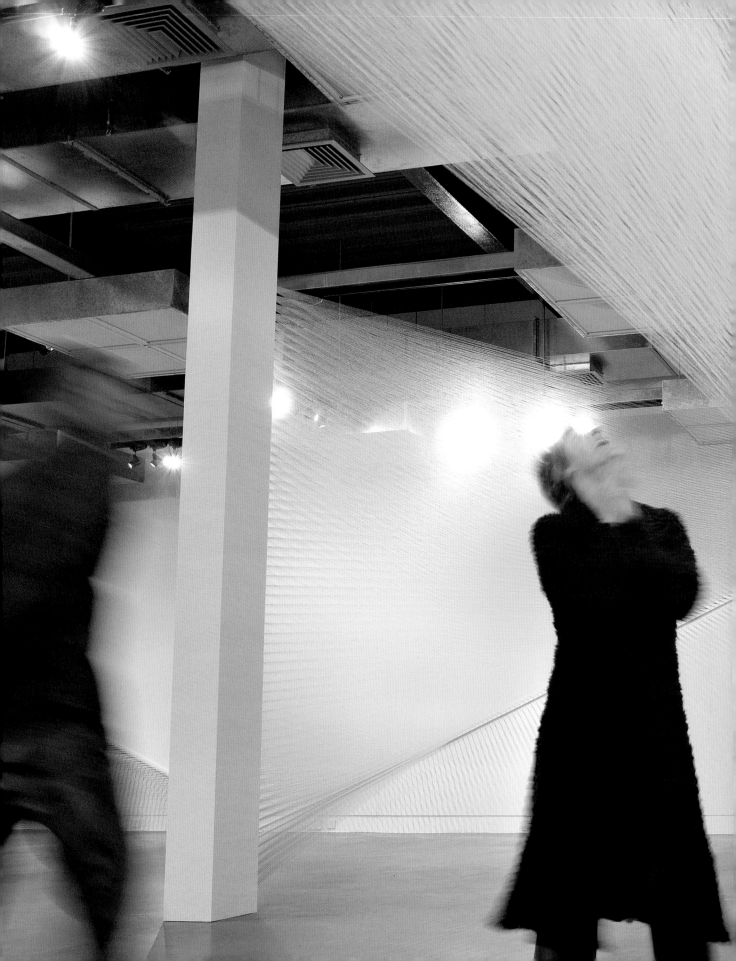

Gabriel Dawe

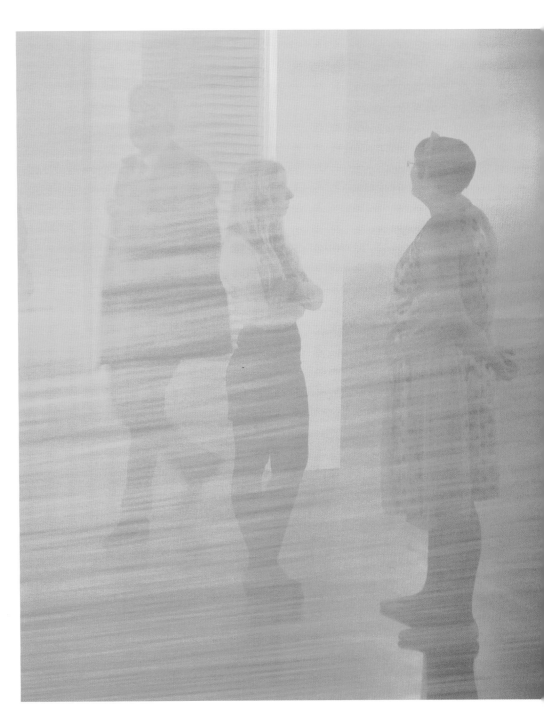

154

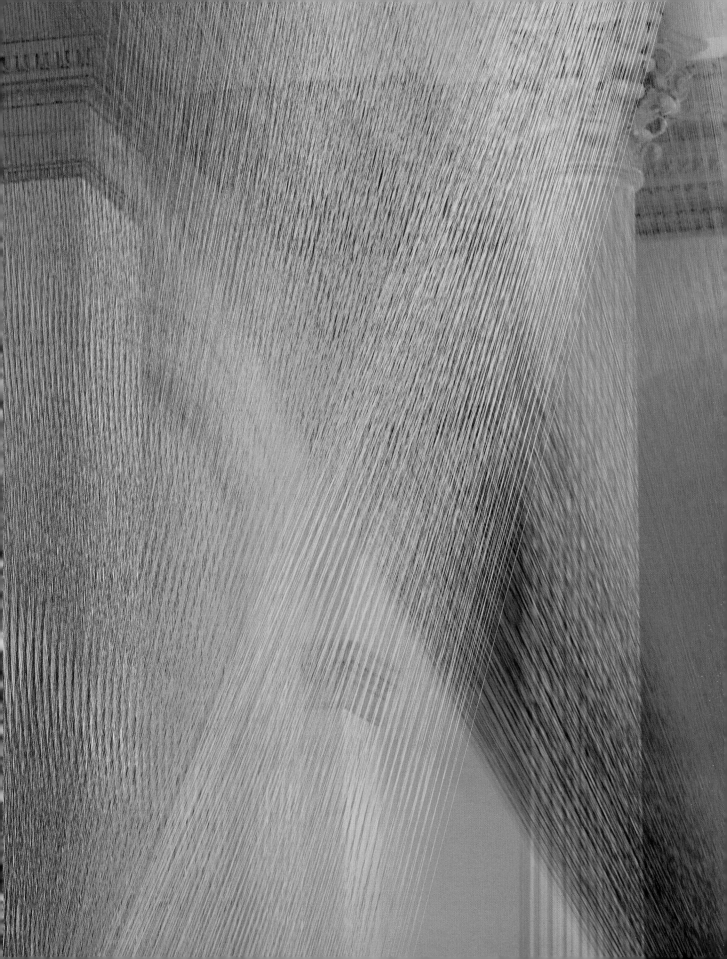

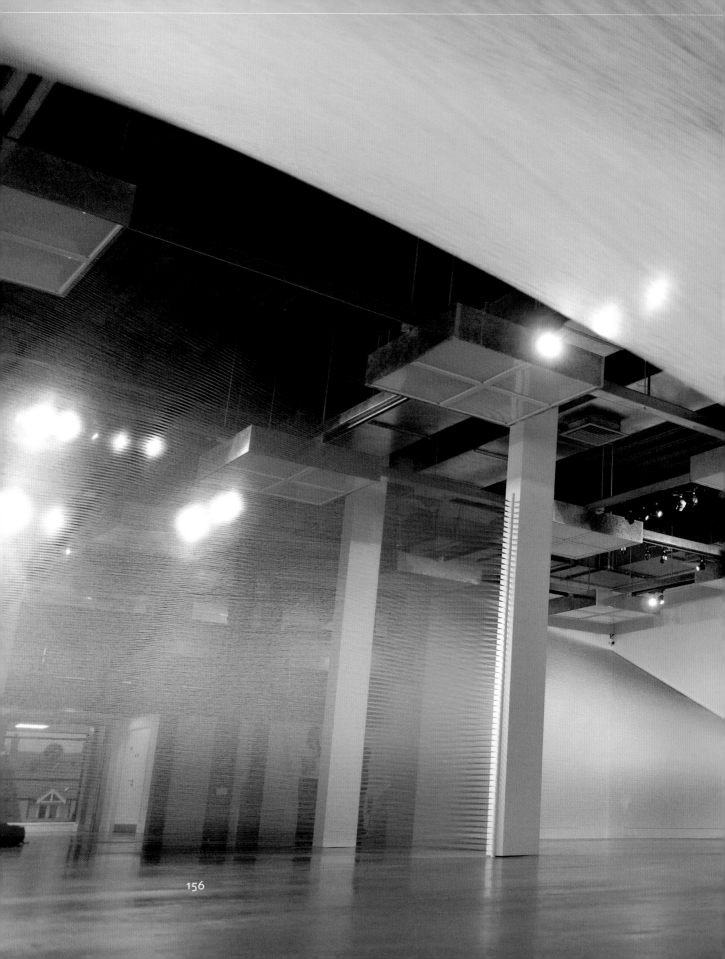

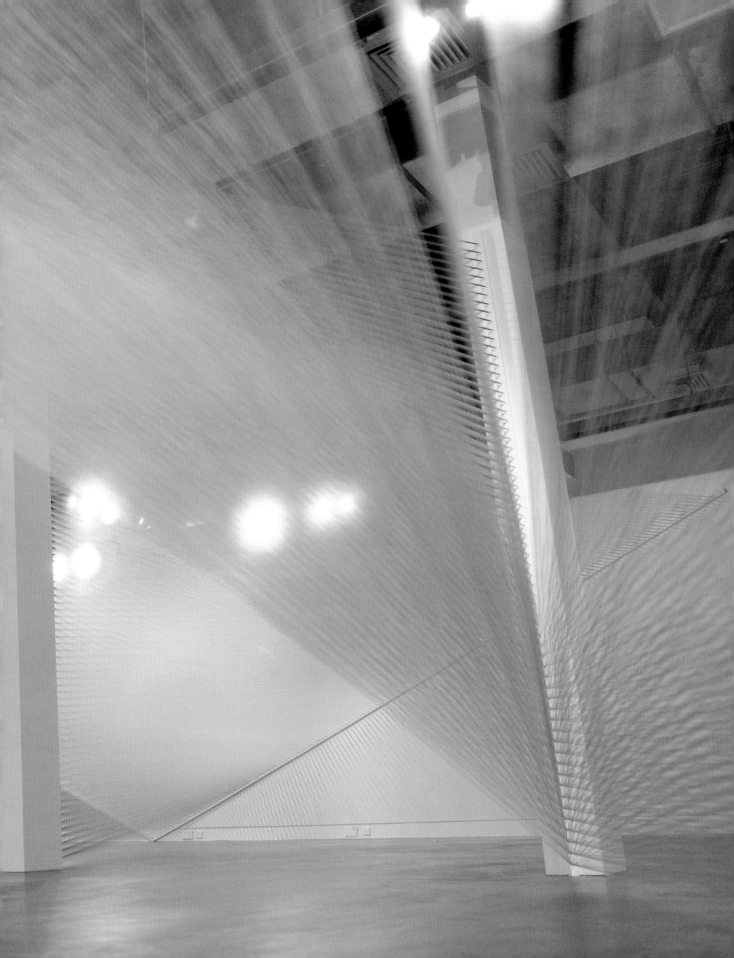

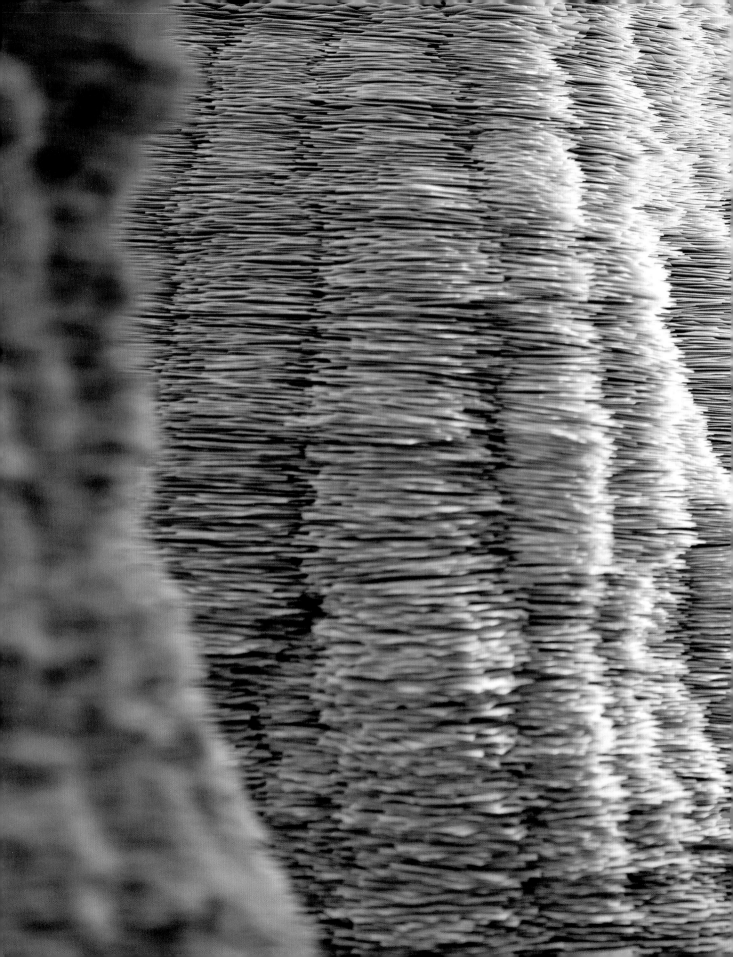

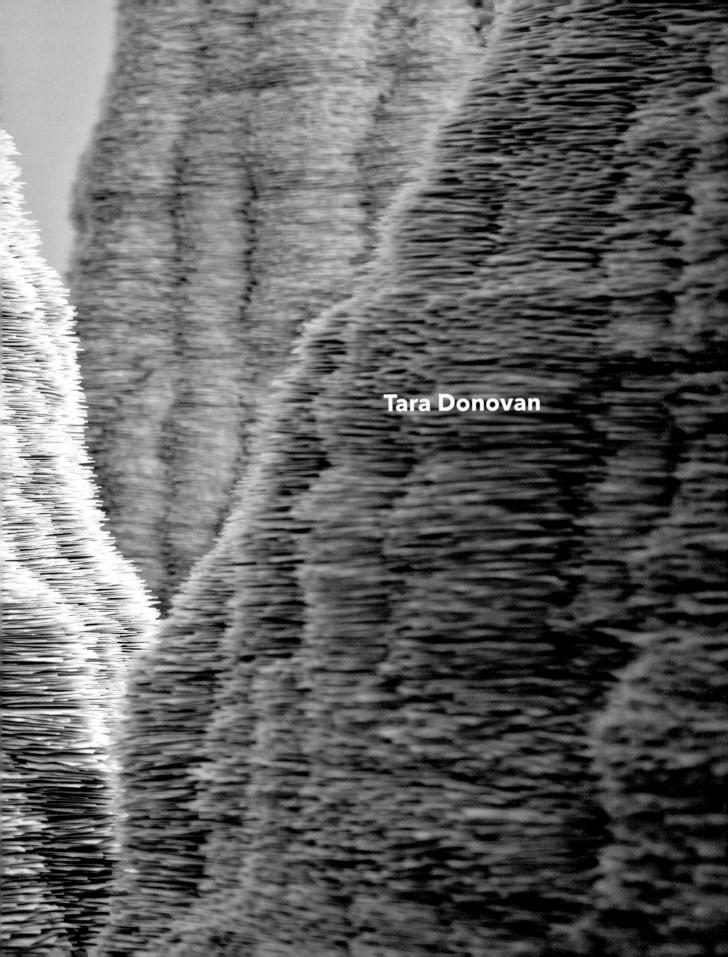

Tara Donovan

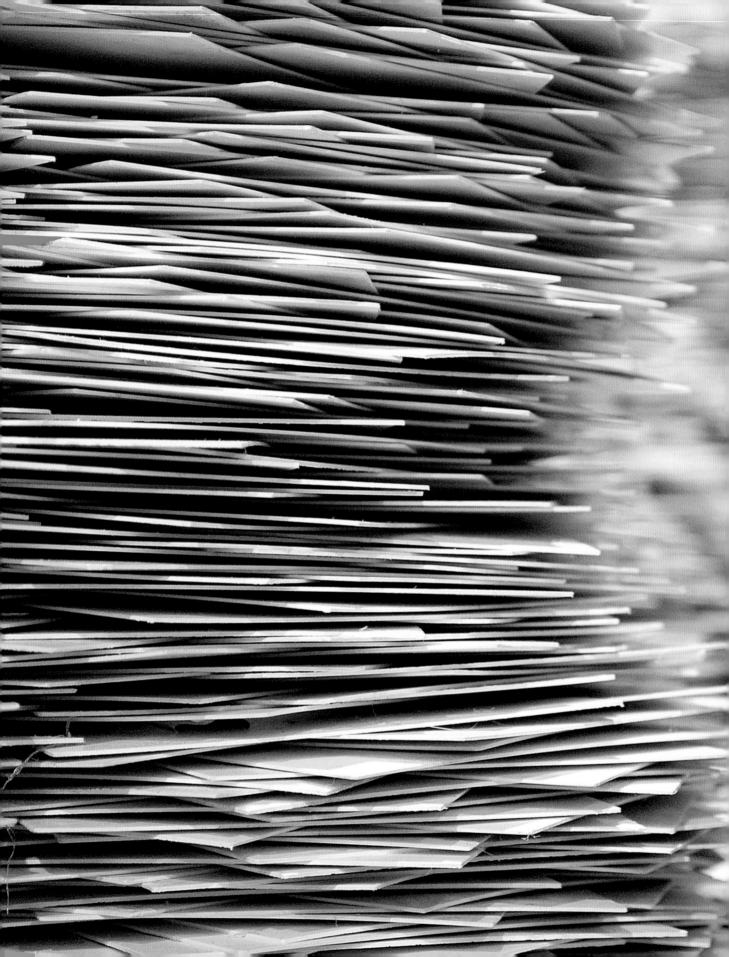

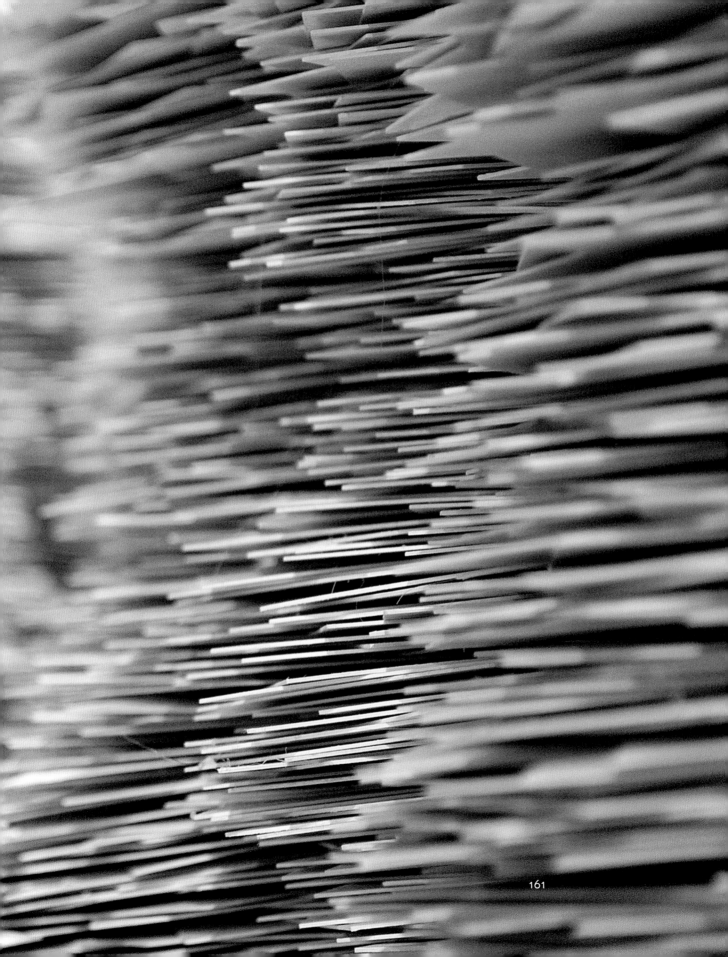

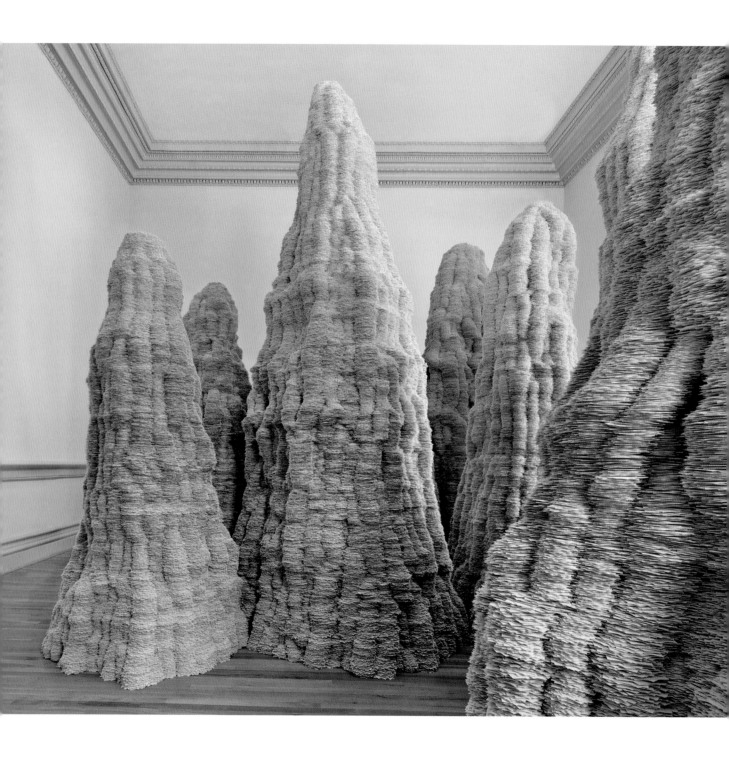

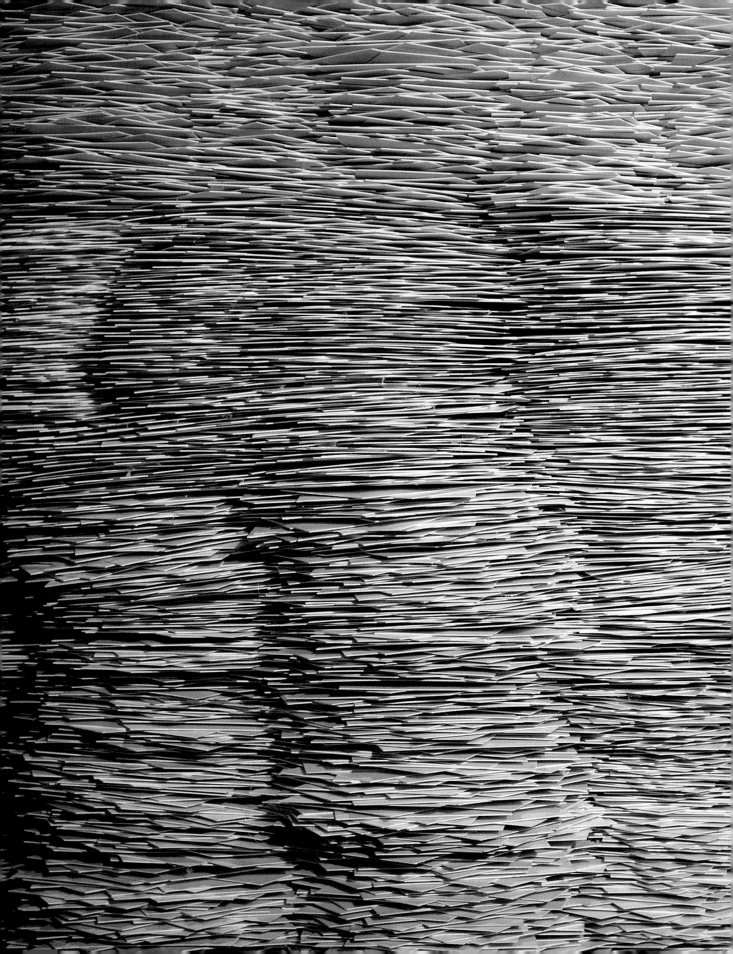

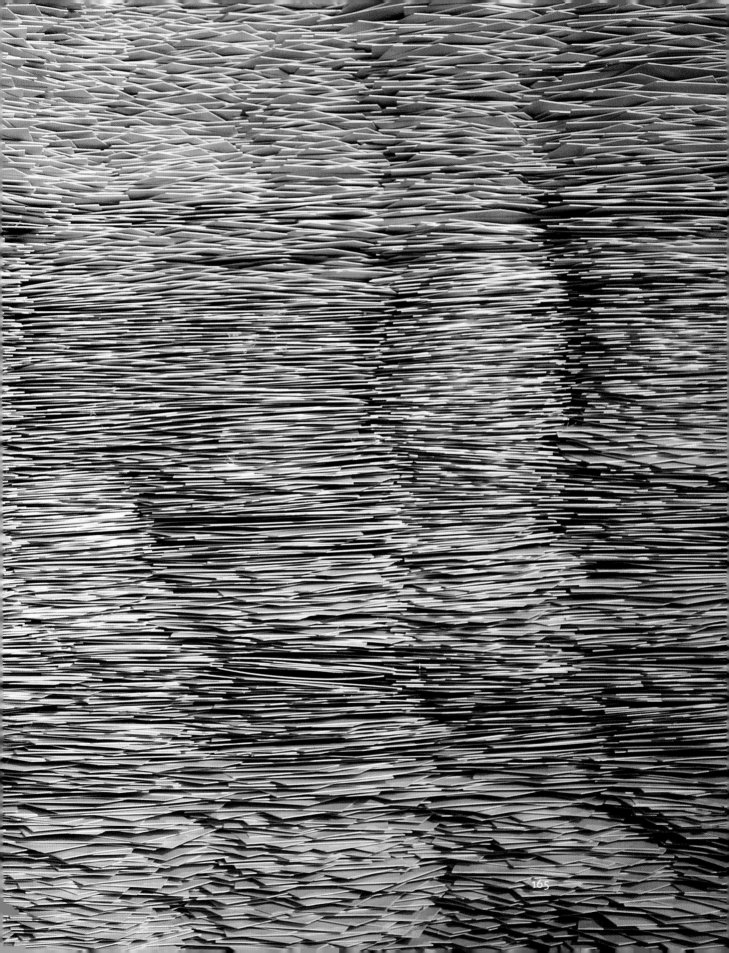

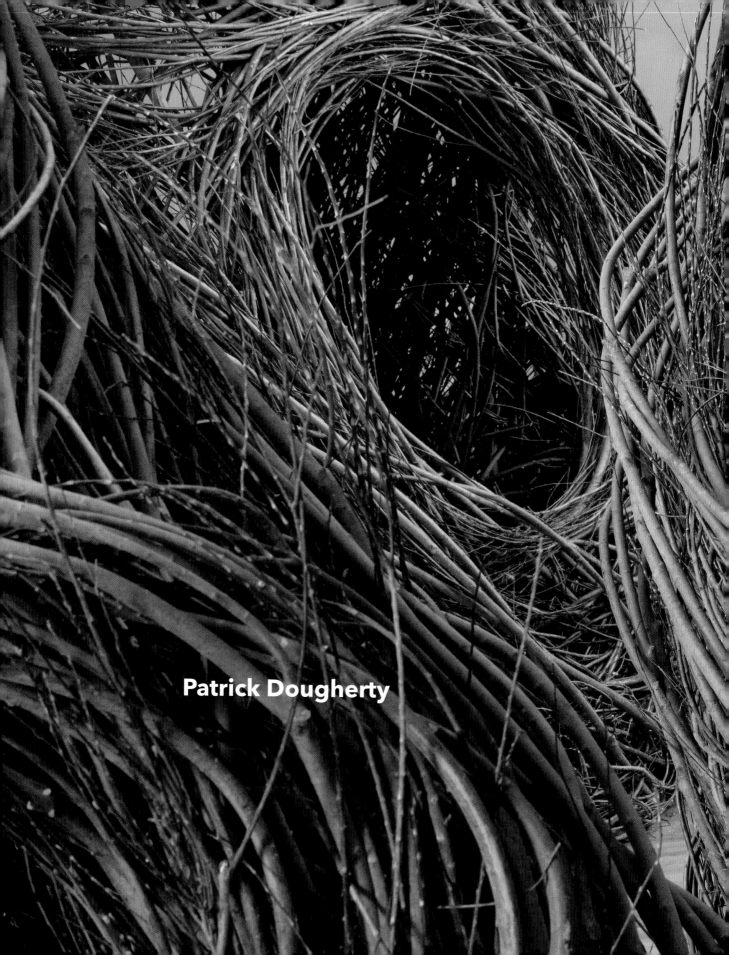

Patrick Dougherty

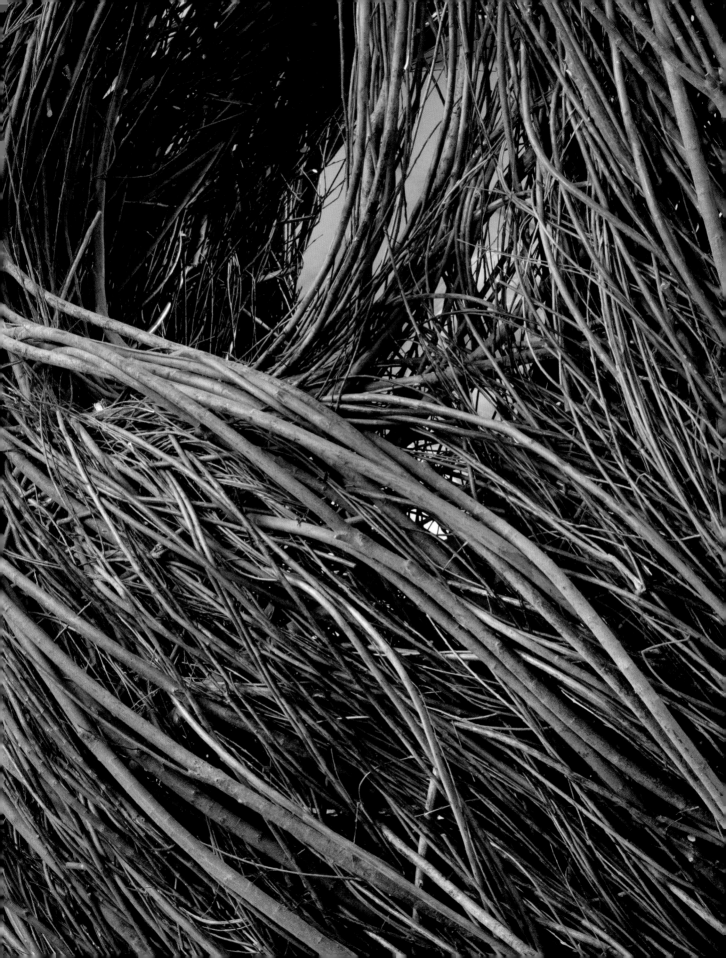

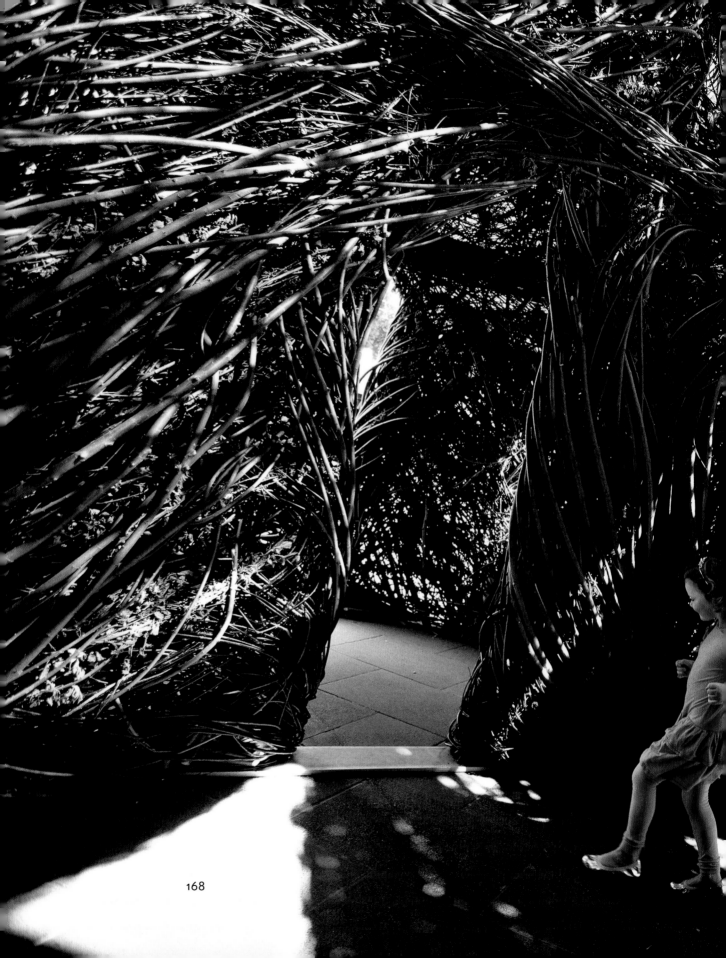

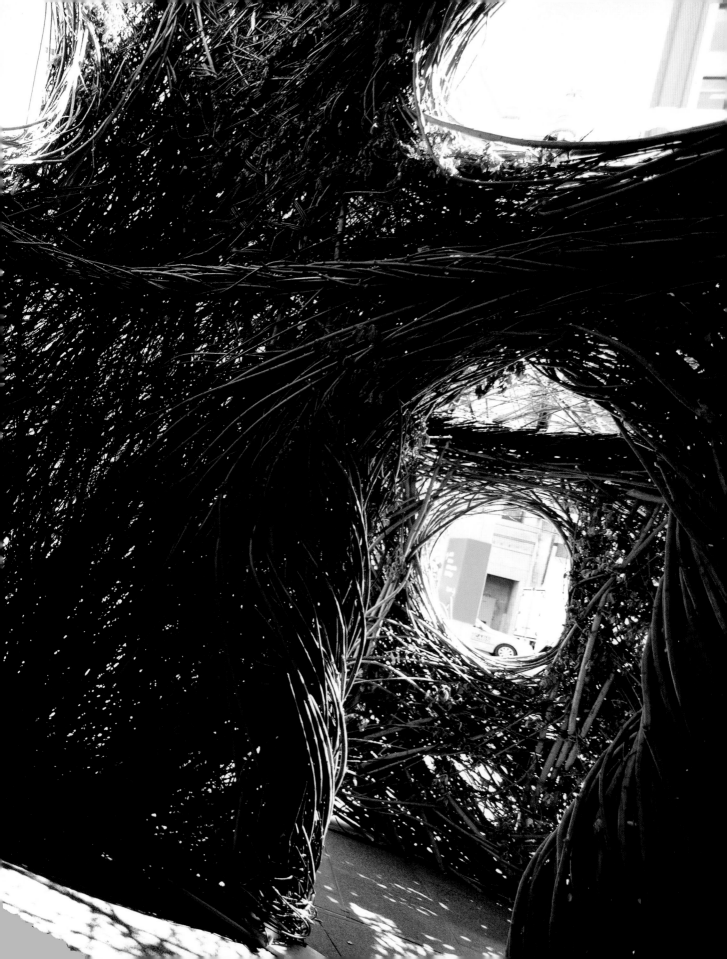

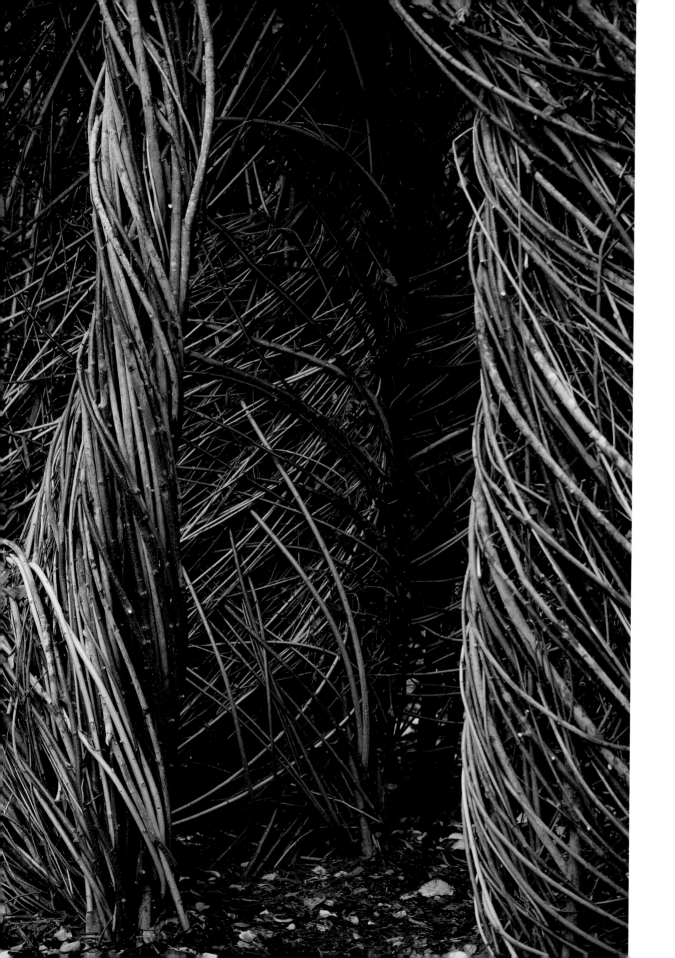

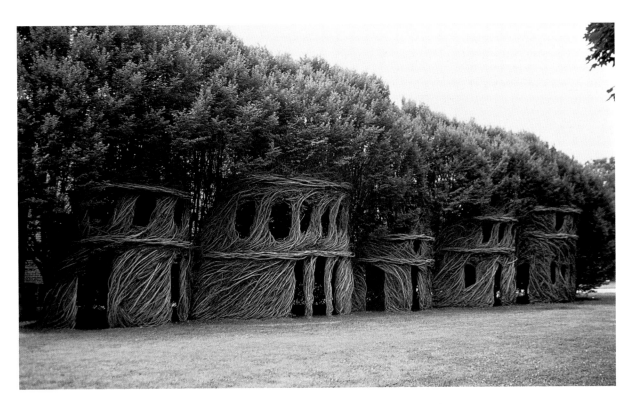

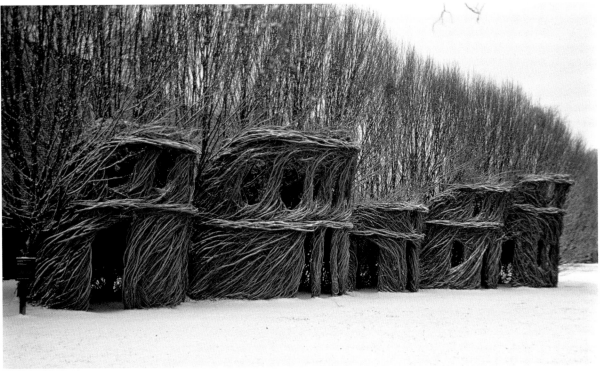

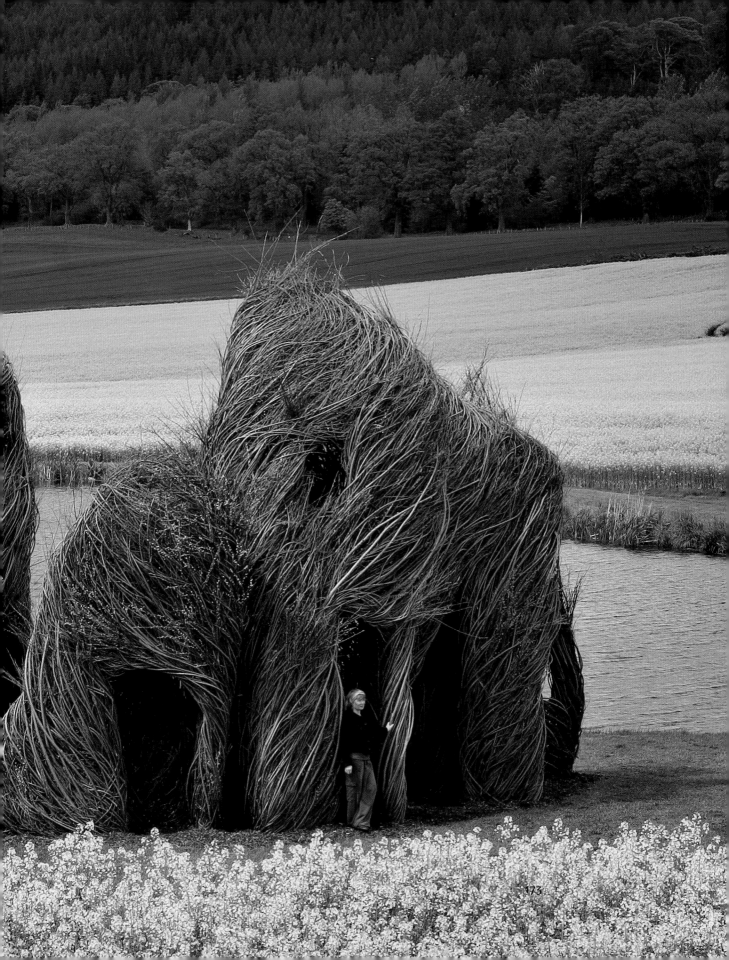

Janet Echelman

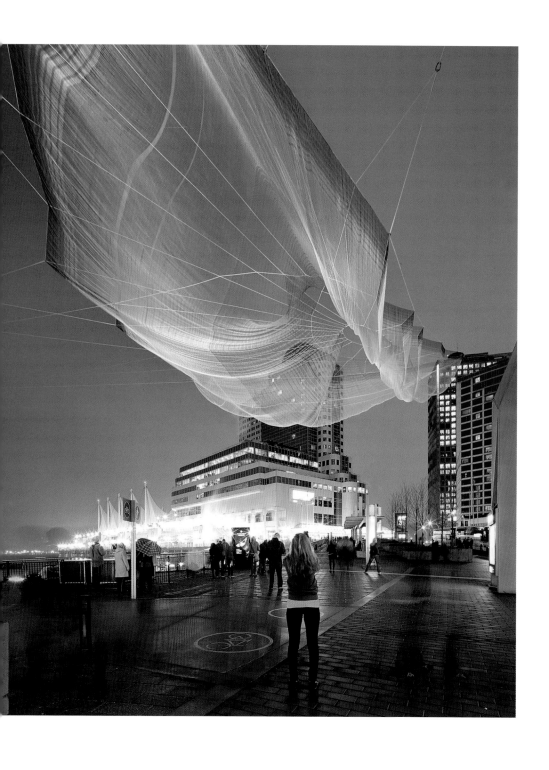

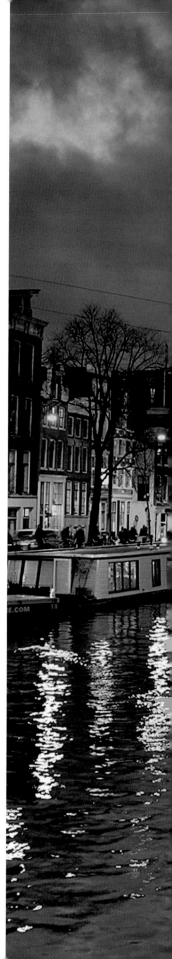

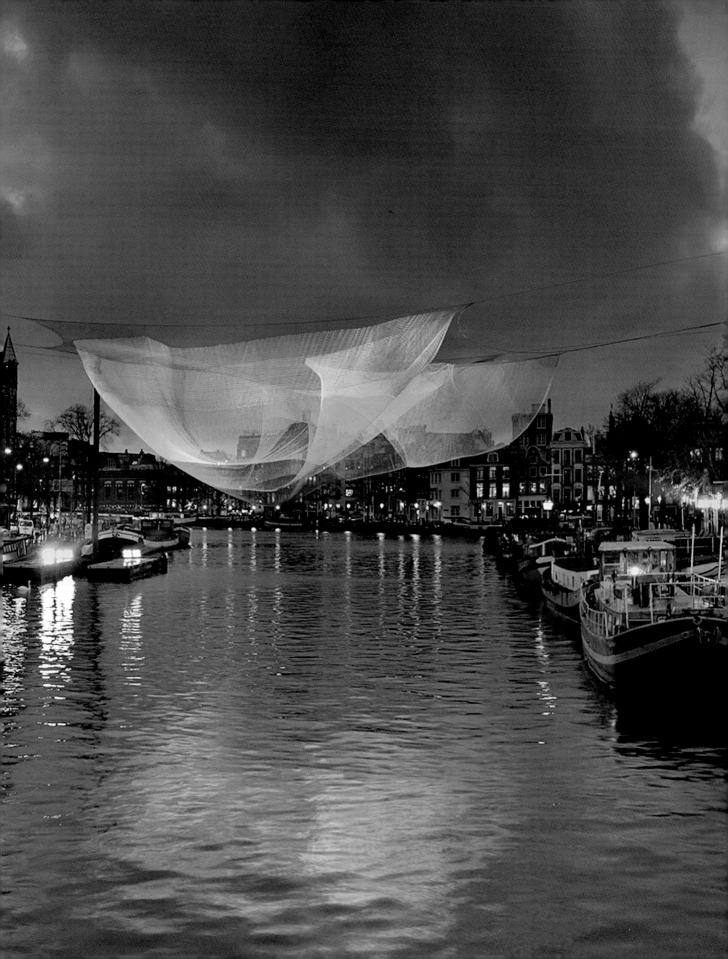

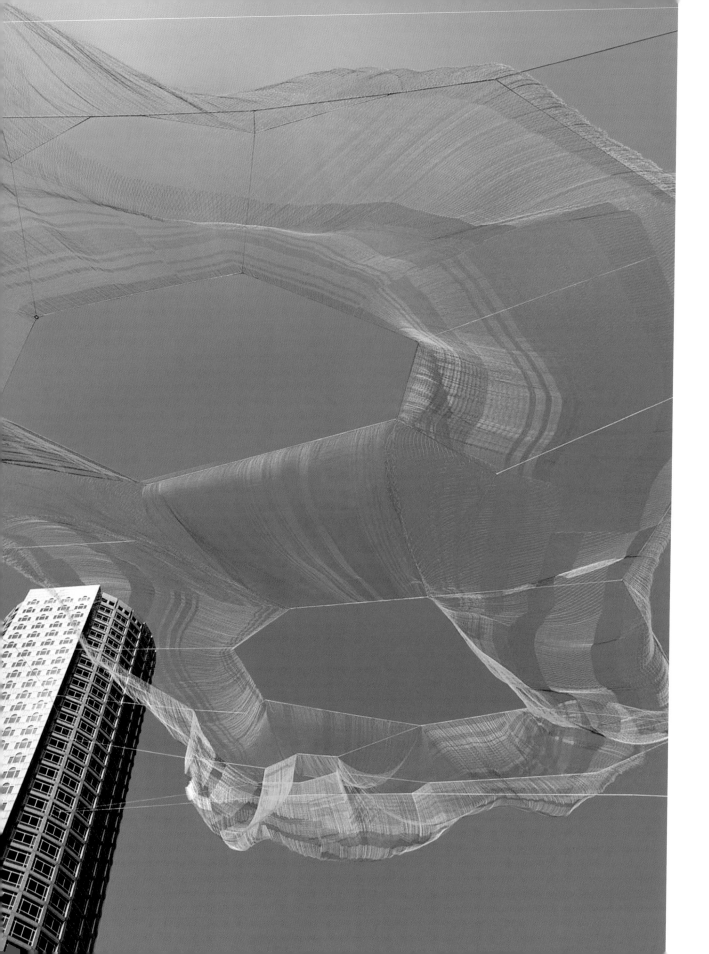

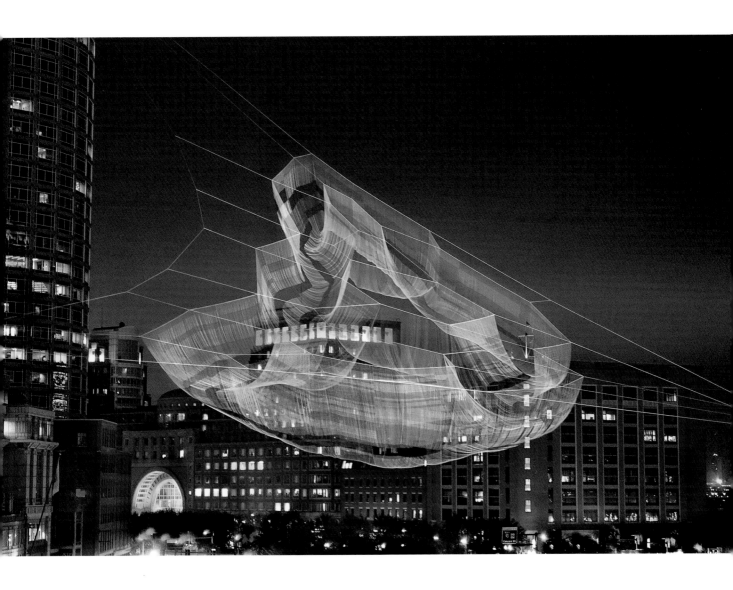

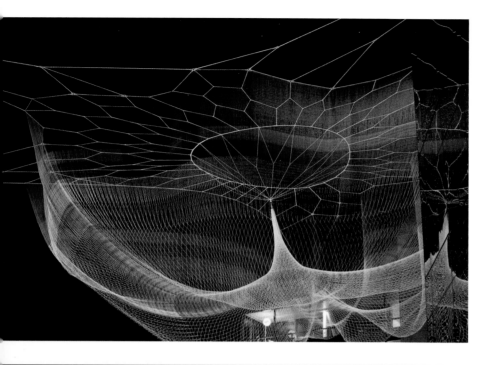

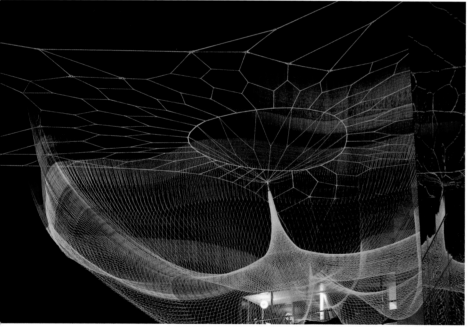

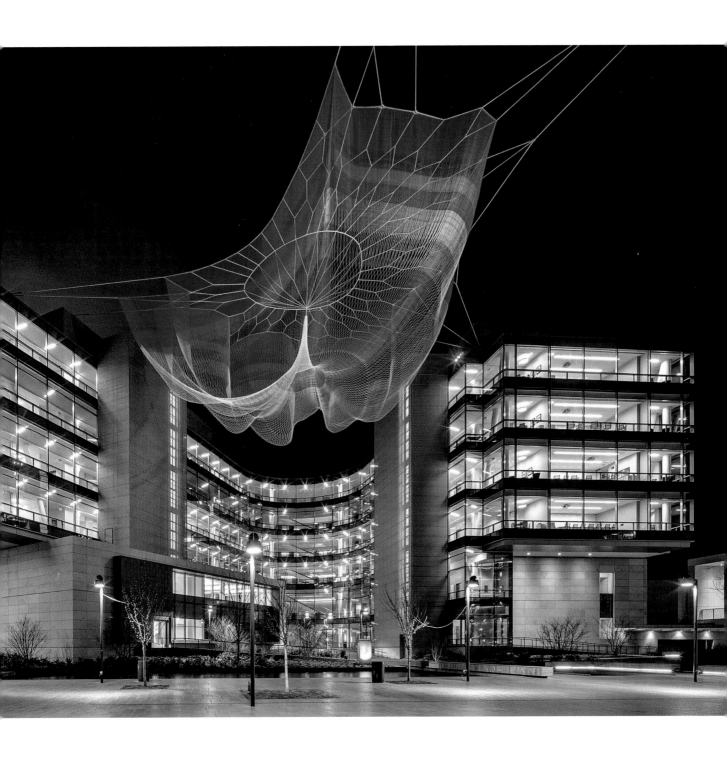

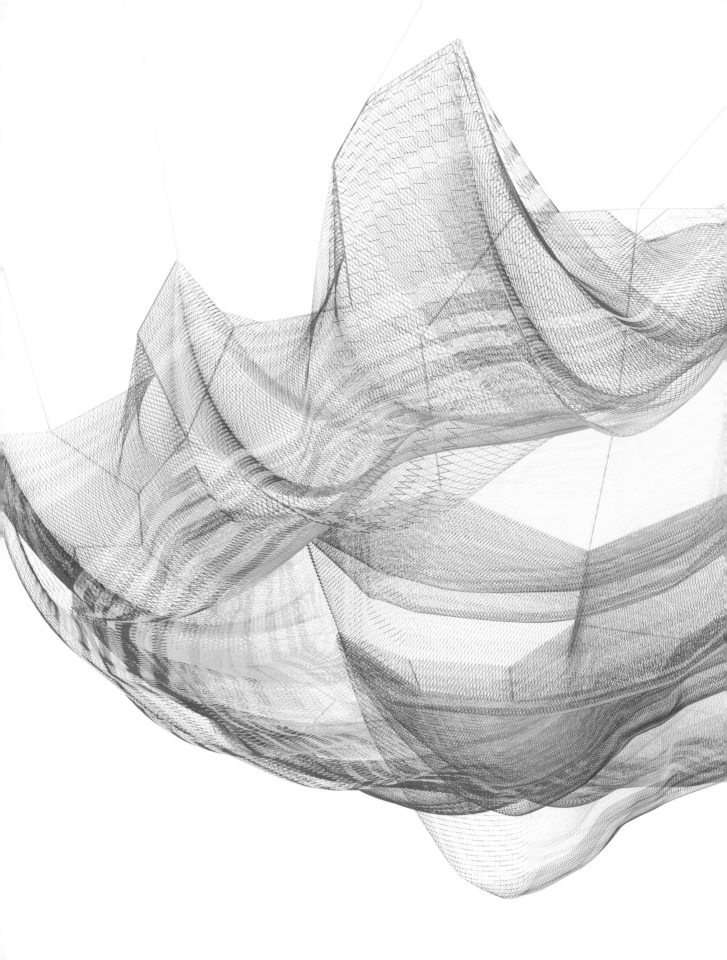

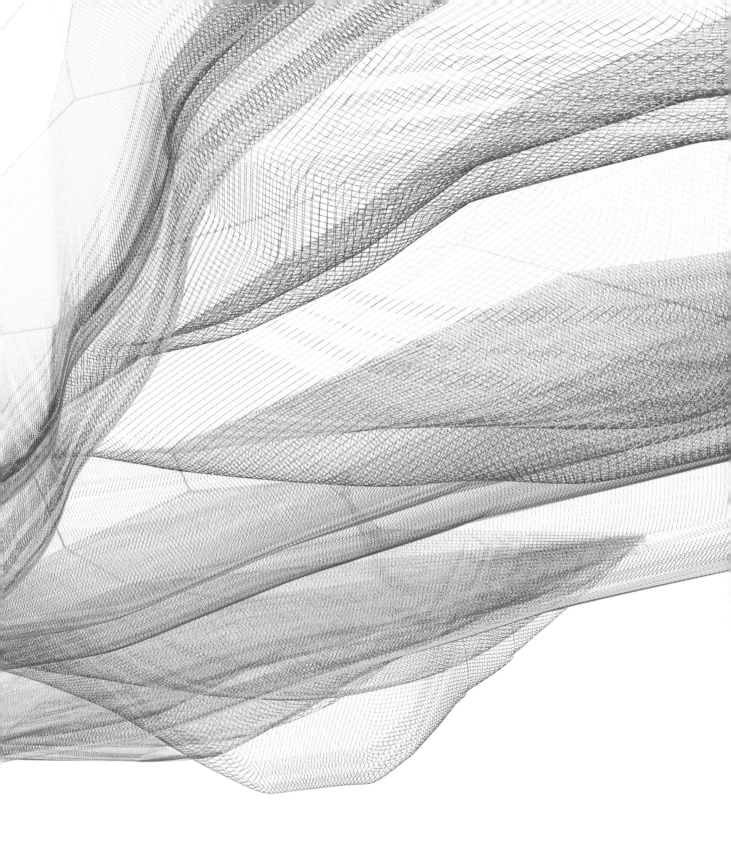

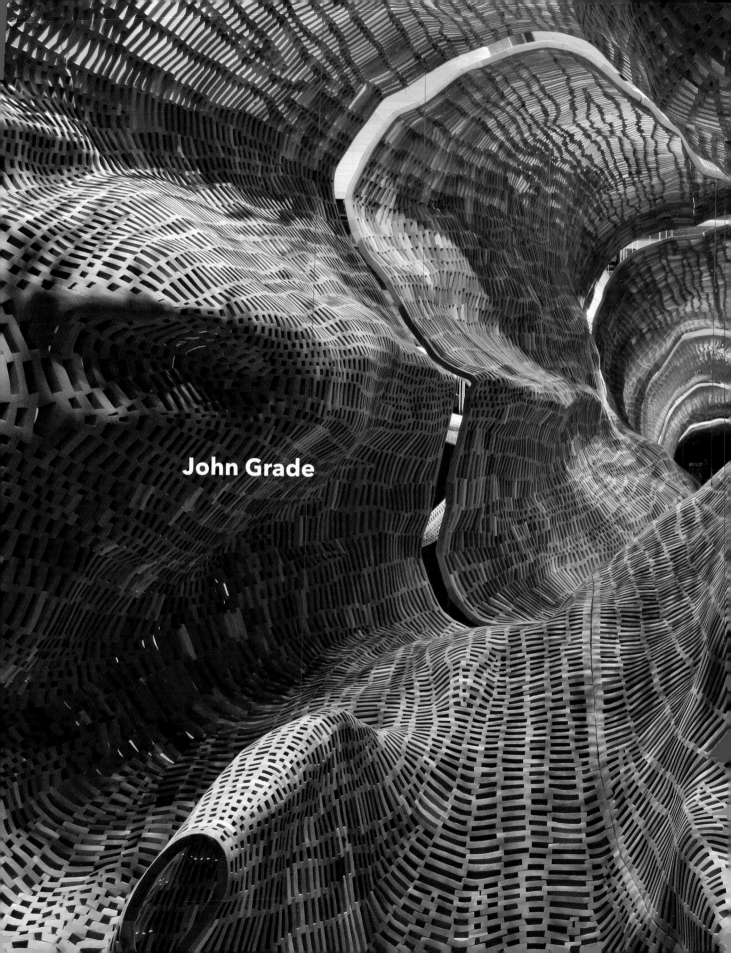

John Grade

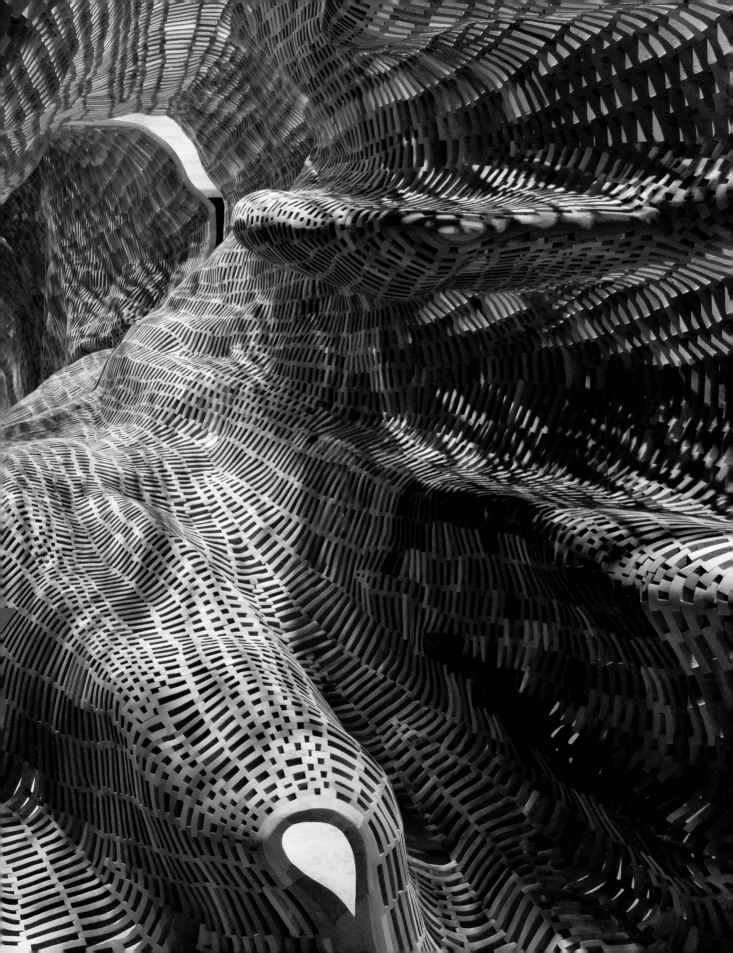

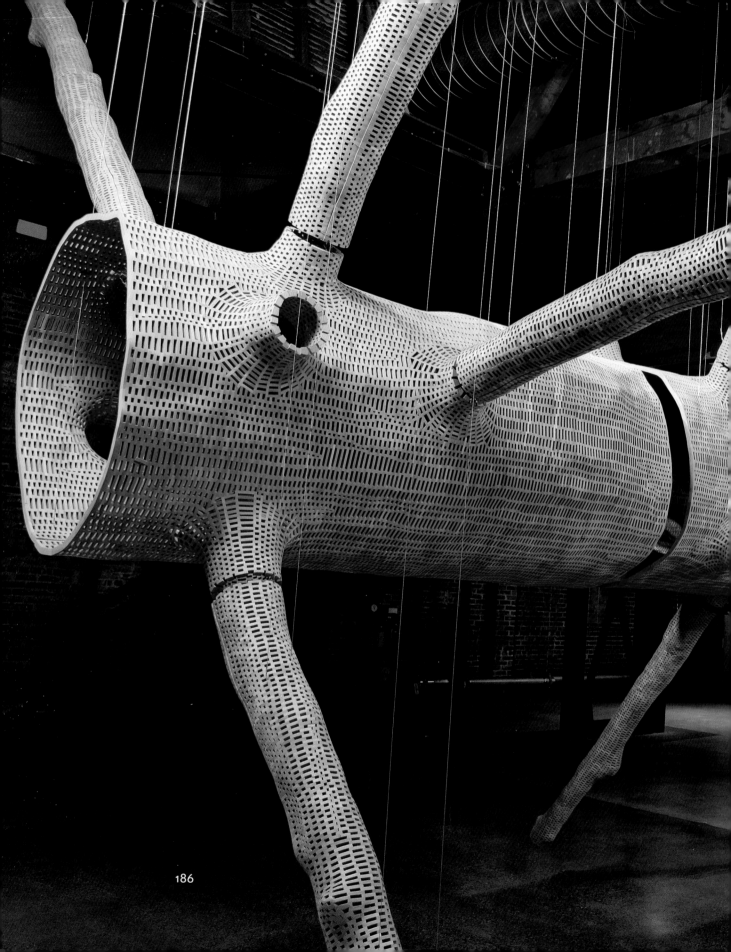

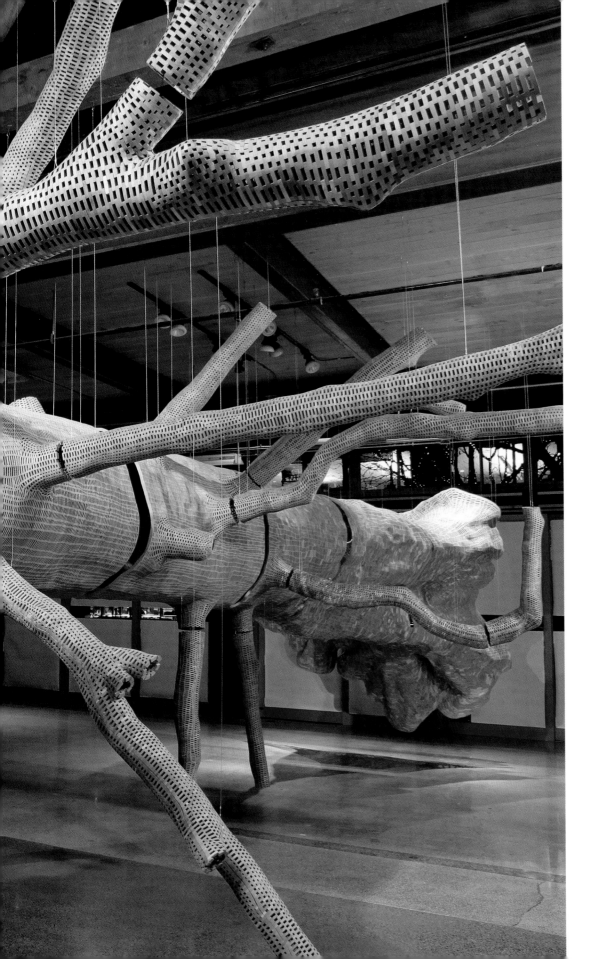

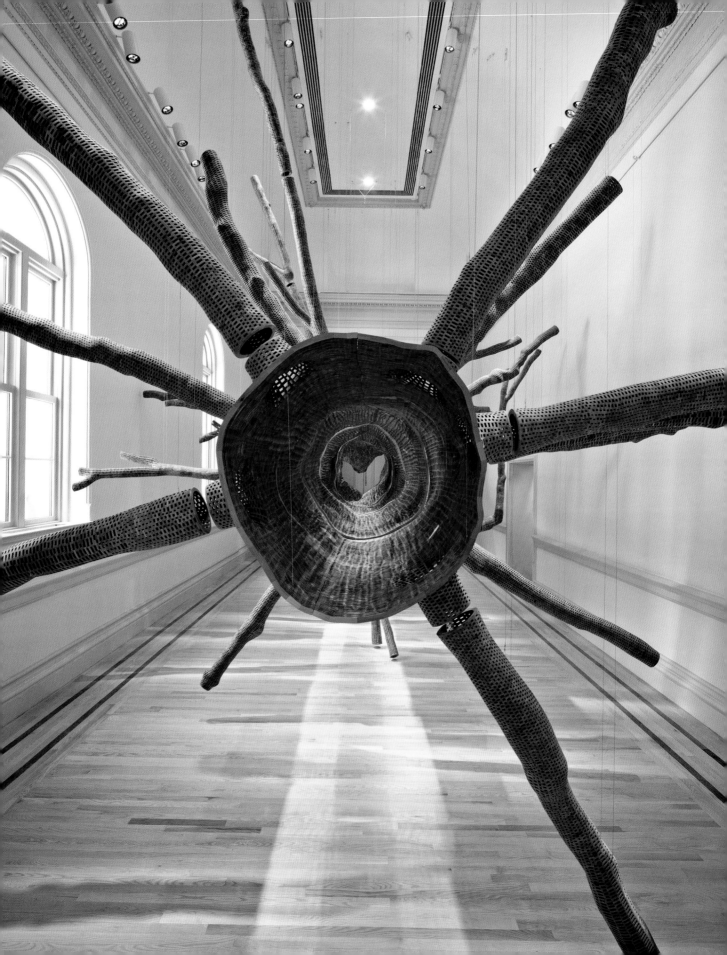

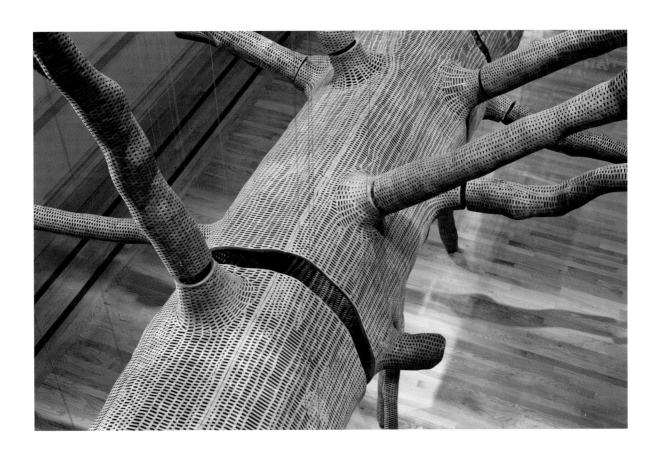

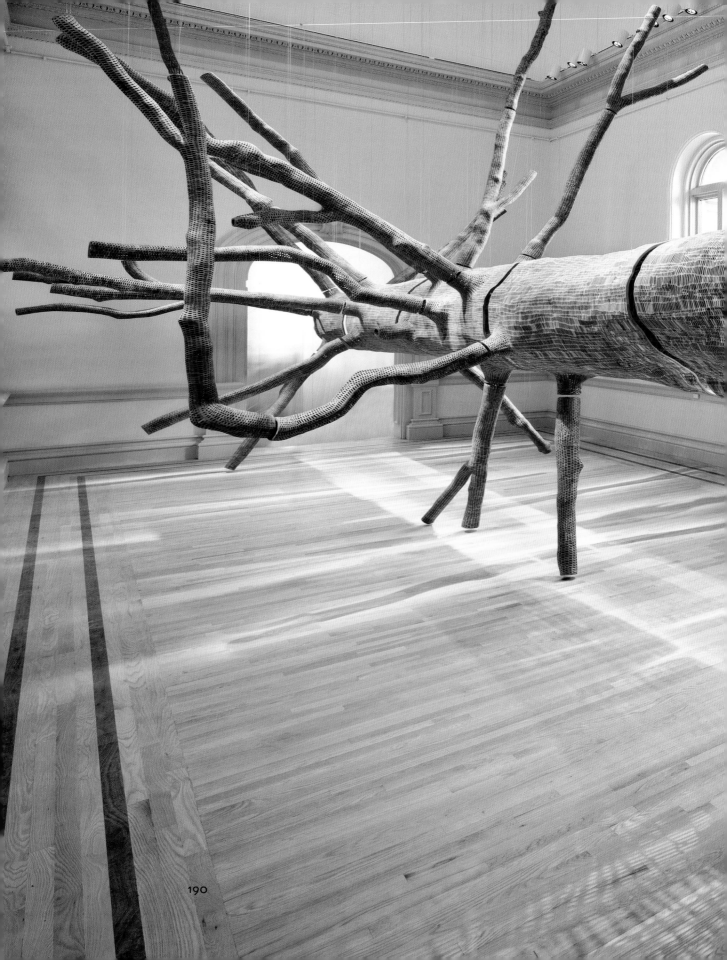

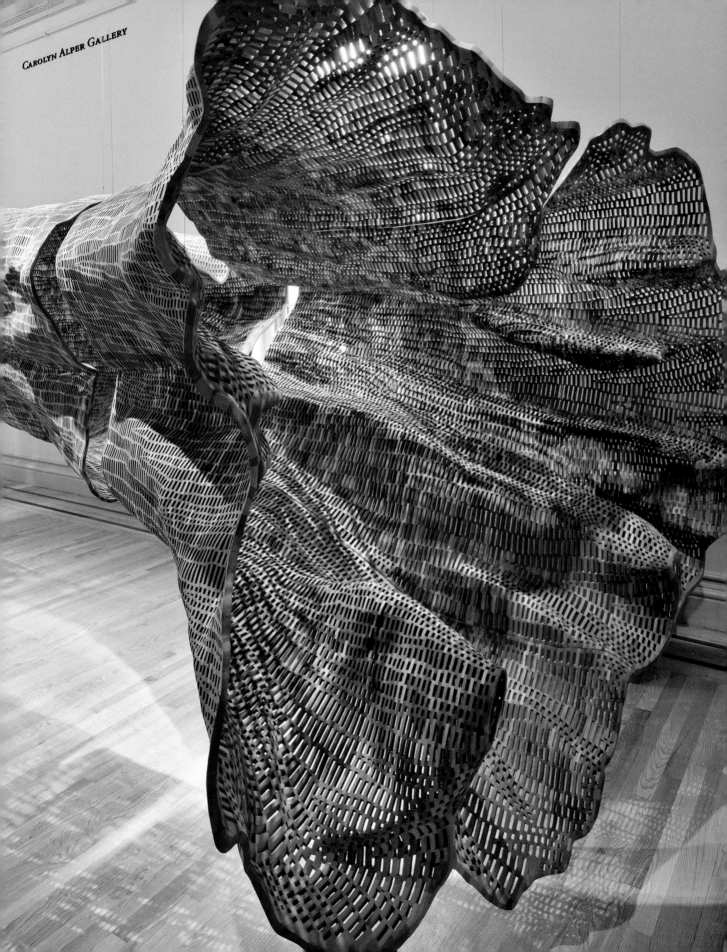

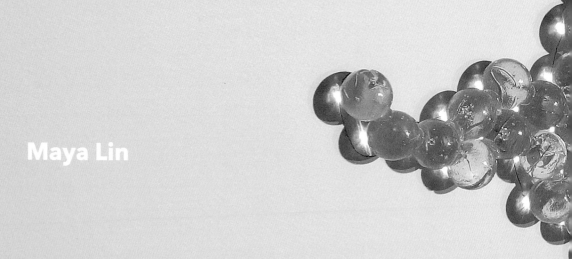

Maya Lin

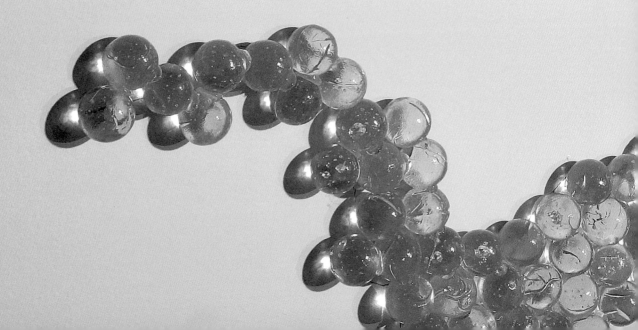

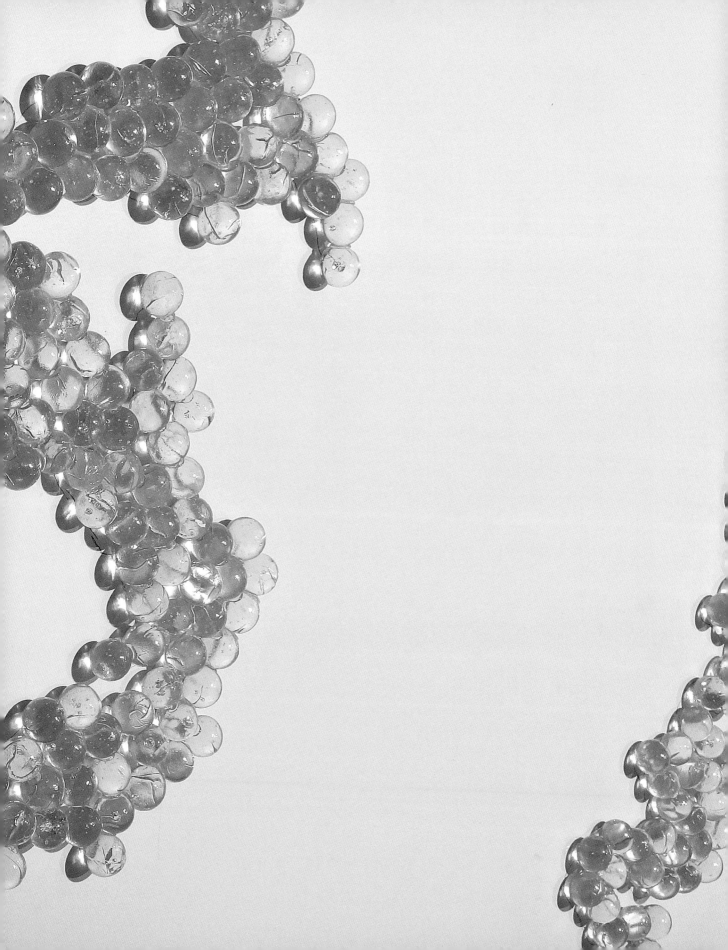

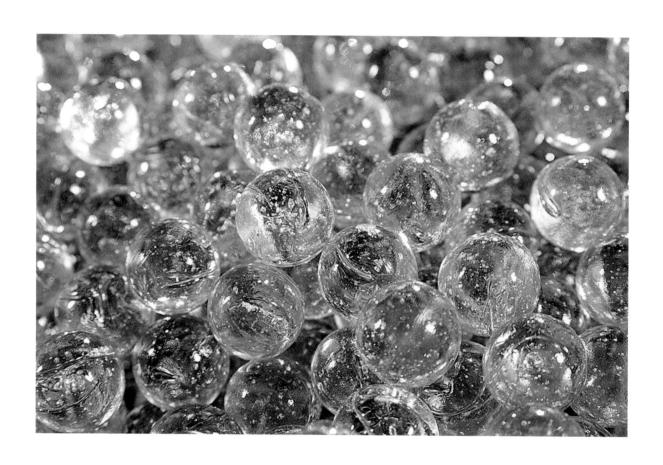

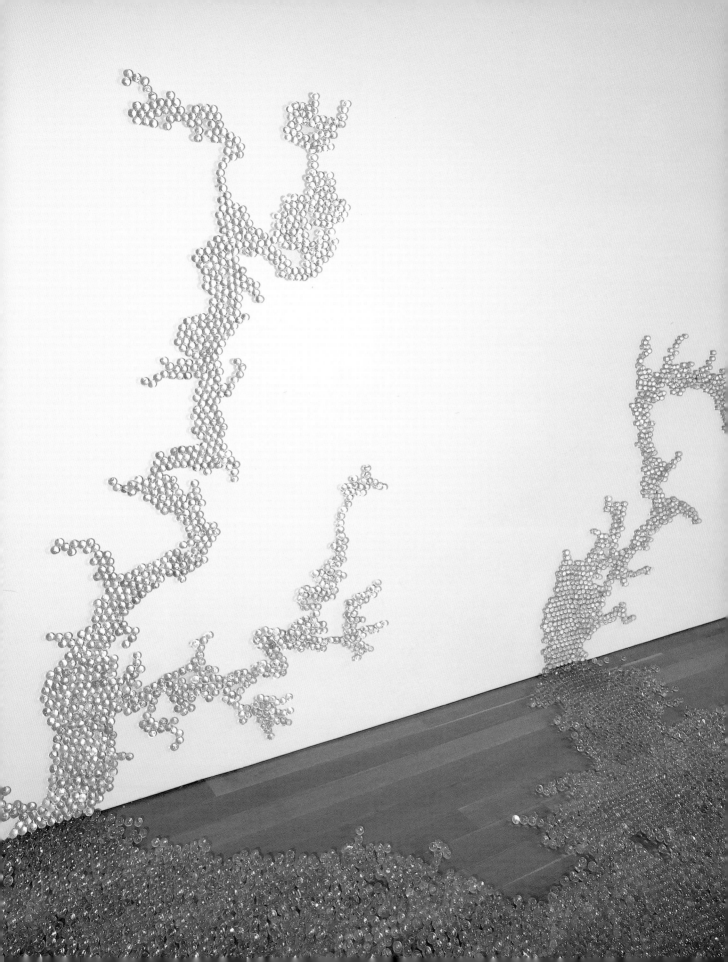

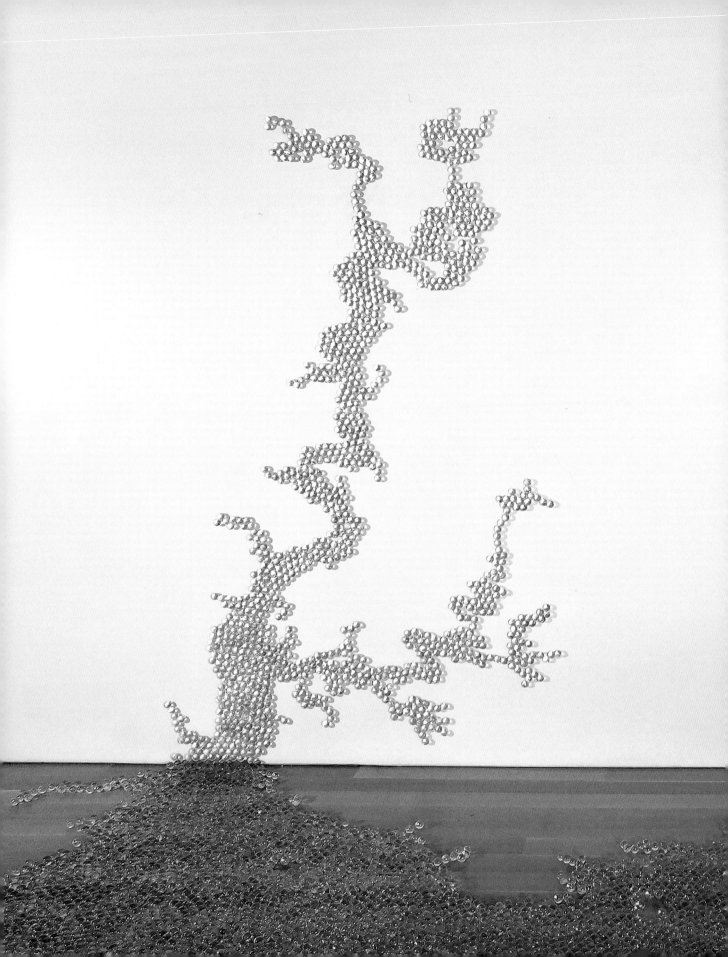

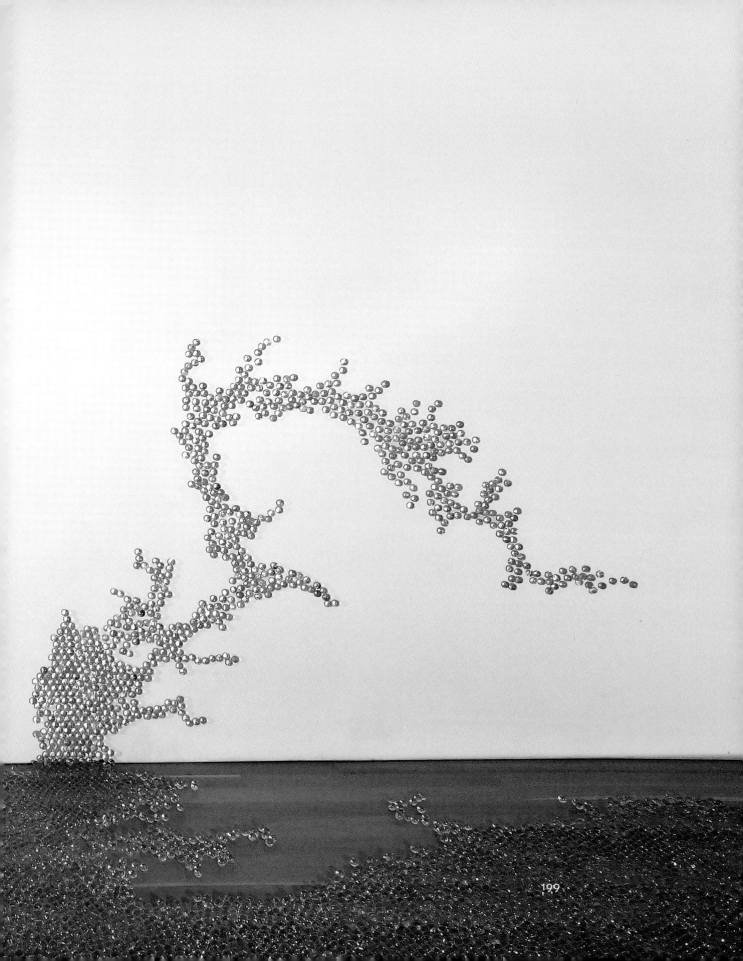

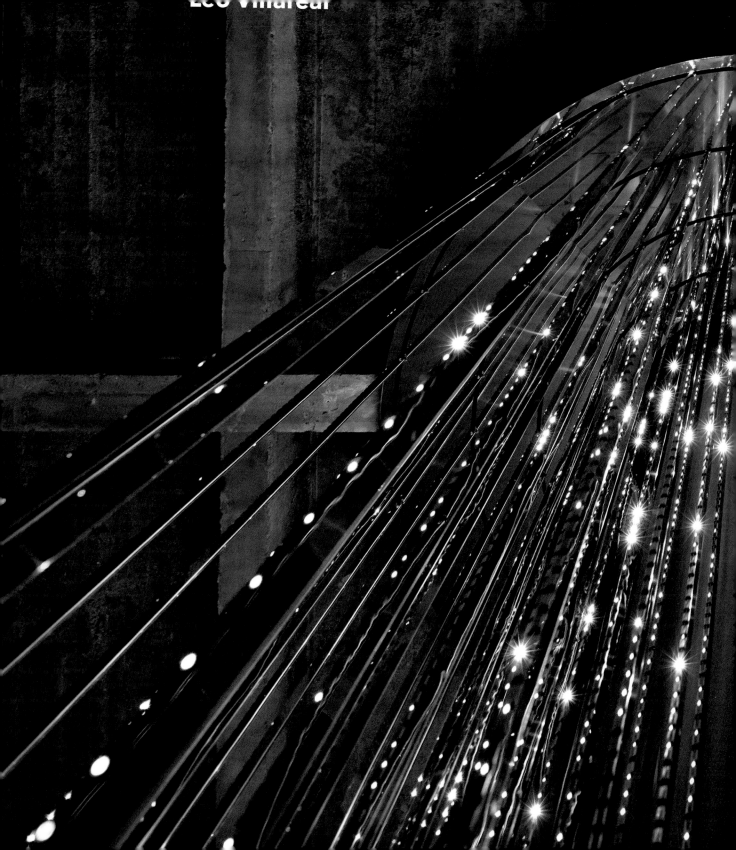

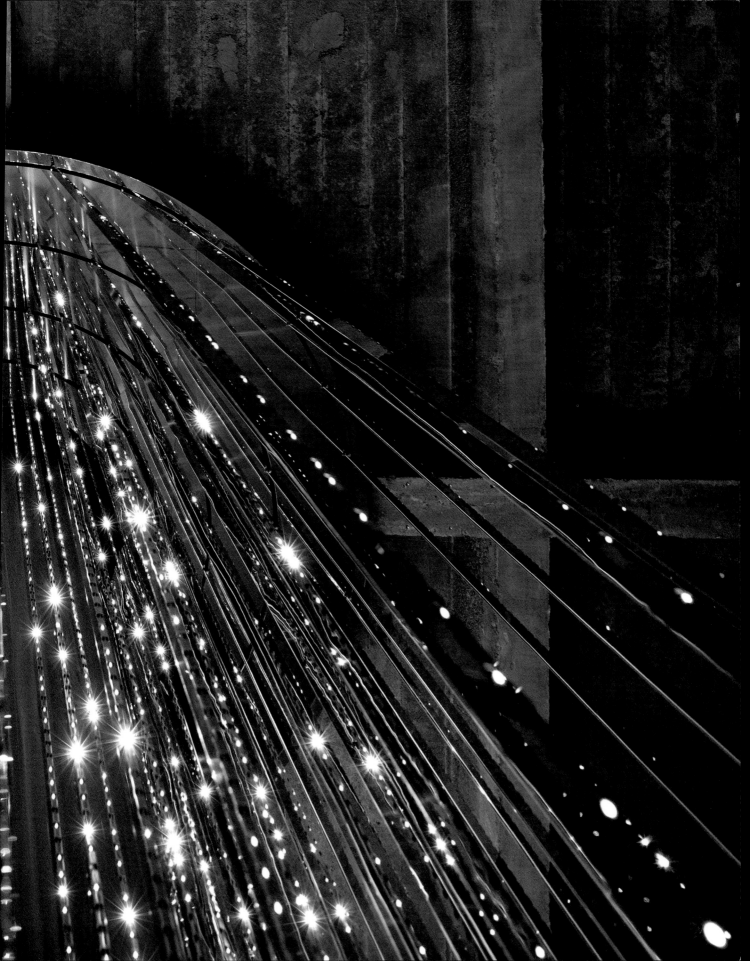

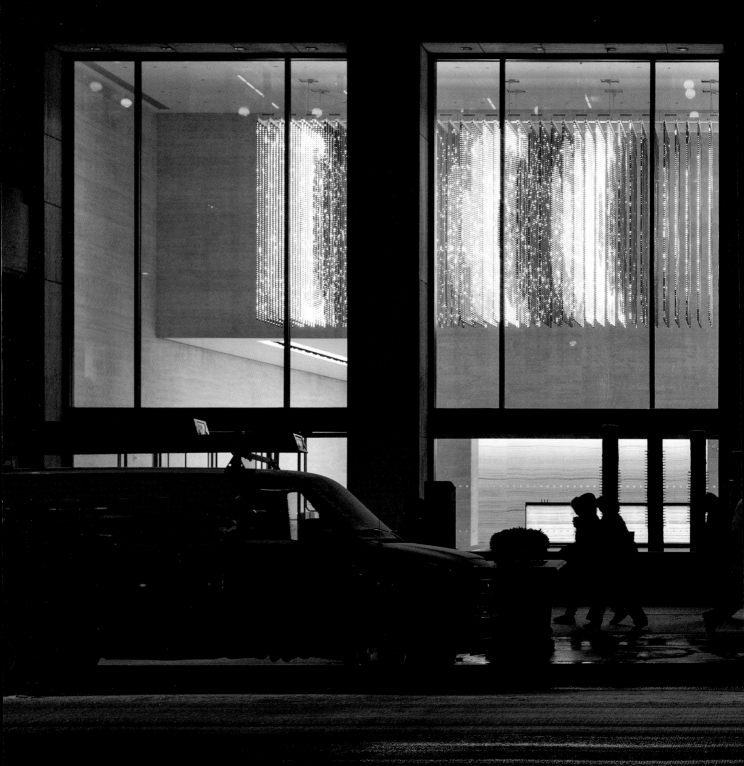

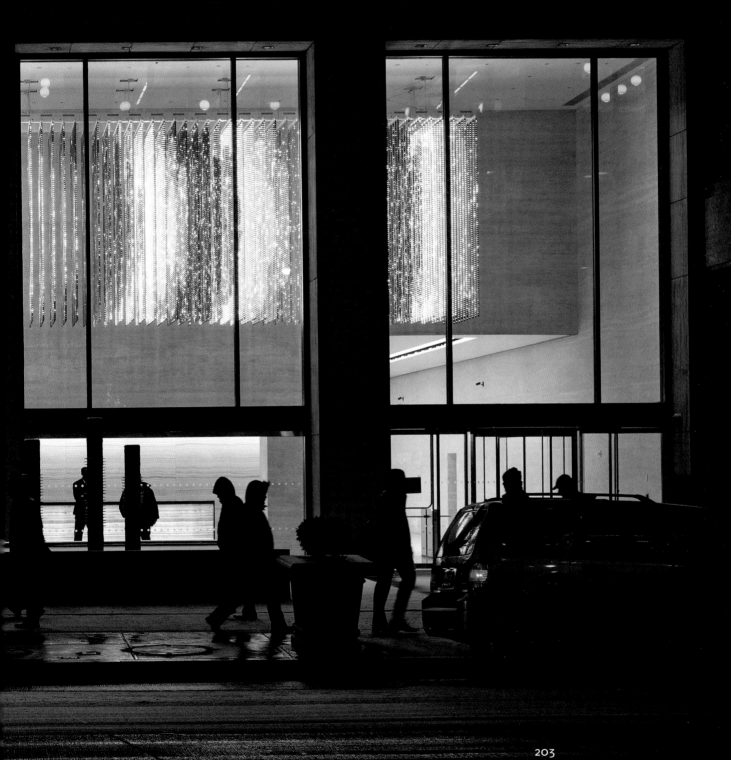

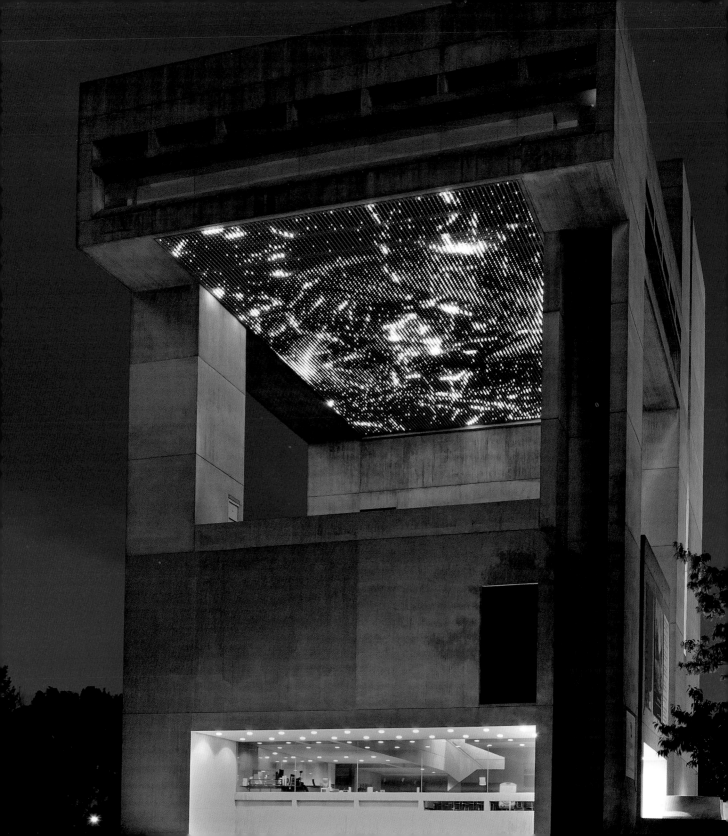

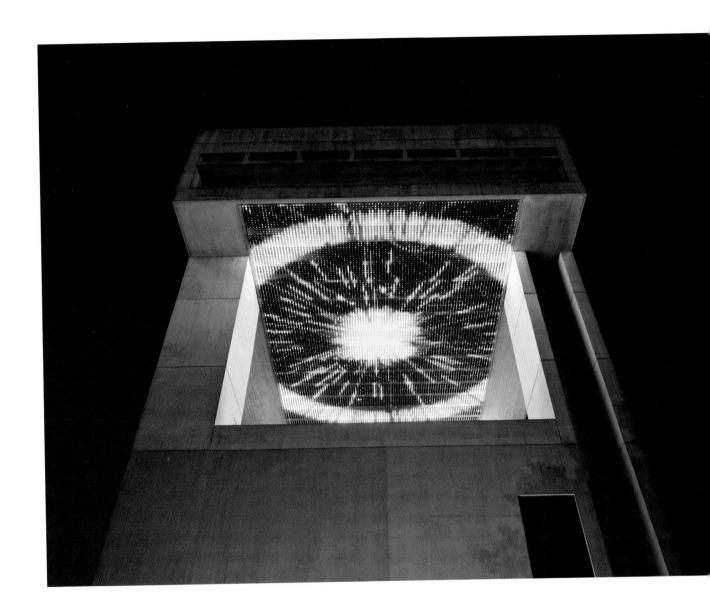

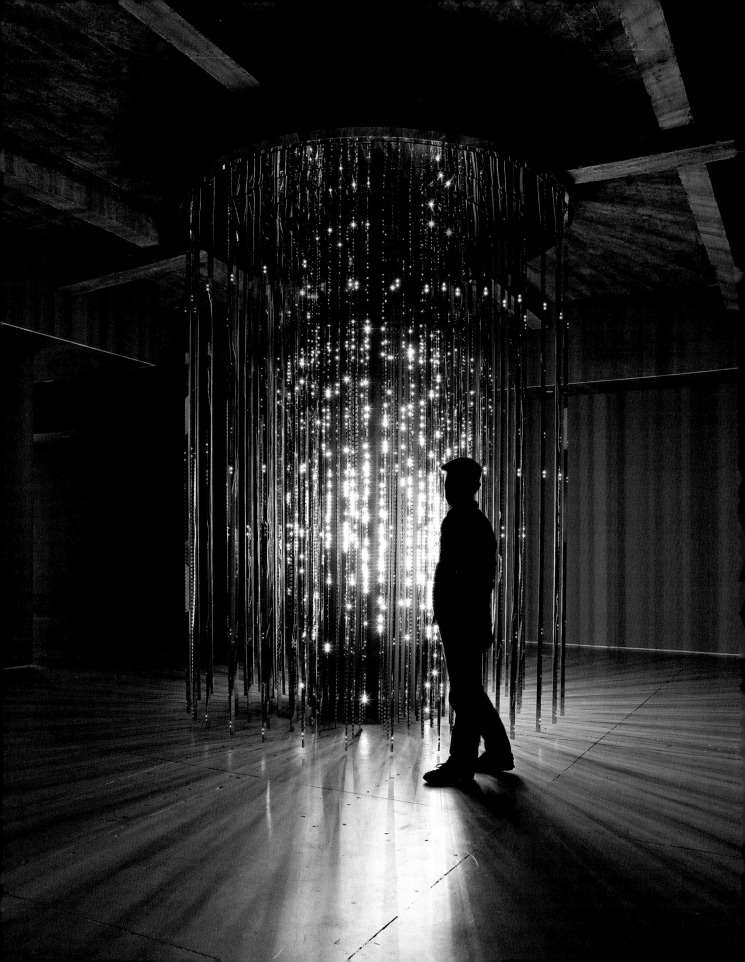

The only reason for bringing

together works of art in a

public place is that . . . they

produce in us a kind of exalted

happiness. For a moment there

is a clearing in the jungle:

we pass on refreshed, with our

capacity for life increased and

with some memory of the sky.

—Kenneth Clark

PLATES

At the time this book went to press, artists were installing their works at the Renwick Gallery. Images of the artworks in situ are supplemented with images of the works in the artists' studios and of earlier artworks.

Jennifer Angus

Pp. 130–31: *Magpie Tendencies* (detail), 2013, various insects, hand screen-printed wallpaper, and mixed media, at Anderson Gallery, Drake University, Des Moines, Iowa. Photo by Rich Sanders–Sanders Photographics, Inc.

P. 132: *Hunters & Hunted* (detail), 2012, various insects, hand screen-printed wallpaper, and mixed media, at Museum Villa Rot, Burgrieden, Germany. Photo by Henry M. Linder

P. 133: *Beauty Unseen* (detail), 2014, various insects, pins, and mixed media, at Contemporary 108, Tulsa, Oklahoma. Photo by Jennifer Angus

Pp. 134–35: *Magpie Tendencies* (detail), 2013, various insects, hand screen-printed wallpaper, and mixed media, at Anderson Gallery, Drake University, Des Moines, Iowa. Photo by Rich Sanders–Sanders Photographics, Inc.

P. 136: *A Terrible Beauty 1* (detail), 2005, various insects, hand screen-printed wallpaper, and mixed media, at Textile Museum of Canada, Toronto. Photo by Stephen Funk

P. 137: *In the Midnight Garden* (detail), 2015, cochineal, various insects, and mixed media. Courtesy of Jennifer Angus. Photo by Ron Blunt

P. 138: *In the Midnight Garden* (detail), 2015, cochineal, various insects, and mixed media. Courtesy of Jennifer Angus. Photo by Ron Blunt

P. 139: *In the Midnight Garden* (detail of contents of cabinet drawers), 2015, cochineal, various insects, and mixed media. Courtesy of Jennifer Angus. Photo by Ron Blunt

Chakaia Booker

Pp. 140–41: *ANONYMOUS DONOR* (detail), 2015, rubber tires and stainless steel. Courtesy of Chakaia Booker. Photo by Ron Blunt

P. 142: *ANONYMOUS DONOR*, 2015, rubber tires and stainless steel. Courtesy of Chakaia Booker. Photo by Ron Blunt

P. 143: *ANONYMOUS DONOR* (detail), 2015, rubber tires and stainless steel. Courtesy of Chakaia Booker. Photo by Ron Blunt

P. 144: *ANONYMOUS DONOR* (detail), 2015, rubber tires and stainless steel. Courtesy of Chakaia Booker. Photo by Ron Blunt

P. 145: *Holla* (detail), 2009, rubber tires and stainless steel. Collection of Chakaia Booker. Photo by Peter Vanderwarker, courtesy deCordova Sculpture Park and Museum, Lincoln, Mass.

P. 146: *ANONYMOUS DONOR* (detail), 2015, rubber tires and stainless steel. Courtesy of Chakaia Booker. Photo by Ron Blunt

P. 147: *ANONYMOUS DONOR* (detail), 2015, rubber tires and stainless steel. Courtesy of Chakaia Booker. Photo by Ron Blunt

Gabriel Dawe

Pp. 148–49: *Plexus No. 10* (detail), 2011, thread, painted wood, and hooks, at National Centre for Craft and Design, England. Photo by Electric Egg

P. 150: *Plexus No. 10* (detail), 2011, thread, painted wood, and hooks, at National Centre for Craft and Design, England. Photo by Electric Egg

P. 151: *Plexus No. 10* (detail), 2011, thread, painted wood, and hooks, at National Centre for Craft and Design, England. Photo by Electric Egg

Pp. 152–53: *Plexus A1* (detail), 2015, thread, wood, hooks, and steel. Courtesy of the artist and Conduit Gallery. Photo by Ron Blunt

P. 154: *Plexus A1* (detail), 2015, thread, wood, hooks, and steel. Courtesy of the artist and Conduit Gallery. Photo by Ron Blunt

P. 155: *Plexus A1* (detail), 2015, thread, wood, hooks, and steel. Courtesy of the artist and Conduit Gallery. Photo by Ron Blunt

Pp. 156–57: *Plexus No. 10* (detail), 2011, thread, painted wood, and hooks, at National Centre for Craft and Design, England. Photo by Electric Egg

Tara Donovan

Pp. 158–59: *Untitled* (detail), 2014, styrene index cards, metal, wood, paint, and glue. © Tara Donovan, courtesy Pace Gallery. Photo by Ron Blunt

Pp. 160–61: *Untitled* (detail), 2014, styrene index cards, metal, wood, paint, and glue. © Tara Donovan, courtesy Pace Gallery. Photo by Kerry Ryan McFate

P. 162: *Untitled* (detail), 2014, styrene index cards, metal, wood, paint, and glue. © Tara Donovan, courtesy Pace Gallery. Photo by Ron Blunt

P. 163: *Untitled* (detail), 2014, styrene index cards, metal, wood, paint, and glue. © Tara Donovan, courtesy Pace Gallery. Photo by Ron Blunt

Pp. 164–65: *Untitled* (detail), 2014, styrene index cards, metal, wood, paint, and glue. © Tara Donovan, courtesy Pace Gallery. Photo by Kerry Ryan McFate

Patrick Dougherty

Pp. 166–67: *Shindig* (detail), 2015, willow saplings. Courtesy of Patrick Dougherty. Photo by Ron Blunt

Pp. 168–69: *Little Ballroom* (detail), 2012, willow, at Federation Square, Melbourne, Australia. Photo by Megan Cullen

P. 170: *Pomp and Circumstance* (detail), 2011, willow, at Oregon State University. Photo by Frank Miller

P. 171: *Just Around the Corner* (above, summer; below, winter), 2003, mixed hardwood, at New Harmony Gallery, Indiana. Photos by Doyle Dean

Pp. 172–73: *Close Ties*, 2006, willow, at Scottish Basketmakers' Circle, Dingwall, Scotland. Photo by Fin Macrae

Janet Echelman

Pp. 174–75: *Impatient Optimist* (detail), 2015, Seattle, Washington, spliced and braided fibers with colored LED lighting, buildings, and sky. Collection of Bill & Melinda Gates Foundation. Image © Janet Echelman, Inc. Photo by Ema Peter

P. 176: *Skies Painted with Unnumbered Sparks* (detail), 2014, Vancouver, Canada, spliced and braided fibers with interactive colored lighting, buildings, and sky. Collection of Janet Echelman/*Skies Painted with Unnumbered Sparks*. Image © Janet Echelman, Inc. Photo by Ema Peter

P. 177: *1.26 Amsterdam*, 2012–13, Netherlands, spliced and braided fibers with colored lighting, buildings, and sky. Collection of Janet Echelman/*1.26 Amsterdam*. Image © Janet Echelman, Inc. Photo by Ben Visbeek

P. 178: *As If It Were Already Here* (detail), 2015, Boston, Massachusetts, spliced and braided fibers with colored LED lighting, buildings, and sky. Collection of Janet Echelman/*As If It Were Already Here*. Image © Janet Echelman, Inc. Photo by Melissa Henry

P. 179: *As If It Were Already Here*, 2015, Boston, Massachusetts, spliced and braided fibers with colored LED lighting, buildings, and sky. Collection of Janet Echelman/*As If It Were Already Here*. Image © Janet Echelman, Inc. Photo by Melissa Henry

P. 180: *Impatient Optimist* (details, above and below), 2015, Seattle, Washington, spliced and braided fibers with colored LED lighting, buildings, and sky. Collection of Bill & Melinda Gates Foundation. Images © Janet Echelman, Inc. Photos by Ema Peter

P. 181: *Impatient Optimist*, 2015, Seattle, Washington, spliced and braided fiber with colored LED lighting, buildings, and sky. Collection of Bill & Melinda Gates Foundation. Image © Janet Echelman, Inc. Photo by Ema Peter

Pp. 182–83: *1.8* (rendering), 2015. Courtesy of Janet Echelman

John Grade

Pp. 184–85: *Middle Fork* (interior view), 2015, reclaimed old-growth western red cedar. Courtesy of John Grade. Photo by the artist

Pp. 186–87: *Middle Fork*, 2015, reclaimed old-growth western red cedar. Courtesy of John Grade. Photo by the artist

P. 188: *Middle Fork* (detail), 2015, reclaimed old-growth western red cedar. Courtesy of John Grade. Photo by Ron Blunt

P. 189: *Middle Fork* (detail), 2015, reclaimed old-growth western red cedar. Courtesy of John Grade. Photo by Ron Blunt

Pp. 190–91: *Middle Fork*, 2015, reclaimed old-growth western red cedar. Courtesy of John Grade. Photo by Ron Blunt

Pp. 192–93: *Middle Fork* (detail, side view), 2015, reclaimed old-growth western red cedar. Courtesy of John Grade. Photo by the artist

Maya Lin

Pp. 194–95: *Folding the Chesapeake* (detail), 2015, glass marbles and adhesive. Courtesy of Maya Lin Studio. Photo by James Cabot Ewart

P. 196: Blue glass marbles manufactured by Johns Manville, Inc., and donated for this installation. Photo courtesy Johns Manville, Inc.

P. 197: *Folding the Chesapeake* (detail), 2015, glass marbles and adhesive. Courtesy of Maya Lin Studio. Photo by James Cabot Ewart

Pp. 198–99: *Folding the Chesapeake* (detail), 2015, glass marbles and adhesive. Courtesy of Maya Lin Studio. Photo by James Cabot Ewart

Leo Villareal

Pp. 200–201: *Cylinder* (detail), 2011, white LEDs, custom software, and electrical hardware. © Leo Villareal, courtesy CONNERSMITH. Photo by James Ewing Photography

Pp. 202–3: *Volume (Durst)*, 2013, white LEDs, custom software, and electrical hardware. © Leo Villareal, courtesy CONNERSMITH. Photo by James Ewing Photography

Pp. 204–5: *Cosmos* (left and right), 2012, white LEDs, custom software, and electrical hardware, at Johnson Museum of Art, Cornell University, Ithaca, New York. © Leo Villareal, courtesy CONNERSMITH. Photos by James Ewing Photography

Pp. 206–7: *The Bay Lights*, 2013, white LEDs, custom software, and electrical hardware. Site specific installation: The Bay Bridge, San Francisco, CA. © Leo Villareal, courtesy CONNERSMITH and Illuminate the Arts. Photo by James Ewing Photography

P. 208: *Cylinder*, 2011, white LEDs, custom software, and electrical hardware. © Leo Villareal, courtesy CONNERSMITH. Photo by James Ewing Photography

PHOTO CREDITS

Frontmatter

P. 2: Photo by Frank Miller; p. 4: Image © Janet Echelman, Inc. Photo by Ema Peter; p. 6: Photo courtesy Johns Manville, Inc.

Pillows of Air

P. 10: © RMN-Grand Palais/Art Resource, NY. Photo by Thierry Le Mage.

The Encounter

P. 18: Photo by Peter Vanderwarker, courtesy deCordova Sculpture Park and Museum, Lincoln, Massachusetts; p. 26 (fig. 3): Photo by PHAS/UIG via Getty Images

A Sense of Wonder

P. 36: Photo by Todora Photography; p. 41 (fig. 4): Courtesy Wellcome Library, London

The Shuffle of Things

P. 48: Photo by Kerry Ryan McFate; p. 57 (fig. 9): KHM-Museumsverband; pp. 62–63, 63–64 (figs. 10, 11): Courtesy Smithsonian Libraries

Mr. Corcoran's Museum

P. 70: Photo by Richard-Max Tremblay; p. 73 (fig. 12): Courtesy Pennsylvania Academy of the Fine Arts, Philadelphia; p. 82 (fig. 14): Photo by Universal History Archive/UIG via Getty Images; p. 88 (fig. 18): Courtesy FultonHistory.com

The Exhibition

P. 92: Photo by James Ewing Photography; p. 96 (fig. 20): Photo courtesy North Carolina Museum of Art, Raleigh; p. 99 (figs. 21, 22): Photos by Stephanie Sinclair; pp. 102–3 (fig. 23): Photo by Mindy Barrett; p. 106 (fig. 24): Photo by Maria Grade; p. 106 (fig. 25): Photo by Amos Morgan; p. 107 (fig 26): Photo by Maria Grade; p. 109 (fig. 27): Photo by Lucas Saugen; p. 112 (fig. 28): Courtesy Center for Tsunami Research, National Oceanic and Atmospheric Administration/US Department of Commerce, Washington, DC, under Creative Commons (CC BY 2.0); p. 112 (fig. 29): Photo by Poobesh Lakshman, licensed through Flickr under Creative Commons (CC BY 2.0); p. 114 (fig. 30): Image courtesy Savannah College of Art and Design, Museum of Art, Georgia

You Are Here

P. 116: Photo courtesy of John Grade; P. 116: Photo courtesy of John Grade; p. 118: Image courtesy History of Science Collections, University of Oklahoma Libraries, © The Board of Regents of the University of Oklahoma, Norman

Notes

P. 125: Used by permission of the Folger Shakespeare Library under a Creative Commons Attribution–Share Alike 4.0 International License; p. 126: Image courtesy Bridgeman Images

Jennifer Angus
In the Midnight Garden
2015
cochineal, various insects, and mixed media
26 ft. 11 in. x 18 ft. 6 in. x 24 ft. 7 in.
Courtesy of Jennifer Angus

Chakaia Booker
ANONYMOUS DONOR
2015
rubber tires and stainless steel
10 ft. x 25 ft. 1 in. x 16 ft. 2 in.
Courtesy of Chakaia Booker

Gabriel Dawe
Plexus A1
2015
thread, wood, hooks, and steel
19 x 48 x 12 ft.
Courtesy of the artist and Conduit Gallery

Tara Donovan
Untitled
2014
styrene index cards, metal, wood, paint, and glue
12 ft. 5 ½ in. x 22 ft. 4 in. x 22 ft. 11 ½ in.
© Tara Donovan, courtesy of Pace Gallery

Patrick Dougherty
Shindig
2015
willow saplings
16 x 90 x 12 ft.
Courtesy of Patrick Dougherty

Janet Echelman
1.8
2015
knotted and braided fiber with programmable lighting and wind
movement above printed textile flooring
96 x 45 x 40 ft.
Courtesy of Janet Echelman, Inc.

John Grade
Middle Fork (Cascades)
2015
reclaimed old-growth western red cedar
40 x 18 x 26 ft.
Courtesy of John Grade

Middle Fork (Arctic)
2015
reclaimed old-growth western red cedar
90 x 33 x 28 in.
Courtesy of John Grade

Maya Lin
Folding the Chesapeake
2015
marbles and adhesive
26 ft. 6 in. x 32 ft. 7 in. x 22 ft. 9 in.
Courtesy of Maya Lin Studio

Leo Villareal
Volume (Renwick)
2015
white LEDs, mirror-finished stainless steel, custom software,
and electrical hardware
6 ft. ½ in. x 9 ft. 6 in. x 20 ft. 9½ in.
© Leo Villareal, courtesy CONNERSMITH

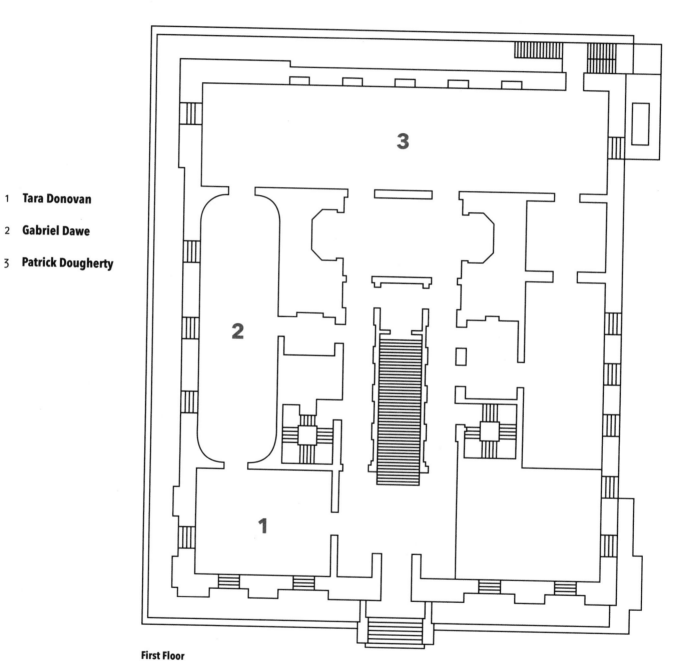

1 **Tara Donovan**

2 **Gabriel Dawe**

3 **Patrick Dougherty**

First Floor

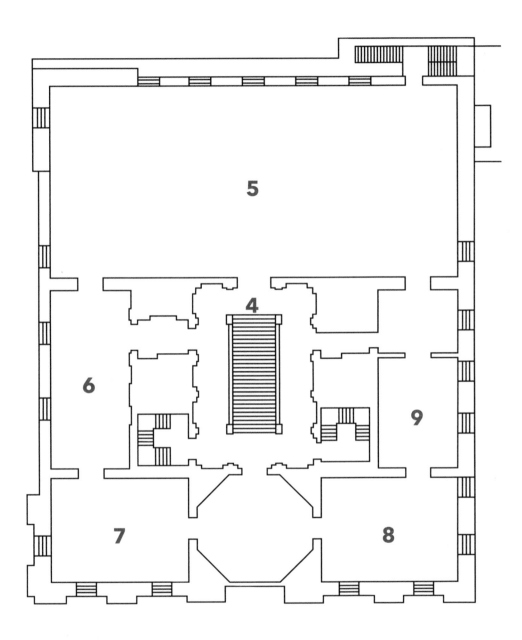

5

4

6

9

7

8

4 **Leo Villareal**

5 **Janet Echelman**

6 **John Grade**

7 **Maya Lin**

8 **Chakaia Booker**

9 **Jennifer Angus**

Second Floor

Once in a long while (and sometimes never) the stars line up just so and an opportunity is born to shape how a generation will experience something as significant as the role art can play in the enrichment of daily life. The renovation and reopening of the Renwick Gallery has been such a moment for our staff—the most thrilling challenge we could wish for, and the most humbling to come through. That it happened at all is the result of an extraordinary effort on behalf of a large cast, each member exhibiting the passion and drive to bring unlikely goals to satisfying fruition. I am deeply indebted to them all.

The Renwick's renewal is foremost the achievement of Elizabeth Broun, the Margaret and Terry Stent Director of the Smithsonian American Art Museum, who championed the cause of this landmark in the history of American culture. Half of the $30 million cost of renovation was funded by the president, Congress, and the American people. The remaining half was generously funded by David M. Rubenstein, The Brown Foundation, Inc. of Houston, Robert and Arlene Kogod, Nancy Brown Negley, Robert H. Smith Family Foundation, Carolyn Small Alper, The Bresler Foundation, Inc., Hacker and Kitty Caldwell, Sheila Duignan and Mike Wilkins, The James Renwick Alliance, Wendy and Jerry Labowitz, The Henry Luce Foundation, Susan and Furman Moseley, Debbie Frank Petersen, the Save America's Treasures Program, Ted Slavin, Windgate Charitable Foundation, Diane and Norman Bernstein Foundation, Mary Lou Boone, Joe and Sheri Boulos, Richard and Joanne Brodie, Elizabeth Broun, Fern and Hersh Cohen, Ann and Tom Cousins, Janet and Jim Dicke, Tania and Tom Evans, Shelby and Frederick Gans, Dorothy Tapper Goldman, Kristin and Kingdon Gould III, Bannus and Cecily Hudson, Deena and Jerry Kaplan, The William R. Kenan Jr. Charitable Trust, Mr. and Mrs. Donald R. Keough, Robert S. and Grayce B. Kerr Foundation, Maureen and Gene Kim, Colleen and John Kotelly, John Liebes, Jean Bronson Mahoney, Kelly Sutherlin McLeod and

Steven B. McLeod Family Foundation, Myrna B. and Sheldon B. Palley, Allan and Reda R. Riley Foundation, Doug Ring and Cindy Miscikowski, Samuel J. and Eleanor T. Rosenfeld, Betty and Lloyd Schermer, Kelly M. Williams and Andrew J. Forsyth, and Susan Winokur and Paul Leach.

Our first renovation in nearly fifty years provided the opportunity to re-emphasize for the public William Wilson Corcoran's original mission for this building, its significance as a symbol of what we, as a people, stand for, and what we hope to become through our encounters with art. For their support of the reopening exhibition inspired by these principles we are immensely grateful to Mr. and Mrs. J. Kevin Buchi, Melva Bucksbaum and Raymond Learsy, Barney A. Ebsworth, Shelby and Frederick Gans, Deborah and Larry Gaslow, Nancy and Carl Gewirz, Elizabeth Firestone Graham Foundation, Susan and Ken Hahn, Bannus and Cecily Hudson, Ann Kaplan and Robert Fippinger, Thomas S. Kenan III, Mirella and Dani Levinas, Jacqueline B. Mars, Robin and Jocelyn Martin, Marcia Mayo, Caroline Niemczyk, Debbie Frank Petersen, in memory of James F. Petersen, The James Renwick Alliance, Dorothy Saxe, Lloyd and Betty Schermer, Suzanne and Walter Scott Foundation, and Mary Ann Tighe.

I began to reach out to the artists in *WONDER* in late 2013, just as we moved out of the Renwick. My pitch was straightforward, but it also came out of the blue, and I will always be thankful not only for their willingness to humor this stranger, but also for their unfiltered enthusiasm for the very notion of wonder. The ardor displayed in their first visits to the Renwick cemented our decision to turn the whole of the museum over to this exhibition, biting off, as it were, the most we could possibly chew. This project's success is due to the vision, drive, and commitment of these remarkable nine. I also want to thank Elizabeth Sullivan and the team at Pace Gallery, Leigh Connor of Connor Contemporary, Conduit Gallery, Dorothy Bank, James Cabot Stewart and Maya Lin Studio, Claire Watkins

and the team at Tara Donovan Studios, the team at Studio Echelman, David Feldman, Brian Stacy and Clayton Binkley at Arup, EGE, Johns Manville, Inc., which donated the marbles for Maya Lin's installation, Tim Bishop and Parallel Development, and Lucas Cowan and the Rose Fitzgerald Kennedy Greenway Conservancy. In addition, we thank the Renwick renovation team, which handily juggled this exhibition's preparation while completing work on the building: Michael Culcasi, Eric Bottaro, Justin Pollard, and Adam Cirigliano at Consigli Construction, Kristina Vidal at Westlake Reed Leskosky, Seth Takoch at Woods Peacock, and Sarah Drumming, Shelli Arnoldi, and Ed Wahl at the Smithsonian, among many others.

This book is richer for the involvement of Lawrence Weschler, whose journey down the rabbit hole, *Mr. Wilson's Cabinet of Wonder*, first brought this topic into focus for me as a teenager, intrigued by objects, but unsure quite how to articulate them. He has helped me to remember that things need not always be what they seem. I am grateful for the guidance of Daniela Bleichmar at the University of Southern California, to the peer reviewers, the staff overseeing the Thomson Collection at the Art Gallery of Ontario, and to Charles Robertson for sharing his research, published in tandem with this volume as *American Louvre: A History of the Renwick Gallery Building*. Our crack publications team, including Theresa Slowik and Jessica Flynn, was joined by editor Jane McAllister, Dan Saal of StudioSaal Corporation, and photographer Ron Blunt, forming a cohort talented enough to make any curator envious. They made what you are holding possible.

At the Smithsonian American Art Museum, I am particularly grateful for the assistance of Rachel Allen, Robyn Kennedy, Nora Atkinson, Fern Bleckner, Marguerite Hergesheimer, James Baxter, Virginia Mecklenburg, Karen Lemmey, Joanna Marsh, E. Carmen Ramos, Jo Ann Gillula, Sara

Snyder, Carol Wilson, Melissa Kroning, Donna Rim, Elizabeth Daoust, Ben Simons, Michelle Atkins, Jennifer Lee, David DeAnna, Carlos Parada, Zachary Frank, Nathaniel Philips, Erin Bryan, Harvey Sandler, Grace Lopez, Amy Doyel, Mary Cleary, Karen Siatras, Emily Chamberlin, Kelli Zingler, Kelly Traywick, Mindy Barrett, Laura Baptiste, Courtney Rothbard, Laura Griffin, Samantha Grassi, Katie Crooks, Rebecca Robinson, Debrah Dunner, and Claire Larkin. I want to especially recognize the awe-inspiring efforts of David Gleeson and Sara Gray in designing the exhibition, and Jasmine Jennings who provided research and curatorial assistance throughout the project.

Finally, I wish to thank my wife, Allison Bell, for her encouragement, patience, and perspective, and our young children, Charlotte, Catherine, and Henry. Witnessing their first encounters with the world has served as the most profound reminder of wonder's value. They have taught me once more to marvel at each pimpernel and dandelion. For that they have my greatest admiration. □

—N.R.B.

WONDER

Theresa J. Slowik, Chief of Publications
Jane McAllister, Editor
Dan Saal, StudioSaal Corporation, with Alvaro Villanueva, Designers
Jessica L. Flynn, Production Manager
Amy Doyel, Permissions Coordinator
Jasmine Jennings, Curatorial Assistant

Typeset in Scotch Modern designed by Nick Shinn, and Avenir® Next designed by Adrian Frutiger in collaboration with lead designer (now Linotype Type Director) Akira Kobayashi. Printed in Italy.

Published in conjunction with the exhibition *WONDER*, on view at the Renwick Gallery of the Smithsonian American Art Museum, Washington, DC, November 13, 2015–July 10, 2016

Smithsonian American Art Museum
Renwick Gallery

The Smithsonian American Art Museum is home to one of the largest collections of American art in the world. Its holdings–more than 41,000 works–tell the story of America through the visual arts and represent the most inclusive collection of American art of any museum today.

It is the nation's first federal art collection, predating the 1846 founding of the Smithsonian Institution. The Museum celebrates the exceptional creativity of the nation's artists, whose insights into history, society, and the individual reveal the essence of the American experience.

The Renwick Gallery became the home of the Museum's American craft and decorative arts program in 1972. The Gallery is located in a historic architectural landmark on Pennsylvania Avenue at 17th Street, NW, in Washington, DC.

Published in 2015 by the Smithsonian American Art Museum in association with D Giles Limited, London

D Giles Limited
4 Crescent Stables
139 Upper Richmond Road
London SW15 2TN, UK
www.gilesltd.com

Library of Congress Cataloging-in-Publication Data

Bell, Nicholas R., author.
Wonder / Nicholas R. Bell.
 pages cm
Published in conjunction with the exhibition Wonder, on view at the Renwick Gallery of the Smithsonian American Art Museum, Washington, DC, November 13, 2015–July 10, 2016.

Includes bibliographical references.
ISBN 978-1-907804-83-0 (cloth : alk. paper)
ISBN 978-0-937311-81-3 (softcover : alk. paper)
ISBN 978-0-937311-82-0 (cloth, special binding : alk paper)

1. Site-specific installations (Art)–Washington (D.C.)–Exhibitions.
2. Marvelous, The, in art–Exhibitions. I. Renwick Gallery, host institution.
II. Smithsonian American Art Museum, organizer, issuing body. III. Title.
N6496.W18R463 2015
745.0973'074753–dc23
2015028177

10 9 8 7 6 5 4 3 2

Frontmatter Captions
P. 2: Patrick Dougherty, *Pomp and Circumstance* (detail), 2011, willow, at Oregon State University, Corvallis

P. 4: Janet Echelman, *Impatient Optimist* (detail), 2015, Seattle, Washington, spliced and braided fibers with colored LED lighting, buildings, and sky. Collection of Bill & Melinda Gates Foundation

P. 6: Blue glass marbles manufactured by Johns Manville, Inc., and donated for Maya Lin's *Folding the Chesapeake*, 2015